The Price and Privilege
of Being a Woman

"Through gripping stories Winnie Williams provides an insightful commentary on the plight of women in diverse settings struggling to achieve their rights in the midst of oppressive cultures. With compassion and honesty, the tales are told of women fighting for their dignity while living at the margins of life. While issues of justice and equality for women have taken a back seat in times of economic and political upheaval, Winnie Williams makes a compelling case that the time has come for persons of Christian commitment to dedicate themselves to the destruction of controlling and dominating traditions that have for too long demeaned women throughout the world."

—Dr. Tom Graves, President
Baptist Theological Seminary at Richmond (Virginia)

"Williams' second book sheds a new light on the plight of women in developing countries. While her findings confirm our darkest fears about the state of women in the world, her clarity of vision and compassion inspire us, because she goes beyond the sad statistics and external, physical conditions of these women's lives: she captures their hearts and spirits. These courageous, enterprising women who battle despair, discrimination and abuse on every front have their best advocate in Williams, who calls for a global movement of love and liberation to help them. Her book is our wake-up call: it is time to come to the aid of our sisters in distress. Every woman counts—this is the message Williams' book drives home, and therefore each one of us can make a difference."

—Beatriz F. Fernandez, Book Reviewer, University Reference
Librarian, Florida International University

"Winnie Williams gives a well-researched and accurate snapshot of the history, landscape and culture of seven countries while skillfully weaving through her writing an exposé of the sub-standard and, in many cases, sub-human treatment of women. The description of captivating scenery sharply contrasted by the underclass plight of women is startling. It highlights what Winnie Williams does so well—burn in the reader's mind the need for all people, especially Christians, to press for holistic care and concern for the oppression of women—physically, mentally, emotionally and spiritually.

"In *The Price and Privilege of Being a Woman* you can see deeply into the author's heart as she roots out the public and hidden disgraces of the treatment of women.

"When the time comes that women everywhere are treated with respect, Winnie Williams' passionate quest to tell the story of oppressed women will have played a part in helping lift them to a rightful place of equality."

—Beverly Greer, Missions Coordinator,
South Carolina Cooperative Baptist Fellowship

"It was my honor to accompany Winnie Williams on her trip to Russia and watch her become involved in the lives of women. In reading this book you will become involved in their lives as well, as you listen in a poignant new way to the voices of women who courageously live in the midst of traumatic social change."

—Dr. Sanford Becket, Associate Director of Northstar Church
Network: An Association of Baptist Congregations, Virginia

"The Price and Privilege of Being a Woman is well written. Tempered with Christian compassion, Mrs. Williams, through her words, reminds us that women, like men, are created by God and therefore are to be treated with equal dignity and respect. Let us pray that if but one woman among millions chooses to stand strong with determination, she will bring new hope to those who endure their injustices with quiet humility."

—Jo Ella White, author of three novels, West Union, South Carolina

"The Price and Privilege of Being a Woman, Winnie V. Williams' recent release, is a penetrating, personal exploration into the challenges women face in many countries. The writing is vivid, easy to read, and takes the reader into the very soul of women around the world. As in her first book, *Women I Can't Forget*, we see the effects, both historical and current, of patriarchy—the near-universal rule of men and disrespect for women and girls. She has lived with these women in their cramped, miserable quarters, and shared some of their suffering. She shows what Christianity has and has not done to bring more justice to the women of primitive and industrial cultures.

"Her discussions are never superficial, but are rich with the history and culture of each of the countries. In this book we go behind the scenes into the lives of women in Russia, Macedonia, Kosovo, Guatemala, Ecuador, Alaska, and the aborigines of Australia.

"This would be an excellent selection for book clubs, as well as for individual reading. A must-read for those who wish to enlarge a global awareness of the consequences of patriarchy."

—Mimi Haddad, President, Christians for Biblical Equality,
www.cbeinternational.org

"The Price and Privilege of Being a Woman is a combination travelogue, personal journal, and call to social justice for the women of the world. Across the continents and through the stories of women facing frightening challenges especially because of their gender, it will call you to action on behalf of the oppressed women of the world."

—Dr. Mari Gonlag, Bible Professor and Executive Director of the Center for Women in Ministry, Southern Wesleyan University, Central, South Carolina

"Having traveled extensively in numerous countries of the world interviewing women of many cultures and customs, and being deeply interested in and concerned about women world-wide, Winnie Williams is an extraordinary woman who has a unique way of presenting the profiles of women in *The Price and Privilege of Being a Woman.* Without doubt, the eyes of the reader will be opened to a greater understanding of the international situation of women as they journey through the pages of this book. The reader, as I, will sense changes in perspective and attitude as together we are challenged by these women of courage, determination and dignity. As privileged, Christian women in the world today, Winnie urges us to recognize that 'Christianity will probably only come to these disenfranchised women when Christian women have the yearnings and longings to be God's messengers."

<div align="right">

—Rev. Ida Mae Hays, retired IMB Missionary to Brazil;
retired Pastor of Weldon Baptist Church, Weldon, North Carolina;
staff of Baptist Theological Seminary at Richmond, Virginia

</div>

Also by Winnie V. Williams
*Women I Can't Forget: A Global Traveler Reveals the Struggle
and Courage of Women Without Rights*

The Price
and Privilege
of
Being a Woman

Encounters with Global Women
Who Search for
Justice and Compassion

WINNIE VAUGHAN WILLIAMS

Blue Dolphin

Published by Blue Dolphin Publishing, Inc.
P.O. Box 8, Nevada City, CA 95959
Orders: 1-800-643-0765
Web: www.bluedolphinpublishing.com

ISBN: 1-57733-188-5; 978-1-57733-188-9 (hard)
ISBN: 1-57733-184-2; 978-1-57733-184-1 (soft)

Library of Congress Cataloging-in-Publication Data

Williams, Winnie Vaughan
 The price and privilege of being a woman : encounters with global
women who search for justice and compassion / Winnie Vaughan
Williams.
 p. cm.
 Includes bibliographical references and index.
 ISBN 1-57733-184-2 (pbk. : alk. paper) — ISBN 1-57733-188-5 (hardcover :
alk. paper)
 1. Women—Cross-cultural studies. I. Title.

 HQ1154.W537 2006
 305.42—dc22

 2006014202

Photo of author by Woodie P. Williams, III

Printed in the United States of America

10 9 8 7 6 5 4 3 2 1

Dedicated to my daughter
Wanda
and my granddaughters
Claire and Danielle

Table of Contents

Acknowledgments

I AM INDEBTED TO MANY INDIVIDUALS who live in other countries whom I will not identify due to security risk. These individuals, such as humanitarian workers, missionaries, and indigenous families, provided me with valuable information regarding the plight of women in their countries that could place them in jeopardy if their identities were discovered. They not only provided me with lodging, transportation, and served as interpreters, but also greatly assisted me with the understanding of their cultures. Without their valuable assistance, I could not have written this book or my last book, *Women I Can't Forget*. To them I will always be grateful.

To my husband, Woodie, who has supported me not only in reviewing my manuscript but who also has accompanied me on some of my journeys and at other times assumed home responsibilities while I roamed the continent. To him I say, "Thank you, thank you."

My loving appreciation goes to Sylvia Titus, English Professor at Clemson University, Clemson, South Carolina, who edited and guided me through my writing endeavors and to good friends Dr. Sandra Reeves of Mountain Rest, South Carolina, Dr. Sanford Beckett of Herndon, Virginia, Rachel Beckett of Kansas City, Kansas, author Jo Ella White of West Unions, South Carolina, Suzanah Raffield of Birmingham, Alabama, and my attorney son-

in-law, David Vickers of Charlotte, North Carolina, who reviewed the manuscript and offered valuable suggestions. Thank you for making my endeavor easier. My special thanks also goes to Paul Clemens of Blue Dolphin Publishing, Inc. for believing in my cause and publishing this book.

Foreword

Do you have true passion for a cause, a mission? In midlife, as I continue seeking that one cause to which I will commit myself, I look to other persons whose examples might inspire me.

While I am fortunate to observe on a personal basis the role model provided by my husband (he is committed to eradicating substandard housing in our hometown), I find myself motivated professionally by the model found in Winnie Williams—a person of many causes, but focused on one in particular.

I first "met" Winnie by reviewing her book, *Women I Can't Forget*, in which she introduced me to her ministry to women around the world suffering from gender, economic, and social mistreatment. I was instantly drawn to her passion for the cause of which she wrote.

When I met her in person a few months later, that same enthusiasm was evident in her personality. She fit exactly my mind's picture of her—slight frame, bubbly, smiling much, talking fast, feisty, and determined. In the years since, I have learned that Winnie tirelessly devotes herself to whatever cause or organization with which she is involved.

In fact, when I learned of all Winnie's involvements with overseas trips, her church, and various boards and agencies, I thought, "There's no way she can be retired." Now, I want to be like her when I retire—a full-time volunteer!

I have seen first-hand Winnie's support of church-related causes. She has been instrumental in placing subscriptions of the news journal *Baptists Today* in the hands of members of her home church and other South Carolina churches and distributing them to students at Baptist Theological Seminary at Richmond. To accomplish this task, she either has personally paid for or enlisted contributors to pay for the subscriptions.

(As a co-worker of mine said, "Winnie is the most connected person I know; she knows somebody everywhere." As most of her "connections" would probably attest, you can't say "no" to Winnie Williams. Her zeal easily hooks you in to her "projects"—you've committed before you know it!)

Now, as an officer of the *Baptists Today* board of directors, Winnie portrays a unique blend of Southern lady poise and an assertive, can-do attitude. She holds herself and others accountable for tasks and commitments—she does not ask anyone to do something she would not do herself. I especially appreciate her organizational skills and ability to stay on task in chairing the partnership/circulation subcommittee. Her boundless physical energy and adventuresome spirit make me tired. Most of all, I am inspired by Winnie's unique ministry.

Recently she told me of a six-week trip to South Africa. While she voiced gratefulness for women there having been freed from apartheid, she expressed grave concern for the sexual exploitation of girls and women that has resulted in a rampant AIDS/HIV infection rate. This trip was part of Winnie's mission as "an advocate for justice for women of the world."

I first met this advocate the week after Sept. 11, 2001, at a professional/social gathering. While emotions in the room were still strained after the attack on our nation, Winnie was hopeful, positive, and optimistic. Interestingly, her work for the rights of women over the past four years has coincided with women in Muslim countries gaining limited rights. Her newest book, *The Price and Privilege of Being a Woman,* lends a personal and spiritual side to such history-making events.

Join Winnie in her travels to some of the forty countries she has visited. Meet the silent women of Russia, the struggling

women of Macedonia, the scarred women of Kosovo, the sup-
pressed aboriginal women of Australia, the servant women of
Guatemala, the abused women of Ecuador, the sturdy women of
Alaska. Learn about the cultural and political history that has
brought them to their current state of need. Champion their
accomplishments, their hopes, their dreams.

You will learn quickly while traveling with Winnie that she
does not take lightly her cause—justice for women of the world.
She refuses to settle for pat answers ("It's their culture") when
discussing the plight of women. Most of all, she offers hope for
change as Christians unite their efforts. To all of us she offers this
challenge: "We must not sit in silence."

Jackie B. Riley
Managing Editor, *Baptists Today*

Introduction:
Women Have Walked Too Long with Stones in Their Shoes

CAN YOU VISUALIZE A WOMAN BEING BEATEN by a Russian man (probably her husband) in a public area until blood covered the ground and the "thrashing" being accepted as a male's "right" to discipline his wife? Can you visualize yourself as a Guatemalan woman considered unworthy of an education? Imagine that you are a Muslim woman who is gang-raped by Serbian soldiers in Kosovo and that consequently your husband and family abandons you because you have been violated through no fault of your own. Imagine being a Macedonian woman who is told that her twelve-year-old daughter's marriage has been arranged to a middle-aged man. Can you visualize living even one day in the shoes of these women? Observing and learning of these and many other such happenings as I have traveled to more than forty countries has provided me with the incentive to become an advocate for justice for women of the world.

As I became immersed in visiting the various countries and investigating the role of women, I learned that only about 10% of the world's income is earned by women and that 66% of the illiterate people in the world are women. I question why 70% of all the poor in the world are women and why is it that 75% of the sick are women.[1] The statistics get worse—200 million women are battered annually and 100 million women are disabled due to childbirth complications as a result of poor health care. Are we

bothered that so many women have no medical care before or during childbirth, as is often the case for some women in countries such as Ecuador? Even though some progress in ensuring justice for women is occurring, the quandary for millions of women is a disgrace and should be an indignity to every person. These atrocious acts of violence, neglect and exploitation, directed at women, are far too prevalent. Every person should feel a moral obligation to help remove some of the stones from the shoes of these women.

Following an exhausting mission-service trip to Macedonia and Kosovo, a friend and I relished in relaxing in Athens, Greece. Among the ancient Grecian historical sites we visited was the Acropolis. We climbed so many steps in the warmth of a summer day to reach the renowned site that we wondered if we were walking into the heavens. Among the intriguing sites that we encountered at the Acropolis was a portion of a building known as Erechtheum, situated near the Parthenon. Its south portico was supported by six caryartids, columns of white marble statues of Grecian women. These caryartids gave the appearance that the heads of these women were supporting the roof structure of the portico. I sat a long time observing these statues and thought of the many years that such heavy burdens have been placed upon them. On their strong shoulders they had born the burdens of suppression and exploitation, yet they had provided a haven for their families. As I meditated on these "strong women," I wondered if I could measure up to the burdens that these women had borne for centuries. Before I left Athens, I purchased a white marble statue of a Greek goddess who resembles these caryartids. She now stands proud and stalwart in my living room as a constant reminder of the never-ending struggles of women through the centuries.

Why have such struggles by these and millions of other women been so problematic, so demeaning and painful? The stock explanation is that it is due to cultural traditions. Though this is true, it is necessary to assess other factors that have significantly contributed to women's dilemma, such as religion, politics, social structures, and the pleasure that males derive from

the lofty position of supremacy, domination and control of women. Historically, males have embraced the belief in their superiority and, conversely, women's inferiority. This patriarchal philosophy has encouraged and mandated women to a role of submission, maltreatment and exploitation. Males have deliberately followed the models of their fathers who perpetuated male's pre-eminence. History, written by males and often biased toward women, has enabled the continuation of the maltreatment of women. It has only been in recent years that women, in the eyes of some, have received recognition as humans of worth and dignity.

As a consequence of the proclamation of the male's dominant role, many women have come to accept their inferior status as a reality, as the norm. I learned in Thailand that "beating is what you expect" if you are a woman. Thus, some women who have developed vocational skills have deferred marriage rather than accepting the humiliating role that accompanies marriage, even though an unmarried woman does not have an acceptable status in most societies.

Though it is difficult for us to confront the anomaly that religion has contributed significantly to the degrading of women, it has been and continues to be a major cultural enforcer of patriarchy. Religions, usually focusing on male deities, have been a foremost influence in the hierarchal positions, and tend to malign women to submissive roles. Christians, as well as other religious groups, value masculinity over femininity. In visiting churches in various countries I have found that women generally attend church in larger numbers than do men, yet it is the men who preach and control almost every aspect of the church or religious group. It seems that the more fundamental the theology of a church tends to be, the greater its disposition is to embrace subservient requirements for its women.

Fundamentalism appears to be more resistant to change and less tolerant of parity for women. A few countries, such as Russia's Methodist churches, are more open toward the utilization of women in church leadership positions, even as clergy, but progress dawdles in most instances. In most developing coun-

tries, however, my observation is that almost no women are in church leadership positions. I learned that women continue to be undervalued, even though they do the majority of the church's mission work in a country.

An example of this discrimination was evident as I visited Baptist churches in Russia. I learned that if a person was not ordained, then the individual could not appear on the stage or platform of a Baptist Church. Since Baptist women are not permitted to be ordained, they, of course, are not allowed to participate in leadership roles from the pulpit. Though I was asked to bring greetings to a large Baptist congregation, the pastor, at the last moment, refused to allow me to do so. Also while participating in a Bible study with a group of women in Moscow, the female leader said priorities for women are: God first, men second, and women third. The Bible study focused on verses from I Timothy, "Wives, submit to your husbands." This philosophy has been infused into these women's value system and is accepted without question, not only in the church but also in almost every aspect of their life. Men have learned to protect their hierarchial position by "putting women down" and using their religious belief system to justify their action. Sue Monk Kidd in her book, *The Dance of the Dissident Daughter,* said, "He learned to stay up by keeping her down, that is, by insisting she be content with things as they are."[2]

Is it not paradoxical that the church is the entity where women seek solace, yet it is the same church that imposes boundaries to stifle them? In almost every area of a woman's life some level of parity is extended to her—except in churches, especially churches with fundamentalist inclinations. A woman goes to church with a strong and exacting sense of herself only to find constraints that silence her. Organized religion, for the most part, is the last arena to affirm women. Only when Christians and other religions become concerned, become alert to the unsuitable dogma and cultural stigma regarding women, and search the scriptures with integrity to unveil God's inclusiveness, then and only then will women be able to enter the altar of justice.

At an autograph signing for my first book, *Women I Can't Forget*, regarding the struggles and courage of women in developing countries, I spoke with an elderly man who came to purchase a copy of my book. He asked, "Do you really think this one book is going to change the culture of the world regarding women?" I was taken aback for a moment but then responded, "This book may not significantly change the world's regard for women, especially in developing countries; but if it can make the difference in the life of one woman, it will have been worth the effort." The civil rights of women will happen, perhaps one woman at a time, one family at a time—for women have walked far too long with stones in their shoes.

Though there are fewer stones in women's shoes today than in past years, the remaining ones are still saw-toothed and painful. Occasionally a stone is removed as a consequence of a woman's becoming educated and informed of her civil rights and given hope of an improved way of life. She looks forward to a better way of life in her society. This book reveals my observations of many destitute women and some of the adventures I encountered as I sought to hear the lamenting of women and also their anticipation of a life with dignity. I have written about women in Australia, Alaska, Ecuador, Guatemala, Kosovo, Macedonia, and Russia.

My purpose in writing this book is to bring an awareness of the plight of women of the world, especially those in unindustrialized countries, as I have observed them through personal encounters. There has been immeasurable assistance from missionaries, humanitarian workers, guides, interpreters and families who have shared their homes with me. Though I have interviewed many women (and some men) and reviewed literature to give me an insight into the conditions and perils of these women, it is difficult to document, without question, all that I have written, heard or read, but I do believe, to the best of my knowledge, that the information which I have written is reliable. Names and professions have been changed to protect individuals and their work in strategic areas.

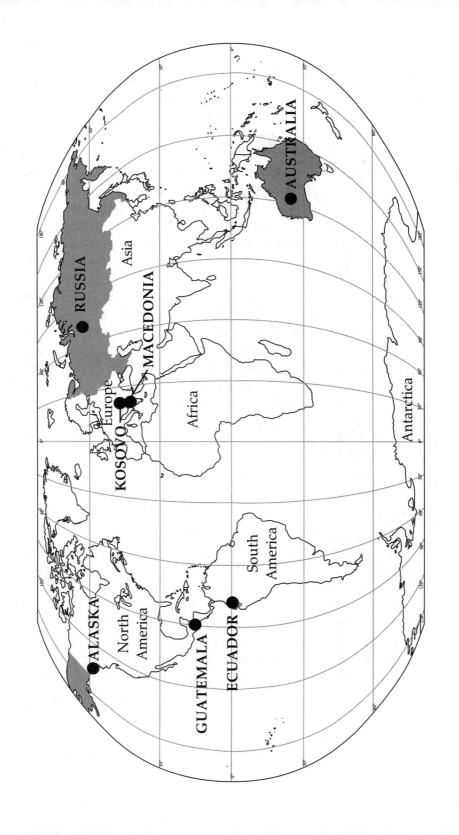

1

Russia and
Its Silent Women

The Beaten Woman

"RUSSIA IS ALWAYS DEFEATED BUT NEVER BEATEN," is a common motto that was frequently used in Russia during the Communist régime. It was not true, however, for Russian women then, nor is it true today, for these women are often defeated and beaten.

This fact was evident on a Sunday morning of my first day in Russia. I had come to live for a short time with a Russian family in their third floor apartment in one of the high-rise apartment buildings of Moscow. A loud noise from outside alerted the family that something was happening near the front door of the building. A middle-aged Russian man was beating a woman, most likely his wife, apparently displeased with her behavior. Repeatedly, he struck her with his fist as she thrashed about to avoid his punches, and soon, with his blows to her head and face, blood began streaming from her nose. She attempted to escape from him, but he caught her and began hitting her again. A woman standing nearby rushed up to the couple and attempted to rescue the woman, but the Russian man turned his hostility on her and began striking her vigorously with his fists. My host family said there was no use calling the police as this was a domestic incident and the police would not intervene. If they were called, they would refuse to come and say, "We are busy catching robbers and murderers." Even my host, a Baptist minister, said, "It is a domes-

1

tic problem not a human problem." I could not believe what I was hearing. Each time I walked outside, stepping over the blood on the sidewalk, I felt a flood of anger twisting in my chest. Finally, the rains came and cleansed the ground, but not my memory of this vulnerable woman being beaten. Thus, my introduction to Russia's treatment of women was more appalling than I ever imagined.

Later, I inquired of other Russian women if it was really true that the police would not interfere when men assaulted their wives or other women. Yes, it is true, I learned. Never mind that husbands and partners kill an estimated 14,000 Russian women each year, and this, according to some sources, does not represent the real extent of the problem.

Mother Russia

As I flew from Atlanta to Moscow, I had no idea that I would soon face some of the greatest challenges of my travels over the past twenty years. Acquaintances of mine who had gone to Russia as tourists returned with glowing reports of its warmth, its historical aspects, its fabulous art and sculpture, and its noble architecture. All of these highlights I hoped to experience; however, I was not going for the usual tourist sight-seeing trips nor residing in the modern hotels or partaking of the admirable Russian cuisine.

My purpose in going to Russia was to develop an appreciation of its culture, politics, and traditions, especially as they relate to Russian women. I soon realized that I was unprepared for being in Moscow, a city where more crimes are committed than in any other place in the world, where I would be robbed twice, searched by guards, stopped by police for no reason, and have my visa and passport withheld until just an hour before I was to depart for home. It was a wake-up call for me.

However, because I was determined to accomplish my goal of exploring the Russian culture, I discovered its history to be fascinating and sometimes rather bizarre. Reviewing some of the historical aspects of Russia helped me in understanding its uniqueness, including its position regarding women. The Russian

people are the product of their past experiences, which have shaped their cultural philosophy, their theology, and even their political struggles. A look into their history reveals some of the radical positions of the past and illustrates how these have fashioned the Russian people today.

It was during the sixth century that the Slavs moved westward from Central Asia to settle in what is now European Russia. These early settlers, including Russians, Ukrainians and Belarussians, all members of the Slavic family, settled along the rivers and became prosperous traders with Europe.[1]

In 1240, Genghis Khan, arriving from the East, led a powerful Mongolian invasion of Russia and established an empire that remained intact until the 15th century. Following the Mongolian rule there was a long line of Russian czars, including Ivan the Terrible, which lasted several centuries. The present capital, Moscow, was established in 1547, but when czar Peter I (Peter the Great) came into power in 1712, he moved the government seat to Petersburg, the second largest city in Russia today. The palatial palaces, the ornamental churches, and architecturally designed squares served the czars for more than 200 years.

Then came a period of unrest during the czarist reign when the serf peasants were constantly abused and forced into hard labor by the nobles and landowners, causing a volatile political situation. Any revolts by the peasants were suppressed through harsh means, resulting in the czars becoming increasingly less popular among the common people. Hence, the atmosphere was ripe for the revolution which the Communist party seized upon and gained control of Russia in 1917. The Communist party would rule Russia for the next 75 years, deploying some of the most cruel and devastating blows that the people had ever experienced. In 1918 the Communists moved the capital back to Moscow which remains today the seat of government.

With the arrival of Communism, the "all people equal" philosophy conceived by the German philosopher Karl Marx and instituted by Vladimir Lenin became the order of the day. The state insisted that to implement equality for every person, it was necessary to restrict freedom in every area of life, including reli-

gion. This entailed the state establishing a powerful military and taking ownership of factories, farms, banks, country estates, and resources such as coal, oil, and natural gas. Newspapers were closed and political activity was prohibited, enabling the government to have complete control. The theory was that all property now belonged to the workers.

When Joseph Stalin succeeded Lenin in 1925, Russia experienced one of its darkest periods in history with more than 20 million people being killed due to Stalin's rigid Communist decrees. He imprisoned or killed opponents and placed ordinary people in concentration camps for forced labor. The results were disastrous. Another dark period in Russian history was in 1941 when Hitler marched into Russia, destroying villages and cities and annihilating more than 27 million people.

Problems continued to plague Russia in the 1960s and 70s, when Leonid Brezhnev was president. The economy became stagnant, living conditions worsened, food became scarce, and people lacked motivation. Though the people were guaranteed employment by the government, there were no jobs. When Brezhnev died in 1982, the country was almost bankrupt.

Although Communism was mostly harsh to the Russian people, it did open some avenues previously unavailable to Russian women. They, along with the men, became educated and trained for vocational positions. This education and training for women was not for altruistic reason but for fiscal gain. Women had long worked in the fields and at menial jobs, but under Communism, additional positions and responsibilities were added which before had been forbidden to women. The change in women's roles enlarged the workforce, thereby enhancing economic gains for the country.

It was in the 1980s that a new philosophic régime began when Mikhail Gorbachev became president and championed such initiatives as "perestroika," which provided a restructuring for economic reforms, including open elections, private ownership of business, and decreased power for the party bureaucrats. For the first time in seventy years, people were able to openly discuss concerns for their country. Another sign of progress was the

adoption of "glasnost," which gave greater freedom to the people. These policies, however, aroused fear and opposition by the hard-line Communists, who attempted a *coup d'etat* in 1991 against Gorbachev. Military forces invaded Moscow but failed to overthrow the government. Boris Yeltsin, who was later elected as Russia's president, and Gorbachev held strong against the Communists, and Yeltsin emerged as Russia's most influential politician.

With the election in 1991 of Boris Yeltsin as president, an enormous hostility developed within the hard-line Communist party members. Yeltsin was, however, committed to reform and privatization of industry, a commitment, which ultimately led to the collapse of the USSR (Union of Soviet Socialist Republic), a momentous time in Russian history.

Today eleven of the former Soviet Republic states have formed the Commonwealth of Independent States, a somewhat loose organization of economic affairs and military armies. There is also a Russian Federation, which consists of twenty-two Republics. The old familiar flag of the Communist Russia with a hammer and sickle is nowhere to be seen; their new flag is red, blue and white stripes. Even with its present problems, Russia longs for a brighter future with a more democratic form of government.

Mother Earth

Driving from east to west across Russia would take a traveler eight days and requires crossing eleven time zones. This massive country, twice the size of the United States, covers one-eighth of the earth and can boast of being the largest country in the world. More than 150 million people reside in Russia with most living in the western area adjacent to Europe.

Surprising to most people is the fact that the extreme eastern portion of Russia is only fifty miles across the Bering Strait from Alaska and, thus, is a very close neighbor to the United States. Siberia, which covers the northern half of the continent, consists mainly of tundra, areas of permanently frozen, flat, and treeless plains, although some areas have coniferous forests known as

taiga. To the southeast of Russia lies Kazakhstan, to the southwest the Ukraine, to the west Estonia, Belarus and Latvia, and to the north Finland and the Barents Sea.

Some of the harshest weather in the world can be found in northern Russia, where the fierce blizzards display their wrath. The Arctic Circle and subarctic are wrapped in snow and ice most of the time because of the slanting sunlight in the region and the lack of any sunshine at all for weeks at a time in winter. Temperatures in these areas may reach –90 degrees Fahrenheit, and it is easy to see why the freezing wilderness of Siberia is referred to as the Land of the Exile. However, around Moscow and St. Petersburg, the average temperature is 16 degrees Fahrenheit in winter and 62 degrees during its short summers, with May having only four hours of darkness each day.

I have never experienced arctic cold and wetness to the degree that I did when I toured the Kremlin in Moscow. Never mind that it was May and a few flowering bulbs were lifting their heads among the scattered blades of grass waving in the blustery wind. The rawness of the cold, mixed with gusts of wind and the assaulting rain, was debilitating, convincing me that my thin windbreaker was an unwise choice. Everyone else seemed to recognize that even in May winter was still present and had prepared for the customary rain that brought puddles and endless mud. It was difficult for me to comprehend the weather I would have encountered if I had been there in the winter months.

As I visited the countryside, I observed forests of tall, slender birch trees with their silver bark and leaves fluttering like butterflies and the flat lands awash with waves of newly sprouted grasses and budding new crops. In the higher elevations of southern Siberia, one could view both the massive snowcapped mountains and the tundra with its stunted vegetation and mosses.

In the European areas of Russia, the country homes showed a few flowering shrubs, such as lilac bushes and a few scattered annuals; however, I never saw a flower growing in the city of Moscow, except on the grounds of the Kremlin. Part of the reason for this absence of flowers is that the people live in tall, concrete apartment buildings where there are no yards or gardens for growing grass or flowers. In numerous sections of Moscow I

observed vendors on the sidewalks selling gorgeous varieties of flowers from metal buckets. Because flowers are a symbol of love and appreciation in Russia, I often saw family and friends presenting flowers to women as they arrived at the airport as a gesture of welcome.

The Russian population, with its more than 150 million people, is composed largely of Russians (82%) with the remainder of the population Tartars, Ukrainians and Chuvashs. These ethnic groups have been in conflict over the years, and this conflict threatens to divide the nation. Another more recent division among Russian people is that group referred to as "The New Russians." Following the collapse of the Soviet Union in 1991, Russia opened its doors to foreign trade, allowing privatization in the country and giving rise to a group of shrewd Russian business people who supplied their country with new products. These entrepreneurs provided the country with such products as jewelry, cars, new food items, and electronic equipment, and made fortunes in the process. Others gained their wealth through real estate, banking management, marketing, and finance. Some, however, have made their fortune through political manipulation, protection rackets, smuggling and drug trafficking, and associating with organized groups such as the mafia. These new rich people, with their chauffeured extravagant cars, sizable luxury homes, expensive clothes, and vacations at elite resorts, are part of a hitherto unknown breed of affluent people. Most of these New Russians live near Moscow and St. Petersburg and live a lavish lifestyle, visiting lush restaurants, clubs, and casinos.

Most Russians, on the other hand, earn about three hundred dollars a year and are deprived of most necessities. Numerous Russians resent this new breed of wealthy people, believing that many of them transformed political influence into personal wealth and secured it at the expense of poor people. It is difficult for the common people to accept this new breed of wealthy people, and they question the wide disparity that now exists between the rich and the poor.

Today, about 80% of the population of Russia lives in the western side of the country near Europe. Three-fourths of these people live in the cities, while the rest live in villages on or near

their farms. A majority of Russians live in Moscow, the capital and the largest city. Moscow seems to have gained most of the wealth of the country with 80% of Russia's banks located there. Situated in the heart of the city is the Kremlin, an old fortress and the seat of Russia's government for many centuries. It was in Moscow that I observed school children who came to see the high-kicking soldiers at the changing of the guards at the Tomb of the Unknown Soldiers. Near the Kremlin is the legendary and celebrated Red Square (which ironically is oblong and not a square, and also it is not red). Adjacent to the square are stately buildings, including the renowned onion-top cathedral of Saint Basil's.

Russia is a country attempting both to preserve its ancient history and culture and modernize with a strong market economy, but the country suffers from the rampant crime, the privatization of businesses, a slow economy, and serious mismanagement in government.

The Bosom of Russia—Its Women

Few nations depend on their women as much as Russia. Before I arrived in Russia, I visualized its women as stocky, stern and unsmiling, the stereotype presented in much of the media. I did see many women who fit this description, but as a result of intermarriage among the more than one hundred nationalities and ethnic groups over the centuries, I saw a variety of physical traits in Russian women. I found that mostly their skin coloring is like that of white Americans, and except for many of the rural women and some of the older women in the cities, the women are slimmer than American women. My general impression was that they were a friendly and generous people; however, I did sense an element of suspicion regarding foreigners.

Many of the younger people I encountered spoke English, which helped me communicate with them without interpreters. The younger women on the streets were quite stylish with their fashionable jackets and boots and very short skirts, even though the weather was cold. Some of the young women wore the latest short hairstyles, while others wore their hair pulled back into

Russian High School girls enjoy a field trip.

ponytails or clasped with fashionable barrettes as American young women do. A few had dyed their hair with blond or reddish hues, but most appeared to have their natural color of black or brunette. Under their arched eyebrows, I saw beautiful eyes that reminded me of the blue of the sky and the dark amber of wheat.

The older women were another story. They personified the image that I had often observed in photographs of Russian women. Most wore their long brown or gray hair pulled back tightly into buns, then covered by scarves tied either under their chins or at the back of their heads. Their bushy eyebrows, ruddy faces, and callused hands showed a lifetime of exposure to severe cold weather and hard work. These women who lived during the Communist era know the meaning of intense grueling labor and living under destitute circumstances. They have maintained

much of the traditional appearance of the Communist era with their drab, loose-fitted clothing and no make-up or jewelry.

Although the Communist era is past, suffering and deprivation remain, especially for the older women and some of the children. An article in *The Russian Journal* states that "Russian women endure the brunt of drunken abuses in the home and exploitation in the work place,"[2] and the British Charities Aid Foundation indicates that homelessness plagues as many as four million people in Russia. Because of inflation, the savings of the elderly have diminished considerably, causing some of them to sell their possessions in an effort to survive. Some of the women who are too old to work have been abandoned by their families, as have many of the children. These forsaken children, some from broken homes and others from low-income or single-parent families, often roam the streets, and it is estimated that there are up to a million of these abandoned children living in train stations, parks, and underpasses. Although some families are significantly more prosperous under Russia's modern capitalism, it is clear that many of the elderly and many of Russia's children endure extreme poverty.

As we drove into the countryside north of Moscow, I saw more women than men working in the fields, most tilling the soil by hand with a hoe or scythe. I saw only a few tractors operating, as I learned that heavy machinery like tractors was more likely to be involved in roadwork. With the benefit of a benevolent springtime and 300 days of rain each year, the fields looked like an ocean of green with their green shoots of new grass pushing through the muddy earth. Without the work of tilling and harvesting crops by Russian women, though, Russia would probably starve and surely the economy would suffer.

The Step-Mothers of Russia—Home Life

Approaching Moscow by air, I saw a myriad of tall white identical concrete structures that created for me an impression of a city with a magnificent skyline. As I walked and drove through the city, however, I was disappointed to see that these 18-24 story

Winnie's Russian interpreter in front of a typical apartment complex.

apartment buildings are old and dirty and in a sad state of disrepair. Built twenty or thirty years ago by the Communist régime, these buildings are crammed with thousands of residents. Located close to each other, perhaps only one hundred feet apart, these buildings lend little character or interest to the city. They are without heat three months of each year, even though the temperature was freezing or close to it, even in the spring, when I was there. In my hosts' apartment, since it was without heat, my hostess was kind enough to provide me with extra warm blankets and also extra clothing for wearing inside.

Under Communist leadership people had no cars, so these tall apartment buildings were constructed without parking areas. Now that some 20% of Russians own cars, they mostly park where grass would normally grow, creating yards mainly of mud due to

Moscow's almost continuous rains. Shrubs and flowers are essentially non-existent; however, tall slender poplar trees add beauty to some of the residential areas.

Entering these apartment buildings requires a key, and then a resident proceeds to his or her apartment in a rickety elevator that accommodates only two people. It was a chilling experience for me to listen to the rattles and struggles of the elevator and wonder if the elevator had been repaired in the last thirty years. When I returned to my host family's apartment building after my first day in Moscow, I approached the elevator warily, fearing that I might not be able to get inside the building. I was anxious that I might not have a way to notify the family that I had arrived, and that the elevator might not be able to make it up to the apartment. I am sure that a communication system exists in most buildings that notified residents when a guest arrives, but for this building the system was inoperable when I was there. With the language barrier between my host family and myself, I found it difficult to inform them just when I would return.

The extended family is an important attribute of the Russian family. About 90% of Russians live together with their families. In about 20% of the families, there are three generations living under one roof, and this is especially true among rural families. A family of four would typically have a four-room apartment with a small kitchen, a living/dining/bedroom for the parents, a children's bedroom, and a bathroom. Often eight or ten people can be found living in a four-room apartment. Russian families are often extended families, either from necessity or closeness to relatives. They treasure families and close friends. During the Stalin era, when everyone's political leanings were suspect, a person's life could be in danger if a family member or a friend denounced him or her, so it was wise for people to be very supportive of one another.

The family that I lived with was typical of Russian extended families. There were nine family members sharing the approximately 400-square-foot apartment, which was divided into four small rooms and a bath. The two couches in the living room became sleeping areas at night. Furniture was lined up around the

room, including a folding table that could be pulled out for seating four or five people when company came, since the kitchen table seated only two. On the walls were numerous small, unframed religious pictures, including pictures of the Good Shepherd, Jesus praying in the garden of Gethsemane, and Jesus washing the feet of His disciples. This religious focus did not surprise me, as my host was a minister.

Although finances were very limited in this home, the family had a phone, VCR, TV, stereo and a computer with printer; however, they did not own an automobile. Owning this many electronics was unusual, since only 3% of Russians own computers, but a family living in Moscow is twice as likely to own a

Winnie's host family in Moscow.

telephone, personal computer, or a microwave oven. Only 5% of Russians own a microwave or possess a credit card.

The bedroom where I slept was about seven feet wide and fifteen feet long with stacked beds for their two girls and a cot for me with just enough room to walk between the beds. The bunk beds had a delicate net-like material that dropped from the top bunk and draped over the lower bed, with the corners lifted to the top bunk and held there by a blue bow. This was one of the few decorations in the house and may also have served as a mosquito net. The room also had a study desk with a bookshelf, a table covered with a sheet for a dresser, and a wardrobe for family clothes. However, my clothes remained in my suitcase on the floor for the entire visit.

A Russian mother combs her daughter's hair.

I shared this room part of the time with five-year-old Olga, who found an American to be fascinating. She wanted to be near me almost all the time and spoke Russian to me, even though she knew that I did not understand her. She learned to say, "I love you" in English and repeated it many times a day. Later Olga mastered a few other words such as "goodbye" and never failed to use it when I was leaving the apartment. The father understood a little English but had difficulty speaking it. No one else in the household knew any more English than I did Russian. Needless to say, we did a lot of communicating by gestures.

The bathroom was divided into separate little rooms. The toilet was more like a closet, about three feet by three feet, and just down the hall was a very small room with the tub and a sink. A spigot and hose in the bath area provided water for the tub as well as the sink. As my hosts showed me the facilities, they told me that water from the bathtub usually leaked onto the floor, and that the tiled wall by the bathtub had deteriorated to the degree that any water splashed on it would drain to the floor below us (and repairs are unheard of). With those cautions in mind, I resorted to a sponge bath—since it was too cold for a shower anyway.

Perhaps the greatest surprise of any component of my hosts' apartment was the kitchen, a room about five feet by six feet without counters. The dishes were placed on racks that hung from the wall, and the cooking utensils were either hung from nails or placed on the floor with potatoes and other food supplies. When hot water was needed, it had to be heated on the stove, so dishes were sometimes washed in cold water and often not rinsed. The kitchen table was about two feet square with two chairs. I ate most of my meals alone at this table, but if guests came, the table in the living room was pulled out and everyone sat down together. The small refrigerator was mounted high enough to have storage both underneath and overhead. Space is cleverly utilized in these small apartments with shelves positioned over doors and in every possible nook.

Because of the congested conditions of these residences in the cities, many Russians view their tiny apartments as just a place to eat and sleep during the week. With the arrival of the weekend,

*The kitchen of
Winnie's host.*

especially from April to September, there is a mass exodus to the country to spend a weekend in cottages called "dachas." Here, people grow vegetables in their gardens, providing much of their food, which is preserved, pickled or stored in cellars. It is thought that more than half of the Russian populace has some access to a dacha, which is not necessarily a luxury for the people but a necessity for securing food for their families. Individuals who are retired may stay all summer in their dachas, along with their grandchildren, while the parents work in the city. In 1993, it was reported that 83% of all potatoes harvested in Russia were grown in the gardens at dachas.[3] Before 1991 the government stipulated that a dacha could have a maximum of 720 square yards for the

Families visit their dachas during the summers to preserve food.

garden and thirty square yards for the house. Today, however, those restrictions have been lifted.

A Russian Baptist pastor, who met me at the airport on my arrival to Moscow, became a valuable source of information regarding life in Russia and the role of women. He said that most women worked outside the home and often the husband remains at home with the children. He told me that his brother had lost his job months before, but his dentist sister-in-law continues her practice while the husband remains at home to care for the children. I asked if this kind of arrangement appears to damage the male ego. "Yes," he said, "Many men in such circumstances resort to drinking alcohol."

Most women do not drive cars to work but walk or ride the metro, the underground rail system. They do not drive because of cultural restrictions and because of traffic congestion. With automobiles being available to the average family only in the past ten years or so, most drivers seem to lack adequate skills and drive haphazardly. Traffic is bumper-to-bumper most of the time, and an impatient driver will not hesitate to bump another automobile if it is not moving as quickly as the driver thinks it should. Perhaps

this is one of the reasons that Moscow is considered to be the most stressful city in the world for driving. There appears to be no concerted effort to control pollution from these automobiles that produce stifling, choking fumes nonstop. I could see why women would choose the metro for going into the city for work or shopping, and I chose the metro at every opportunity rather than being locked in Moscow traffic with its eye-watering haze.

Life in the country is even more spartan than life in the city. Electric power companies have difficulty in providing dependable power service in rural areas, resulting in frequent blackouts, which leave thousands of people living in dark and cold homes. Rural homes are primitive, and only about half have water and sewer. As I rode north of Moscow into the country, I saw women hand-pumping water from wells and carrying it into their homes. Crop production is in decline in Russia, and thousands of farms are collapsing due to financial concerns. Most farms are presently in cooperatives, private partnership, or joint stock companies.

Perhaps the greatest yearning of the Russian people is for better living conditions. While the country was under Communism, the state guaranteed low-rent housing to all citizens, even though there was a long waiting list. Presently, the housing for many families is unavailable and that which is available is inadequate. The government and private developers want to create single-family, low-density housing and to improve existing living accommodations; however, with a serious lack of financial resources, solving this major problem seems almost impossible in the immediate future. The financial structure does not lend itself efficiently to home mortgages, so buyers usually must have cash or commit to a short three-year loan at high interest rates. With most people making low wages, it becomes almost impossible for a single family to buy a home, thus encouraging the extended family situation.

Home life is adversely affected also by the high rate of divorce, which has tripled since 1960. Today about one out of every three couples gets a divorce. Numerous reasons exist for such high divorce rates, but a large contributor is the males' use of alcohol and the subsequent physical abuse of their partners. Though

marriages usually occur when couples are in their twenties with huge celebrations of music and a feast, some of these marriages may lack the stability that their parents experienced.

Borscht, Mushrooms, and Other Fine Foods

A focal point of the Russian home is the sharing of a meal together. Because the Russian people are so appreciative of their food, and since it is customary to stand for all prayers, they stand when (and if) a blessing is offered, whether it is for an elaborate feast or a simple meal consistent with the status of the family. A special meal may consist of an assortment of appetizers, such as salads with sour cream, pickled tomatoes, marinated mushrooms or sardines served with rye or white bread. The main course would perhaps be meat or poultry cooked with fruit and served with potatoes or rice. Dessert would consist primarily of pies, cakes, or sweet breads, fruits or their specialty dessert of ice cream, served with Russian tea. To top off a meal, wine or the national drink of vodka is usually served. However, tea, wine or vodka may accompany the meal as well as being served as an after-dinner drink.

I learned to eat the simplest of foods in the home where I lived most of the time while in Russia. Upon arrival I discovered that the wife of the home was absent due to the death of her father; thus, for several days the husband prepared my meals. My first meal consisted of an elongated spicy sausage, wonderful white loaf bread, and spaghetti topped with fresh cut-up tomatoes and sprinkled with catsup. After the meal, which I ate alone, I was served tea with crackers topped with homemade apple preserves. I had almost no coffee during my stay in Russia but lots of delicious tea. Most meals consisted of cucumber and tomato salad, pasta or potatoes, dried fruit, bread, and tea. Usually the menu was the same for breakfast, lunch, and dinner. I had to adapt to their eating schedule, which was several hours later than I was accustomed to. Lunch was served as late as 4:00, and dinner was usually served at 9:00 or 10:00 in the evening. While I was waiting for a mealtime, I occasionally tiptoed to my suitcase to sneak one

of the delicious breakfast bars or candies that I brought with me for just such times as these.

Several days after my hostess returned, she became concerned that I did not like her food since I ate such small amounts. I did not want to tell her that I just was not hungry enough to eat the food and that I had concerns about the dishes not being washed in hot water and food being left on the table between meals. For example, the same salad of tomatoes and cucumbers was served day after day by just adding either tomatoes or cucumbers as needed. Though I wanted to be gracious, I sometimes found it difficult to eat very much. This was complicated to explain, though, due to the fact that my hosts did not speak English, and I did not speak Russian.

A dish that I especially liked, though, was borscht, a popular Ukrainian soup made from beets and cabbage. Also popular, and meals that I liked, are substantial meals like beef stroganoff, chicken Kiev, and "solyanka," a thick broth with meat and vegetables, foods which help to fortify people against the cold hard winters.

Russians search for variety in their food by shopping at the farmer's market for local and imported foods. The most common fruits and vegetables grown in Russia are apples, pears, beets, beans, potatoes, carrots, tomatoes, cabbage, and eggplants. Perhaps the most popular and most frequently eaten food is cabbage, which is used in salads and soups and also turnovers, which are also filled with meat, fruit, cottage cheese or vegetables. Sour cream is used at almost every meal and served on just about everything, including soups and vegetables. Since most Russian women work outside the home, they frequently shop on their return trip home from work. Often they have to wait in line to buy things like bread and meat and then only buy what they can carry home in a shopping bag, since they walk or ride the subway and have only modest storage and refrigerator space.

Another favorite food in Russia is the wild mushrooms with their strong earthy smell. It is not unusual for people in the spring or fall to take holidays to go mushroom picking in the countryside. Harvesting food, whether mushrooms or other food, is the re-

sponsibility of all people. Adults and children from both the country and the city, participate in the harvesting of crops since mechanical harvesting is very limited.

Bread in Russia is the substance of life. When bread is scarce, people become anxious. A family purchases its bread daily, and it is consumed so quickly that it seems never to grow stale. I believe my favorite food in Russian was the fresh warm bread with the chewy crust. A special bread baked at Easter is called "kulich," and it is formed to look like a dome of a Russian church.[4]

Health Care—The Great Imbalance

In order to become more familiar with Russian women, I hired an interpreter for $10 a day plus a car and driver for $20 a day to drive me to a variety of homes to discuss life before and after Communism. I especially wanted to talk with older women who could compare their lives during the Communist régime with conditions that exist today. Every woman I talked to said medical care and the health care system today are inferior to the system under the Communist regime. Although freedom, which has been embraced since the early 1990s, is cherished, women feel that there are major inadequacies not only in health care, but also in such areas as housing and food. Especially the older women say they do not have adequate funds to pay for medical treatment or medicine.

Although the Soviet Union was the first country in the world to provide free medical care for all its people, the health care system caused tribulation for many. Most of the health care workers were women who were poorly paid and lacked adequate training or sufficient medical equipment to perform suitable services. Doctors were considered nonproductive and had little status and were paid only half the salary of factory workers. However, the medical services were free to all citizens.

Though many of these difficulties still exist today, there is also the financial burden of having to pay for medical services. In addition people lack confidence in Russia's medical care system and to get adequate care, it often appears necessary to use bribery.

Doctors say they are forced to resort to such methods in order to support themselves and their family due to the modest salaries they are paid. One family told me that doctors might even go so far as to misdiagnose an illness just to get the patient to return for further treatment.

The most prevalent illnesses for Russian people are cardiovascular disease and cancer, but communicable diseases such as diphtheria and tuberculosis take a serious toll on the populace due to the scarcity of immunization. There also appears to be minimal education about narcotics abuse and AIDS; thus, these problems are on the rise. Most health disorders are related to smoking, lack of exercise, diets high in fat and cholesterol and especially alcohol abuse, which is more prevalent for men than women. Infant mortality rate is high, 26 per 1000 before the age of one. With a population growth rate of minus 0.07, more people are dying than are being born in Russia. Today Russia is offering an incentive to families to have more children.

To illustrate further the status of health care for Russian women, Urda Jurgens writes, "For Soviet women seeing a gynecologist is rare; seeing one once a year, rarer yet. Attitudes toward women's health are still primitive, at best. Gynecological treatment in particular is minimal, partly because of inadequate facilities and partly because of the refusal of many men to allow their wives to be examined so intimately by a stranger. As a result, many women suffer illness and unwanted pregnancies."[5]

As a result of inadequate health care and prevention programs, the life expectancy of the Russian people continues to fall. Russia now has the lowest life expectancy of any industrialized nation in the world. For example, in 1933 life expectancy was 59, but by 1997 it had dropped to 58.

Wounded Women

When I was able to plan a trip to an open shopping area, I was excited about being able to select souvenirs and gifts for my family. I found hundreds of merchants with small stalls, selling all kind of trinkets such as pottery, dolls, and clothing, and just about

anything one wanted to purchase. I enjoyed going from one stall to the other, examining all the indigenous merchandise. Shopping alone, I realized that I became vulnerable to pickpockets and thievery, and I was determined to be very careful with my purse. I was anxious to purchase one of those Russian fur hats with earflaps for my husband.

As I started to pay for the hat, the merchant, realizing that I was unfamiliar with sorting my rubles, made unusual overtures in English to "help" me count my rubles. I declined his offer several times but he kept pulling bills out of my hand even though I was saying, "I can do it." When we settled on what I thought was the correct amount for the hat, he turned to obtain a plastic bag for the hat. At that time a young Russian boy, about twelve years of age, standing just behind me and observing the transaction whispered into my ear, "He took a thousand rubles from your hand instead of a one hundred ruble bill."

I had not been aware of the merchant's sleight of hand in taking my money and was incensed at his theft that I yelled at him, "You thief, give me back my money." He acted innocent, as if he didn't understand what I was saying, even though I knew he did. I yelled again at him and crowds began congregating around us, so I felt the merchant would not harm me in front of all the people. I even drew back my purse over my shoulder as if I was going to strike him with it.

You can just imagine how really scared he was of this petite American woman; nevertheless, I made such a commotion that he finally reached in his pocket and handed me the 1000 rubles. I walked away, clinching my rubles but rather frightened at my performance and the thought of what could have happened.

As I continued to shop, the bargain hunters were shoulder-to-shoulder, comparable to shopping in the U.S. at Christmas-time. A short time later, while I was making a purchase of some pillow covers, someone pushed me hard on my shoulder, and I had to catch on to a stall to keep from falling. While I was rather unbalanced, trying to keep myself from falling, someone reached into my purse and took my wallet with my money, driver's license, health cards, and credit card. When I got upright, the person was

gone—out of sight, vanished into the crowd. Within the next five hours, the thief charged $5,000 worth of merchandise on my credit card. I have an idea that it was the merchant whom I had just had the confrontation with who followed me and snatched my wallet, but naturally I really don't know, as thievery is not unusual in Moscow. The credit card company did not require me to pay for the illegal charges.

The day was not over, however. As I was leaving the shopping area, I observed a policeman shoving a young woman on the street. I did not know what she had done or why he was mistreating her, but I assumed he was taking her to a police station. Even though she was not putting up any resistance, several times the policeman grabbed her by the arm and slung her until she almost fell. It was clearly police brutality. All the shoppers, except me, seemed oblivious to the incident. I stopped and watched as long as I could see them, and the violent shoving of the woman never stopped. I was learning very quickly about violence and crime in Moscow. Although the government of Russia would readily indicate its "disapproval" of crimes against women, to my view, it fails to afford victims of violence the protection required by the International Human Rights Treaties to which Russia is a party.

Russia's laws state that violence is criminalized, but the country often fails to ensure that incidents are investigated and prosecuted. In fact, I was told that the police are more likely to obstruct an investigation and prosecution of a victim than to pursue a criminal. Some women say that when women report an offense to the police that some police officers will say the offense is fabricated or that the woman must have provoked the attack. Women confront hostility, reluctance, and bias against their cases and are truly victims. Police, infiltrated by the mafia, fail to collect evidence, which in sexual assault cases is necessary for proof of the violation of women. Laws seem to fail to work in almost every segment of life, including the police or prosecutor's office.

What is even sadder is that most women are not even aware that violence is legally prohibited because the authorities do not enforce the law. Being aware of the law does not alleviate the dilemma, but it is a beginning. Most women will refrain from calling the police when they are violated because they are aware

that the police are being influenced by organized crime rings, protection racketeers, and the mafia. With the government's failure to respond to victims of violence, the Human Rights Watch found that brutality toward women is perpetuated. When men do not recognize that women have the right to be treated with dignity and parity, it is necessary for prominent judicial leaders to show concern regarding violence toward women. The government must ensure that laws will be enforced.

Though statistics regarding the number of abused women in Russia are vague, many cases are well documented such as the following. A woman convicted for killing her husband related an incident to me. She said she acted in desperation after pleading for years to the police and the courts, requesting relief from an abusive husband. She said that she had nowhere else to go. Because she was refused a divorce, she had to endure ten years of abuse with no one offering to help her. She even kept a journal of the husband's mistreatment, yet she was sentenced to ten years in prison for her husband's death, and prison life may have been better than the life she was living.

Thousands of Russian women are sold into prostitution and work in brothels and nightclubs. *The Russian Journal* reported in 2000 that "each night thousands of young girls line the streets of the city's central and prestigious district in a parade that is an indictment on Russia. Most respectable citizens, who need only peer out their windows to see the terrible reality in the country, dismiss the problem with a wave of the hand saying the girls are only 'Ukrainians and Moldavians.'"[6]

Domestic violence occurs in about twenty-five percent of Russian families yet is rarely discussed. It is estimated that some 14,000 women die every year at the hands of their husbands or significant others, primarily because of the stress of poor housing conditions and the men's drinking. Russian women are ten times more likely to be abused in Russia than in the United States, and while there are many homes for abused women in the U.S., there are only six such homes established in all of Russia.

A majority of Russian women have accepted their unceasing workload and the role of subordination to their husbands. However, many who search for a way out of this situation attempt to

find a mate abroad through Internet marriage agencies. Hundreds of marriage agencies advertise Russian girls to American men, and though this process is often filled with entrapment and negative consequences, it has become a frequent alternative to Russian women's present existence.

As I reviewed some of these Internet listings, I observed that Russian women list their attributes and often attach a photo as they seek an alternative to their present life. It is difficult for me to visualize how a woman could practically sell herself to a man in another country, but then I have not experienced what life is like living in Russia where men often drink excessively and beat the women in their lives.

One such woman is Olga, a Russian woman seeking marriage who went to an international marriage agency in Moscow with a brief biography and an attractive snapshot of herself. Within a few weeks her picture was on the Web for men all over the world to see. Shortly thereafter, James Brewer, a thirty-four-year-old computer specialist from Michigan liked what he read and saw regarding Olga. After communicating by letters and phone, James flew to Moscow to meet Olga and about six months later they agreed to marriage. She came to America for her wedding, hoping to have many of her dreams fulfilled. Olga's desire was to have a husband not addicted to alcohol and able to financially provide for life's necessities, since many Russian men are unable to do so.

In prior decades it was Asian and Latin American women who came to the United States as mail-order brides, but now most of the brides are from Russia. According to the United States Immigration and Naturalization Service, in 1998 there were between 4,000 and 6,000 Russian women coming to this country as brides, twice as many as had come in the last decade. These marriages, however, are not without problems. Coming from an impoverished country in search of utopia, some women's expectations are far from being met. Oftentimes they encounter abuse and neglect and are taken advantage of because of their lack of fluency in English.

On several occasions while I was in Russia, I encountered an American woman, Sara Jo, who had been in the country for seven

years. We often discussed the horrid conditions of Russian women. Sara Jo related an experience that happened to her as she was shopping in a downtown area. She encountered a man who was molesting a woman, probably his wife, right on the sidewalk. Sara Jo said that she was so distressed to observe the unfortunate woman being violated that she decided that she would jump into the fracas and tell the man to stop beating the woman. The man stopped hitting the woman but turned on Sara Jo and started beating her, hitting her in the face. Sara Jo was stunned by his attacking her, but said she "just licked her wounds and walked away." Never again, she said, would she interfere in a domestic fight.

Education and the Cultural Experience

During the Communist era, education was free and compulsory because the Communists believed that all people should be literate. This entailed not only the education of children but also of common people like farmers and peasants. Even the women were required to develop skills that enabled them to read. This philosophy produced a generation where almost everyone could read; in fact, the government boasted that 98% of the Russian people were literate.

Children today attend school from first grade to the eleventh, but education is compulsory only through the ninth grade. Students may select one of several tracks offered in high schools, depending on their intellectual abilities and their vocational aptitude. They may choose technical training, agriculture, or office work, or prepare for the rigorous admission tests to enter one of the 900 institutions of post-secondary programs. In addition, there are special schools for the arts and mathematics and foreign languages. Special emphasis is placed on mathematics and the physical sciences.

Only about 15% of the population goes into higher education because entrance requirements are so stringent. During the Communist era, the government guaranteed employment to all students who graduated from the university, so students were

Russian children attending a Baptist Church in Moscow.

highly motivated to complete their course of study. Today students with college degrees are having difficulty finding employment, and if they do, they are finding salaries low, often minimal.

Students are no longer required to study the theory and practice of Communism or the history of Lenin's life, but a few teachers still utilize the rote methods of learning and use old Communist-era textbooks. The transition to using new books and modern teaching methods is encouraging, even though it has been slowed by a shortage of funds available for the education system. Even though more religious and private schools have been established, teachers are still so poorly compensated in the teaching profession; some are turning to business to earn higher salaries. Thus, the educational system is being distressed as Russia makes its adaptation to a market economy.

Fortunately, as a result of the high rate of literacy, Russia has produced generations of people who love to read (especially Russian authors) and to listen to music (especially of renowned Russian composers). Russia is especially known for its famed Bolshoi Ballet in Moscow. (The Bolshoi was not performing while I was in Moscow, but I was able to attend the ballet "Napoleon" in the Kremlin Theatre, which captivated me with its lavish and majestic performance.)

The Great Imbalance in the Workplace

Following the Russian revolution in 1917, the Communist regime recognized the potential of an improved work force through the utilization of women. For the first time women anticipated that their status would be enhanced, and this was the high point of the women's movement in Russia. However, according to journalist Irina Yurna, the revolutionaries granted equal rights to Soviet women, and yet, in reality, the status quo of women remains the same.[7]

At this time, there was an enormous increase in the employment of women with far-reaching consequences. On paper, equality with male coworkers was championed, but in actuality women never achieved parity with men. They occupied positions requiring lesser skill and were paid lower salaries than men, even though the World Bank reported that women had educational qualifications superior to the men: 47% of the women had completed higher and secondary education as compared with 34% of men. This period of so-called employment uniformity did allow women in the workplace, but they still had to continue with the usual responsibilities of the home.

It appears that lack of parity for Russian women continues, even after the demise of Communism. The Moscow Center for Gender Studies in 1991 stated, "Russian women earned an average of 75% as much as men." In 1995 the figure was 49%, while unemployment of women in some regions of Russia is 85%.[8] For recent graduates the unemployment rate is up to 90%. Women become the first to be dismissed from a job even though they are the lowest paid. One of the reasons for this disparity occurs because women are in areas such as medicine and education and other traditionally low-paying professions that do not adapt well to Russia's new market conditions.

Though most Russian women still work outside the home, those who can afford not to work often prefer to stay home. A "stay at home wife" is seen as a status symbol because most women work out of necessity to supplement the family income or in some cases to provide the only income for a family. Though the

law (on paper) protects women's rights, women still are the recipients of lowest-paid jobs with only a few reaching the summit in the workplace. It is common for an advertisement for a position to require information on the candidate's sex and age. The phrase "bez kompleksov"[9] is a common term in Russia employment advertisements that is abbreviated as "b/k." Everyone, it seems, knows what such a position entails—young women must sleep with the boss to secure or maintain a job.

At the end of June 1994 in Russia, six to eight million out of 150 million people were unemployed, and sixty to eighty percent of these were women. The Minister of Labor issued an edict stating, "All women must be fired before a man could be released from a job." The justification appeared to hinge upon very conservative social values—that unemployment for the female is more acceptable because of the cultural preference for women to be in the home. Presently, some men who are unable to find a job stay at home to care for the children while their wives work, but this practice is only slowly gaining acceptance.

The director of the Institute for Strategic Analysis and Development of Entrepreneurship and Economic Policy Institute says, "Women have to be at least ten times smarter than males to be successful." Also it is very difficult for a woman to participate in the Russian culture of drinking and being a part of the "good ole boy" system. One woman says, "I can't drink vodka or go to the bathhouse with the guys and frankly I don't want to." However, another professional woman, a medical doctor, comments, "Everything depends on a woman's priorities, what means more to her, her domestic duties or her profession."[10]

Exploitation of women is more the rule than the exception in Russian business. However, with foreign-run business on the rise in Russia, the foreign companies are employing women in areas such as media, telecom business, and consumer goods, and have come to the realization that women possess exceptional skills and are beneficial to a company. Hopefully, Russian business will follow the model of these foreign businesses by moving women to leadership positions. A suggestion has been made that the government would do well to give some type of tax break to busi-

nesses that promote women to production and management positions.

Today many entrepreneurial women are owners of small or medium-size enterprises. In fact 45% of women who work own their own business, 32% are engineers, 14% bankers, 9% farmers. These statistics do not include women in the helping professions such as teaching and medicine. It is encouraging that Russian women today are able to have new opportunities in small businesses that were not afforded to them during the Communist era. In 1997 women received nearly half of the loans that were made by the Europeans Bank for Reconstruction and Development. Being the owner of a business also alleviates some of the sexual harassment that is prevalent in the male-dominated work place. A survey conducted by Moscow's Center for Gender Studies in several Russian cities found that one in four women have been victim of sexual harassment at work within the past five years.[11]

Another problem regarding women's employment is the matter of suitable child-care. With local governments strapped for sufficient funds, child-care issues are a low priority. However, if progress is to be made, ideologies regarding women will need addressing as well as policies regarding such necessities as child-care if women are to receive parity. Provisions, in addition to child-care, should include training and retraining for women along with social and psychological rehabilitation facilities.

Russian women who are too old or unable to find employment struggle day by day in the weak economy. They receive low pensions (in 1995 approximately $38 dollars per month), which is considerably below the official poverty line of $70 per month. Women in Russia live at least a decade longer than males, thus the majority of the pensioners are females. As I visited with some of the pensioners, they expressed how difficult it is to survive as compared to life under Communism. One female pensioner whom I visited with in her home said, "At least then (under Communism) we had a free place to live, food and health care, even though it was inadequate; now we do not have enough money each month to hardly survive. I can't buy the medicine that I need. It is a high price to pay for freedom."

Though there are few women in the Duma (legislature), they are mostly women of the Communist persuasion and it is said that they are not very supportive of legislation regarding civil rights of women. When women are in political positions, they are often assigned lower and more difficult jobs with the preeminent positions filled by men. Russian women are still struggling for basic rights that women in America take for granted. A law regarding domestic violence is in the making, but most women say that it really is a law regarding child abuse. A few of the current Dumas members are trying to organize a women's caucus across party lines, but success will probably come only when there is an alliance with males.

The same struggles women experience in vocational work are duplicated in the literary and art scenes. Male artists are sought out by the male political hierarchy while women with potential in the arts are usually disregarded, as are those women who would be candidates for political office. Again it is a scenario of the "good ole boy" system at its best.

There is an old Russian fable that reveals something of the life and struggles of a typical Russian woman.

A man upon returning to his country after a visit to Russia tells his friend the following story.

"And the most amazing thing is, Russians practice polygamy," said the traveler.

"I never heard that," says his friend, "How do you know?"

"Well, when I visited a Russian apartment, I was amazed at how luxurious it was. So I asked the man, 'Surely you can't live like this on one salary?'"

"No," said the Russian man. "My wife works."

Then I noticed how clean the apartment was, so I said to him, "But you must have a housekeeper?"

"No," said the Russian, "My wife cleans the house."

Then I asked, "And all these nice things, surely you have a driver to comb the shops for them?"

"My wife does that," said the Russian.

"And this delicious food, you must have a cook."

"My wife does that," said the Russian.

"And such well-behaved children! Surely you have a nanny for them?"

"My wife does that," said the Russian.

"Then I figured it out," concluded the traveler, "that man had at least five wives."[12]

Famous and Not-So-Famous Russian Women

RAISA GORBACHEV was the real "First Lady of the Soviet Union." Though there were several first ladies of the Soviet Union, none had been known or recognized until Raisa Gorbachev was elevated to this position. Previously Kremlin wives were invisible and few citizens even knew their names. Raisa was of a different caste and became more than just visible involving herself in major decision-making policies.

Raisa's childhood, as related in Urda Jurgens' book, *Raisa—The lst First Lady of The Soviet Union,*[13] was one of dreadful deprivation. She was born in 1932 in Siberia to hard-working parents. Her father, a railroad worker, moved the family more than a dozen times during Raisa's early years. Also her father was a prisoner in the Stalinist Labor Camp in Siberia for four years, which added additional adversity to the family.

Though growing up in very difficult circumstances, Raisa, due to her superior intellectual abilities and perseverance, was able to attend the prestigious Moscow State University to study psychology. There she met a young law student, Mikhail Gorbachev, whom she later married and they developed a true partnership, which was highly unusual in the Russian culture. She continued to pursue her education and eventually received a Ph.D. Her intelligence and aptitude for politics were priceless to Gorbachev's career and especially later when he became General Secretary of Russia. Her contributions in the areas of health, art, schools, culture, and social life of the people of Russia were unprecedented.

Though Raisa was charming, attractive, stylish, educated and ambitious and served in the unusual role of advisor to her husband, she was not without her critics. People outside of Russia admired her, but in her homeland she was often referred to as "Tsarina" and political officials even wore buttons that said "Raisa Nyet." Raisa's life-style, her intellect, her beautiful clothes and

slim figure were out of reach for most Russian women who said she was "too much the queen and too little the wife." It was almost too much of a drastic cultural adjustment for Russians to accept. It seems that she was adored by the international world but lambasted by Russians, especially by her husband's peers. Culturally a woman could not assume a role in Communistic decision-making processes without criticism from the "ole boys." They detested her role in their political hierarchy. Nevertheless, she made history as an attractive woman of power and influence. She was indeed the real first lady of Russia who was a strong advocate for Russian women and opened the gate for future female influence and leadership in Russia.[14]

VALENTINA TERESHKOVA was the first USSR woman in space—it was in 1963 that she made a three-day flight in Vostok 6, orbiting the earth forty-eight times. It was a great moment in history for women of the world, and especially for the women of Russia. They now had a real hero in Valentina, one who had made it to the top.

Valentina was born to a farming family in the small rural village of Masslenikono, north of Moscow, in 1937. Her father was a tractor driver on a farm and her mother worked in the textile industry. Not immune to hard work, Valentina became a textile factory worker early in her life. As a youth she became a member of the Communist Youth Organization learning how to parachute, and in 1962 she became a member of the Cosmonaut Corps. Valentina jumped many of life's puddles to excel in parachuting which led to a career as an astronaut. After her successful flight into space, she was presented the highest award in the former Soviet Union, Hero of Soviet Union, the Simba International Women's Movement Award, and was twice awarded the Order of Lenin.[15]

OLGA KORBUT was one of the gymnasts who brought great fame to Russian women by winning three gold metals in the1972 Olympics. VITALY SHCHERBO, another gymnast, won a record of six gold medals in 1992. Gymnast LARISSA LATYNINA won the greatest number of gold medals ever won by an individual and IRINA RODINA won ten titles with two different partners in ice-skating.

The Russian government financially supports their athletes and greatly encourages excellence. These four superb female athletes honored their country through excelling in the Olympics and inspired scores of young women to train for numerous sports.

GLANOVA ULANOVA is perhaps the world's greatest classical ballet dancer of this century. Surely she is the most legendary Russian dancer. Serious ballet began in Russia during the 18th century and continues to achieve worldwide acclaim through their renowned ballet companies, the Bolshoi and the Korov. These ballet companies have produced numerous illustrious females ballerinas for the pleasure of the Russian people and the world. NATALIA MAKAROVA is another celebrated Russian ballerina who is remembered not only for her exquisite dancing but because she defected from the USSR.

ANASTASIA, THE RUSSIAN PRINCESS, is a legendary figure in Russian history. Perhaps more people have heard of Anastasia's plight than any other recent female in Russian history. She was born near St. Petersburg in 1901 as the youngest daughter of Nicholas II, the last of the czars. When Nicholas was overthrown and murdered by the Bolsheviks, she probably died along with the rest of her family in the massacre. However, there is no positive evidence regarding her demise. Americans have, therefore, been mesmerized with the possibility that Anastasia survived the massacre of her family. To add to the awestruck Americans, a woman called Anna Anderson, in 1960, claimed that she was Anastasia and the legal heir to the Romanov fortune held in Swiss banks. DNA tests confirmed that Anderson was really of Polish and German origin. However, Americans continued to be fascinated by the mystique of the story to the degree that Hollywood produced a play called *Anastasia,* followed by an animated film utilizing the voice of Meg Ryan. Even the French got into the act and produced a play called *Anastasia.* Also numerous books have been written regarding this charming and precocious young Russian girl who for many years has fascinated the world.[16]

LYDIA is not a celebrated or prominent woman of Russia, but she represents millions of ordinary Russian women who struggle to cope with the post-Communistic period. I was driven to Lydia's

Lydia, Winnie, and Shura fellowship in Lydia's Russian apartment.

apartment by her pastor and his sister who was my interpreter. We climbed the dimly lit stairs to her very small flat in one of the tall apartment buildings in Moscow and were greeted graciously as we entered her modest flat. This sixty-year-old woman, who evidenced wrinkles well beyond her years, wore a heavy woolen sweater and skirt with gray woolen socks that reached high up her legs, almost to her knees. On her feet she wore a pair of fluffy, cozy slippers. Her shiny scrubbed face was surrounded by fuzzy, gray streaked hair and she wore no jewelry, not even rings. I have never met a more gracious hostess, especially under such meager surroundings.

Lydia lives in a one-room flat with an undersized bathroom and a minuscule kitchen. In the main room of the flat was a bed, a couch and one chair plus a foldout table. In the kitchen was a small table with two straight back chairs. Even though the flat was meagerly furnished, it was orderly and attractive. Shortly after we arrived, Lydia prepared tea for us and we four squeezed into her cozy kitchen. She presented a lovely tea table as the sun kissed a blooming cactus that sat in the large kitchen window. With the tea

she served orange slices, small wrapped candy pieces, wafer-type cookies, a sweet food something like a pretzel, and a hard sweet roll. She had prepared for our visit, probably using funds to purchase food for the tea table that she needed for necessities. The atmosphere was cheerful but the story of her struggles under the Communist regime was not so joyful.

Prior to our arrival Lydia had been informed that I would like to talk with her about her life in Russia. She appeared delighted with the prospect of sharing information with me. Sometimes as she told her story she was overcome with sadness, yet at other times her conversation produced joyful moments when we laughed together. It was such a poignant time for me as I longed to know more about her.

Lydia was born in 1942 in Yugoslavia and only attended school for a year or so. In her younger days under Communism the people were prohibited from going to church or even worshiping in the home. Though her family owned a large Slavic

Lydia prepares tea for her guest.

Bible that belonged to her grandparents, it had to be hidden. She said the consequences for owning a Bible were severe—even death. Her grandparents, however, in spite of the dangers of being discovered, taught her about "being good and about prayer." These early imprints remain with her even today.

At sixteen years of age Lydia came to Moscow to be a nanny and married a Russian man by the time she was seventeen years of age. In the next five years she had two little girls, but shortly after the last little girl was born her husband abandoned the family. Since her parents were dead, she faced each day alone with her little girls, one just five years old and the other, a baby six months old. "Life was so tough," she said, "taking care of the girls, working in a school and also taking classes."

She had to make a living for her girls but had no one to care for them while she worked. Thus, she had to leave the two little girls alone in their flat at night to work. In the day she could not get sufficient sleep, as she had to care for the children. There was not enough food for all three of them, so the girls ate and she then ate that which was left. Finally the girls were placed in an orphanage for five days a week. Lydia was able to sleep more and she took another job to make more money to buy food. She brought the girls to her apartment on the weekends and provided the necessities for them.

Lydia's husband remarried and had a son, but it wasn't long before he divorced his second wife and returned to Lydia. Lydia refused to take him back as her husband and continued to struggle alone with the girls. She said that there were many years of hardship, but she saw the girls graduate from the University and become teachers. They are married now with children and even one great grandchild. Lydia swells with pride as she discusses her family. Though her life has been burdened with unbelievable struggles, her faith and her hope for a better life gave her the momentum she needed to continue.

When I asked her if she would rather live under Communism or the New Democracy, she answered, "That is a difficult question. Under Communism, we had better health care but no freedom of religion. Health care for old people presently is very poor.

Doctors are very expensive and a widow's income is very low. Hospital care is so expensive. We even have to pay the nurses as well as the doctors. Doctors are not as kind and caring as they were under Communism when we had free health care. My pension is so small, just as it is for all old people, and real estate is very expensive." She never gave me a direct answer to my question, but it appears to her that freedom for Russians carries a high price-tag.

A significant impact on Lydia's life was her conversion to Christianity at a Billy Graham meeting about 1990, when he came to Russia following the fall of Communism. She has been a follower of Jesus since that time, she said, and regularly attends her little Baptist church, which gives her daily inspiration and provides her friendships with other Christians. Though she may long for some of the benefits of early days, she definitely enjoys the religious freedom of the New Democracy.

SHURA is another typical Russian woman whom I had the pleasure of getting to know. Shura was about fifty years old, radiated a smiling personality, and loved talking about her life. I had not previously encountered such a vivacious and fun-loving person in Russia, so I was delighted with our visit of several hours. She wore the typical warm woolen sweater and skirt and socks, and her slightly-tinted auburn hair framed her face. Most Christian women her age stated that they are "honoring the scriptures" through their avoidance of jewelry and make-up. Shura said that when she first went to church, she wore earrings, lipstick, and jewelry and now chides herself that she did not know better. I listened with chagrin as I sat talking with her, wearing my make-up and dangling earrings and wedding band, and felt sure that to her and other women like her, I was not seen as a "committed Christian."

Shura also experienced difficult times during the Communist reign. She was able to attend school only seven years, later married, had two daughters, and then divorced. She struggled to support her two children as she continued her education, and now much of her life centers on her grandchildren and her church.

The Dawn of Spiritual Consciousness

In 988 Vladimir, a prince of Kevan Rus proclaimed the faith of the Byzantine Empire as Eastern Orthodox and forced his subjects to be baptized into the Eastern Orthodox Church. This action isolated the Slavic people from the Catholic Church of Western Europe and promoted their own unique culture. Russian architects and artists, during the Byzantine era, created unique churches and icons—small painted panels of religious images. Today every Russian church and monastery and many homes are decorated with these striking and often elaborate icons.

Most Russians today are affiliated with the Russian Orthodox Church, a branch of the Eastern Orthodox Church. Their beliefs are based on the Bible with emphasis on faith and piety, and the head of the church is the patriarch of all Russia. The extremely long worship services are ceremonial, elaborate, and colorful. Because the Russian Orthodox followers believe only the human voice should offer praises and songs to God, they do not allow musical instruments in their worship ceremonies. The priest, who chants, is usually married and may remain in one parish for his entire career. Women are not permitted to enter the clergy.

One of the most awesome sights in Moscow is the Church of Intercession on the Moat, also called St. Basil's Cathedral. It was constructed in the 16th century and consists of nine churches combined into one glorious edifice. The onion- or octagon-shaped domes of St. Basil's Cathedral are typical of the unique structure of the Russian Orthodox churches. Ornate wood shingles decorate the domes of these churches, which are said to resemble the headdresses worn by women in medieval Russia. Some of the churches will have as many as twenty-two of these decorative and eye-catching onion domes.

Prior to 1920, there were around 45,000 churches in Russia, but by 1939 fewer than 100 of them remained in use. During the Stalin era of the 1930s and subsequent years, many of these magnificent churches were closed, used for non-religious purposes, or destroyed, including St. Basil's Cathedral. The Communist government killed thousands of the priests and monks, and Stalin blew

up the Church of Christ the Savior, near Moscow's Kremlin. It was one of the most magnificent structures in Russia with forty-eight marble reliefs, 177 marble tablets, and five domes that reached 335 feet in height. Though Stalin had planned to build a swimming pool on the site, it was never built.

Another religious group that suffered from the cold-heartedness of the Communist party was the Jews. Following 1917, more than 1000 Jewish synagogues were destroyed. By 1980, only sixty synagogues remained, and many of those have been returned to the Jewish population. Most large towns in Russia have at least one synagogue, and Moscow has a rabbinical academy. However, because of persecution, Jews are emigrating in large numbers to North America and Israel.

During the late 1980s some of the restrictions regarding religion in Russia were lifted, and churches gradually reopened and reconstruction began, including the restoration of St. Basil's Cathedral and the Church of Christ the Savior. Today Russia experiences a renewed interest in its history, culture, and religion with more than 5,000 Orthodox churches open for services. Many of the frescoes and icons of these early churches that were hidden in basements are now being returned to the churches as restoration gets underway. In numerous areas, I observed the process of the restoration of the magnificent domes, which once again are glistening in the sunlight. Though the Russian Orthodox Church is thriving, many Russians have lived so long without worshiping that they seem to have become spiritual neophytes. Trying to unravel some of the mystique of the Russian religion, I traveled northward to visit the site of the time-honored monastery of The Holy Trinity St. Sergius Laura. Because it was springtime, the lilac bushes were heavy with blossoms, the fields were a tide of green, the newly plowed ground was ready for seeding, and men and women with their hoes were tilling plants that were peeking through the soil.

The monasteries, which had their beginning in 1422, were like a complex of churches with their countless onion domes, standing stalwart in the glistening clouds that hovered against the azure skies. An array of tulips and other flowers gave dazzling signs of

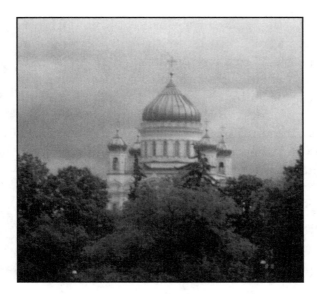

Church of Christ the Savior in Moscow.

spring, and other than the lilacs we saw on our journey to the monasteries, these were the first flowers that I had observed in Russia other than on the grounds of the Kremlin.

Viewing the many icons and reliefs, hearing of the history of the monasteries, and observing traditions of the monks gave me a better grasp of the Greek Russian Orthodox Church. Christmas is one of the most significant celebrations in the church, lasting from December 24 until January 7, and this festivity includes spiritual preparation, decorating trees and preparing for the arrival of "Father Frost." Another significant religious celebration is Easter, including the decorating of Easter eggs, which become delicate works of art with imaginative designs painted on the shells of empty eggs. The process of creating these artistic designs is passed from one generation to the other, and after the artisans finish their decorating, the eggs are taken to the church to be blessed and then stored for the next Easter celebration.

Islam is the second largest religious group in Russia. Their Islamic religion has roots among the Tartars, Bashkir, and some of the people in northern Caucasus. Islam continues to grow in popularity, and new churches are being built throughout Russia. Other religious groups in Russia include Lutherans, Roman

Catholics, Methodists, and Baptists, who together compose only about 1% of the Russian population. If a religious group does not have a building in which to worship, it is referred to as a sect, so some of these groups are sects.

According to the *United Methodist Connection*,[17] the United Methodist Church is thriving, especially in areas where the Russian Orthodox Church has minimum participation. What is so astounding about the Methodist movement is that most of the pastors are female, and Russians refer to them as "the church with women priests." Since women usually do not have a role in the Russian Orthodox Church, Islam, and many Protestant churches, women's participation in leadership of religious groups is a new paradigm for Russians. These women minister primarily to prisoners, alcoholics and abused families.

Winnie at the Monastery at Holy Trinity St. Sergius Laura.

I visited several Baptist churches in Moscow, but the Central Baptist Church in downtown Moscow appeared to be the mother church of the sixty or so Baptist churches in the area. At one time Central Baptist Church's membership was 5,000, but now there are about 3,000 members, since some members have moved to outlying areas to begin new churches. This is the only Baptist church that existed during Communistic governance, and perhaps it was allowed for propaganda reasons, so I was told. As in most churches, 85% of the congregation were women, but only men were allowed to sit on the podium. A person must be ordained to sit on the podium, so, of course, that eliminated the women. Men were in charge of all activities of the worship service, such as ushering and collecting the offering. Most of the women in the congregation were women over fifty, who were modestly dressed, devoid of any jewelry or ornamentation, and wearing the traditional headscarves tied under their chin or behind their head. I learned that the headscarves are symbolic of their submission to men.

Central Baptist has the greatest ministry of any church that I have ever witnessed. There were one hundred fifty women volunteers who ministered at an institution for the mentally retarded. In addition, there was a ministry to homeless and poor women and a ministry to the deaf, as well as a cardiologist and a dentist available for charity work. I observed twenty tons of rice in the church foyer, which was to be distributed to the poor, including some of their own church people. Each day that I was at the church, there were dozens of people involved in mission endeavors. I made a presentation to the women who worked with the mentally handicapped, and I never got so many hugs and kisses as the old women gave me. This church's ministry demonstrates the church's true mission.

An American minister who was a missions team leader told me that he had arranged for me to speak ten minutes or so at the Central Baptist Church's midweek service where hundreds would be present. He had discussed it with the pastor and all seemed well until minutes before the service began, when the pastor walked up to me and said "nyet" (no). I'm sure the refusal

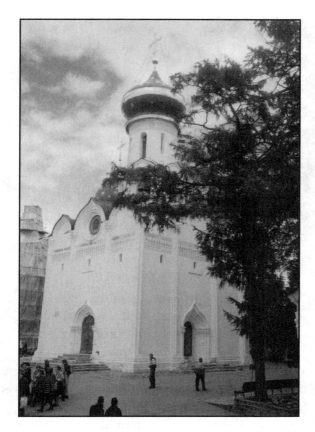

Russian monastery constructed about 1422.

for me to speak evolved around my being a woman. Heat twisted inside my chest, but with a misshapen smile, I said, "No problem," and walked away. I immediately walked out of the church to find the strongest cup of coffee on the streets of Moscow, as I realized first-hand that women have a long way to go before being accepted as leaders in Russian churches.

In another church I was asked to stand to be recognized as a guest. I asked if I could "bring greetings from American churches." The pastor spoke some English, but in this case, he indicated that he did not understand me. He understood English when it was convenient, but if it didn't suit, he understood nothing.

I was asked to lead a woman's seminar at my host pastor's home on the topic "Marriage without Regret." I spent several hours preparing the presentation, outlining my comments based

A Bible study group of Russian women.

on forty-five years of equal partnership in my own marriage. Just prior to giving my presentation, however, I discovered that the interpreter I was given was not proficient enough in English to interpret the speech I had prepared, so I was unable to give it. Instead, one of the members, using the Bible and a workbook, proceeded to teach for almost three hours on the topic "Jesus is first, the husband second, and the wife is third." Her text was I Peter 3: 1-3 (NIV): "Wives, in the same way be submissive to your husbands.... Your beauty should not come from outward adornment, such as braided hair and the wearing of gold jewelry and fine clothes." Perhaps it was good that I did not have an interpreter, for my philosophy would have been in conflict with their literal interpretation.

Perhaps the most pain I felt in Russia was when I inquired about my host pastor's trip to America three years earlier. He had taken a correspondence course from a Presbyterian seminary in Atlanta and went there to be awarded a diploma. He was in America for a month, traveling from Boston to New York and then to Atlanta, staying in homes along the way. When I asked him what he thought of America, he placed his hand over his heart and said, "Americans have no heart." It was heart-rending to know he was in America for a month and returned with such a

negative impression of American people; however, because of our poor communication skills, I did not pursue the conversation to learn the basis for his impression.

Conclusion: Can There Be Justice and Equality?

If ever there was a group of women that I feel I should align myself with for the cause of justice and equality, it is the women of Russia. Men have clamped down so ruthlessly on these women that they have lost the shine in their eyes. They combat economic struggles, but even more demoralizing is the inequality in most every aspect of their lives including home life, social activities, vocations, protection from crimes, and health issues. For a country that is so literate with its emphasis on education, I have not experienced such dreadful treatment of its women. Though many women have accepted the cultural requirement of submissiveness, living a life to be tolerated, millions of others are seeking a healthier way of life.

A large number of women are seeking to escape their devastation by seeking a mate through the Internet, a sure sign of unrest among Russian women. Large numbers of women are no longer willing to submit to men's abusive treatment or to labor unendingly for an alcoholic, violent man. They are seeking alternatives, such as initiating new protection laws and the enforcement of present laws.

Although Russia is trying to preserve its traditions and regain its lost status as one of the world's great powers, it appears that the struggle to survive is almost overpowering. The country has vast natural resources, educated professionals, and a skilled labor force, yet even after more than a dozen years after the overthrow of the Communist régime, Russia has serious economic problems and unacceptable human rights issues, especially in its poor treatment of its women.

The Communist system provided Russians a low standard of living but stability. Today, Russia has a multitude of problems: housing is crumbling, unemployment abounds, food shortages are everywhere, crime has increased (especially toward women),

alcoholism is at an alarming rate among men, schools lack ad-
equate facilities and pay for teachers, the infrastructure is in need
of much repair, and the health system is inadequate. Russia has
one of the highest proportions of widows of any nation, due
primarily to the alcohol-related death rate of men, and even the
life span of Russians is decreasing due to alcohol misuse. Political
reforms have not rendered sufficient solutions to many of Russia's
present concerns.

So what happens to women's rights in this conglomeration of
problems? There is the Woman's Movement of Russia (WMR),
founded in 1996 with 194 members and branches in sixty-two
regions of Russia.[18] Members seek to elevate the awareness of
women's plight through their monthly publications and a journal
entitled *Women in Russian Society*. The group seeks to be inclusive
not only of women's organizations but also of public organiza-
tions, which uphold the interest of women, family and children.
They seek equal rights, liberties and opportunities for men and
women and seek to enhance women in the business, social and
political life of Russia. The Women's Movement of Russia sees
their goals as:

- Raising issues regarding the social status of women
- Establishing of schools for women leaders
- Women participating in the law-making process
- Drawing attention to the government regarding public and
 commercial structures
- Alerting mass media to the problems of violation of the
 rights of women, family, and children and
- The promoting of women's entrepreneurship.[19]

Another women's organization, the Association of Indepen-
dent Women's Democratic Initiatives, founded in 1993, is an
organization that seeks to unite more than ten public women's
organizations and other groups to elevate every aspect of wo-
men's rights. Their membership is not limited just to Russians.

Even though the goals of the various women's organizations
are lofty, they are attainable, provided affirmative actions could
be in effect for twenty years or so. If affirmation action were

instituted by the Russian Federation legislature for state and local governing bodies and for other political leadership positions, radical changes in the role of women could be initiated. Also, if higher education were made available on a free basis for women, sweeping changes could occur. If women were equally employed in police departments and other public administrations, perhaps some of the corruption that now plagues the country would be reduced. Maybe some of these ideas are far-reaching for Russian women, but women must not be without dreams.

According to an article in *The Russia Journal,* 2002, President Vladimir Putin, in addressing the plight of women in Russia said, "Improving the quality of women's lives is a priority."[20] The same article stated, "The action for improving the lot of women must begin at every home and workplace, and equality for women should be more than just talk." With the president and a major newspaper taking a stand for women, there is hope. It is necessary to bring men into the struggle for women, because for women alone, it is almost impossible.

2

Macedonian Women Struggle

THE HUMBLE CROSS, MADE OF APPLE TREE BRANCHES tied together with twine, enhanced the communion table that was positioned against a picturesque view of elegant mountains, one of God's divine gifts of nature. The unassuming homemade cross towered over an open Bible alongside the communion wine, which was grapes, and communion bread, which was tiny goldfish crackers lugged all the way from a U.S. supermarket. It was not the traditional communion service usually observed by Christians, but it was symbolic of our desire to honor God and to covenant with God in prayer for the people of Macedonia. It was the prelude for one man and six women who had come from the United States to Macedonia for a prayer-walk. We were mostly strangers to one another, so this retreat provided an opportunity of bonding with fellow Christians and with our sponsors, Marcia and Sam, humanitarian workers from the United States, now residing in Macedonia.

As we traveled to a ski resort for our two-day retreat, our eyes were consistently focused on the trees that hugged the rock-sided mountains and hung gently over the asphalt roads, flaunting their fine radiant fall colors. The air was heavy with the moisture that clung to the vaulted cliffs showing just below the leaden clouds, and the valleys seemed ready for the winter's snow and rain that would arrive shortly. Herds of goats scrambled along the

narrow mountain trails, seeking bits of russet grasses that were by now going brown as the frost sucked the life from the grasses. In that it was October, neither the snow nor skiers had arrived, so the desolate lodge provided a perfect respite for communing with God.

After a short period of time for rest and renewal, our group ventured into the village, walking in pairs and silently praying for individuals we encountered and even for people who resided in their homes. Ann, my traveling companion and roommate, and I walked down the village road that extended into a valley as a slant of sunlight broke through the frilly clouds. The road, which meandered toward a valley, soon became covered with water, and we realized that the road and stream were one. We continued our walk over the rocky roadbed, as the water was only a few

*A road and a
stream become one.*

inches deep. I wondered which came first, the road or the stream, but no matter, for now they were the same. Not only did we encounter individuals walking on this water road, but a wagon with passengers passed us as well. As far as we could see up the valley, the roadbed followed or merged with the stream.

Later as we walked on a dry roadbed, we encountered two elderly Macedonian men dressed in tattered black suits and wearing plaid berets, which they tipped to us as we passed. We accepted this as a cordial gesture, so I motioned to my ever-present camera for permission to take a photo, and they indicated with their body language that it was all right. I wanted their permission to take a photo since an old woman just up the street, tending her cow in her front yard, had refused to let me take her

Drying corn on the wall of a village home.

picture. With her hand, she had shushed us away. Later I took a snapshot of her house, but I really wanted a photo of her, since she seemed to me the epitome of a Macedonian woman.

We observed that most of the residents in this village lived in small bungalow-type homes, often consisting of two or three rooms. Usually attached to the side of the house was a lean-to or some kind of enclosure for their cow, goat or horse. Bundles of corn stalks with their bright yellow and golden ears of corn attached were nailed to the sides of houses for drying, assuring food for cattle during the approaching snowy winter. I observed this colorful display of drying corn in most of the Macedonian countryside. As we moved among the people and visited their homes, we learned more of their customs and mores and began to stretch our definition of just who is our neighbor. Even though Macedonians are unique in their ethnicity, they are universal in their longing for love, integrity, and justice for their people.

Our Group's Two-Fold Mission

Our arrival in 1999 in Skopje, the capital of Macedonia, provided my first insight into the role of women in Macedonia. Almost all of the airport workers, we saw, were males. The airport was crowded, small for an international airport, and custom operations were cumbersome, as one would expect with Macedonia being one of the poorest countries in Europe. After we arrived, some of our group rushed to the public airport restroom to discover that the toilet was a hole in the floor, a new experience for many of our group.

We had brought with us more than 5,000 vitamin tablets for the Kosovar and Macedonian people, which created a frustrating situation at customs. The vitamin tablets were in labeled bottles, but the airport attendants could not read (or speak) English. Perhaps they suspected that we were transporting illegal medications into Macedonia. I was the first to clear customs with no problems, but some behind me were detained and had their luggage searched. When customs officials discovered bottles filled with vitamin tablets in some twenty pieces of luggage, I was

motioned to return to customs for an additional search. It took an extended amount of time and much discussion to explain why we had vitamin tablets in our luggage. We indicated that Sam and Marcia, our host and hostess, had told us of the desperate need for vitamins in Macedonia and Kosovo, especially for the children and pregnant women, and we had responded to that need.

In addition to the prayer walk, we had come to offer humanitarian assistance in sorting and packaging used clothing for neighboring Kosovar people residing in the Macedonian refugee camps. During the first week, the seven of us sorted and bagged 10,000 pieces of clothing that had been contributed by 250 Baptist churches in the United States. The clothes, some new but most used, were stored in the unheated first floor of an Albanian home, which had been rented for this purpose. We sorted women's, men's, children's and babies' clothes, including underwear, shoes, caps and scarves and placed them into red and blue plastic bags. Since the bags had zippers and a handle, the local people referred to them as suitcases, but to us they were just plastic bags. In each bag we placed 75-100 pieces of clothing for a family of four. We realized that the sizes of clothing placed in the bags might be

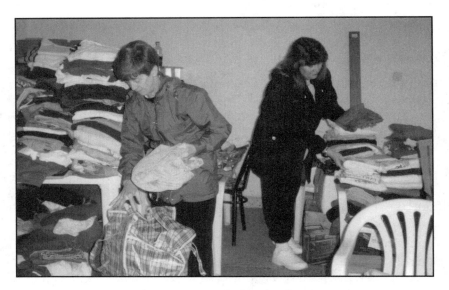

American volunteers sort clothes for Kosovar refugees.

inappropriate for a particular family, but we thought that they could exchange items with other families, according to their needs.

Sam told us of the effort (and bargaining) that was necessary to gain possession of these clothing packages upon their arrival at the Macedonian post office. The Macedonian postal system required a $2,000 fee, even though the senders of each package had paid full postage from the U.S. Although the Macedonian post office was aware that these items were sent for humanitarian aid, they still required a substantial fee from Sam before releasing the packages to him.

In addition to sorting and packaging clothing, we packaged small school backpacks for the children with pencils, pens, notebooks, rulers, and a few additional supplies, plus a box of cookies for each child. Later some of us had the privilege of distributing some of these supplies to the refugee children of Kosovo.

Discovering Macedonia

For most of our stay, our home was a hotel in northwestern Macedonia. Each room was sparsely furnished with two single beds, a chair, a desk, and a very small bathroom, about four by four feet. We eventually learned how to use the hand-held spray in the shower and simultaneously to hold onto a bar of soap and bath cloth. Once I dropped the showerhead on my foot and had a bruise for a week, but we learned to adapt and did become accustomed to our new living arrangements.

Perhaps the most inconvenient aspect of our accommodations was the lack of heat when the prevailing freezing winds were lapping at our windows. It was so cold in our room that we could often see our breath as it blended with the cold air. We slept in several layers of clothes or in sweat suits with hoods pulled over our heads; however, the wind blew through the cracks around the windows, causing the curtains to dance, even after we attempted to stuff pillows in the cracks. Several times, due to lack of sleep because of the cold, my eyes would tingle and seem to beg "for forty winks." Hotel employees told us that heating coils

existed under the covering of our floor and would be activated upon the arrival of winter, and I assumed that winter arrived when the ground was hidden with snow. Eventually, we did acquire a small electric heater, which saved the day—or the night—for us.

Macedonia, located in southeastern Europe, is landlocked by several countries, plus chains of mountains that separate Macedonia from Bulgaria on the east. Greece, a not-too-friendly neighbor, is to the south, Albania is to the west, and Kosovo and Serbia are neighbors to the north. Macedonia, about the size of Vermont, boasts a population of almost two million people. This area was earlier a region of Greece, comprising the northern and northeastern portions of that country.

The loveliness of the Macedonian countryside awakens one's inner soul. The rivers follow a serpentine course, dissecting pristine forests and fertile valleys, while the fog-topped mountains, scattered with pebbles, large rocks, trees, and scattered grasses, provide a home to the sheepherders and their sheep. In the autumn, the leaves cascade down the edges of ravines, providing an unbroken canopy of a thousand shades of color. It is a land of

A farmer hauls his tobacco to market on a wagon.

Macedonia, a land of splendor and awe.

vast beauty and friendly people whose cordiality was always apparent.

The Macedonian population consists of two distinct groups of ethnically diverse people. The Serbian Greek Orthodox constitute about 75% of the population and the Albanian Muslims about 22%. Although the Albanian Muslims are a small percentage of the population, they are a very vocal group. Of the remaining population, about 4% are Turkish, plus a small number of Roms or gypsies. The people of Macedonia generally speak a South Slavic language similar to the Bulgarian and Serbian languages, which evolved from the Greek, Albanian and Turkish languages. Young people are more likely to speak English than any of the twenty dialects spoken in the country, making Macedonia a truly multi-linguistic country.

Who Are the Macedonians?

These 2.2+ million people who live in Macedonia have a confused and controversial identity with their mixture of Greek or

Bulgarian or Albanian heritage. Neighboring Greece is extremely hostile toward them, charging that the Republic of Macedonia stole Greece's northern province. Greece asserts that the country is a historical insult against their northern province and refuses to recognize either a Macedonian state or nation on the grounds that everything in Macedonia—the name, the people, the history and territory—is exclusively Greek. Greek nationalists claim that "Macedonia is, was and always will be Greek, that all Macedonians are Greeks and that only Greeks can be Macedonians."[1]

We learned of the Greeks' abhorrence for the Macedonians as we arrived in Athens to visit historical sites such as the Parthenon and to sail to the Greek islands. When we registered at a hotel in Athens, we remarked that we had arrived from Skopje, Macedonia, and we were informed in no uncertain terms that there is no country by the name of Macedonia, that the only Macedonia is located in northern Greece. Thereafter, we were careful not to mention our previous stay in Macedonia so as not to offend the Greeks.

We also learned that the neighboring country of Bulgaria recognizes the existence of Macedonia as a state but not as a nation on the grounds that Macedonians are really Bulgarians. Along the same lines, the Serbians refuse to recognize the Republic of Macedonia and refer to it as South Serbia.

However, Macedonians say they are a unique people with their own language, culture, history and national identity.[2] In spite of the Macedonians referring to themselves as the "Heart of the Balkans, Mother Macedonia," it remains one of the most ethnically and religious complex areas in the world. Ethnic nationalism lies at the heart of most of their present conflict. Thus the word "Macedonia" has various definitions and connotations, determined largely by the person who uses the reference.

Squabbling over nationalism is nothing new to the Balkan people. A review of Balkan history indicates that the region has been engrossed in strife since the Slav descendents arrived in the Balkans during the sixth and seventh centuries. More recent history indicates that the Macedonian People's Republic was established in 1944 with most of the people identifying them-

selves as Greeks, Bulgarians or Serbs. Their claim to nationhood was ignored until the end of World War II, when the republic was established within the Yugoslavian Federation. Prior to 1944, the primary source of identity was religious, but later it shifted to language as well. It is said that during World War II, the Macedonians rose to national identity to keep Yugoslavian Macedonia separate from Bulgaria.[3]

When Yugoslavia disintegrated in the early 1990's, four of the Yugoslav republics sought to become sovereign states, and they became antagonistic toward those of differing religions, especially the Serbs, Croats, and Bosnian Muslims. Macedonia now finds itself confronting the same issues of political and economic transition that the former Yugoslavian republics encountered. In 1989 the Macedonian government amended its constitution to define the country as a nation-state and declared its independence in 1991, identifying the country as the Republic of Macedonia.

The Albanians, composing only one-fourth of the population, not only wanted input into the Macedonian government but demanded their "own political and territorial autonomy of Albanians in Macedonia."[4] They also desired equal status with the Macedonians and inclusion in the decision-making process for the new country, thus creating even greater conflict. The Albanians claim to be persecuted at the hands of the Macedonian government. They report having fewer representatives in the Macedonian government and on the police force, closure of many Albanian schools, hiring discrimination, and ban on their right to write and speak their language in their villages. Macedonians, it is said, have also restricted Albanians from purchasing property from Macedonians in the western part of Macedonia to keep the Albanians from creating "ethnically pure territories."[5] The majority of ethnic Albanians live in the cities of Tetovo and Gostivar, in the northwestern areas of Macedonia.

With Macedonian Serbs being fearful of an Albanian takeover or of the Albanians joining forces with their western neighbor and ancestral country of Albania, the tensions between the Albanians and Macedonians have escalated. Violence had been under control for almost a decade until the last few years when outright

conflict dramatically increased. However, with international pressure and intervention from NATO, some of the violence has come to a standstill. The country is still deeply divided, even though a peaceful agreement was signed in August 2003 between the hostile groups.

Problems related to prejudice are deeply rooted, both in blood and in the hearts of the people. This dilemma appears to be inherent in the religion and culture of the Macedonian Serbs and the ethnic Albanians. These ethnic prejudices go back hundreds of years but have increased in intensity since the disintegration of Yugoslavia. The hatred between these two groups is fearsome, and an immediate solution to the conflict is rather evasive.

Women's Role in Ethnic Relations

As a result of this ethnic discord, women's organizations, those ethnically based as well as the non-ethnic groups, have initiated work with refugees, even working across ethnic lines. Since the killing of police and soldiers in some areas, the conflict has appeared to escalate. Many women desire to be involved in seeking solutions to the conflicts that devastate their homes and country. They appear to have an enormous yearning for peace, perhaps even beyond the scope of most Macedonian men. Their empathy goes beyond ethnicity as they identify with the oppressed refugees and seek togetherness with the hopes of peace. Although men retain all power in Macedonia, women are now questioning why they are restricted from participating in the peacemaking process for their country. They want to become educated, to obtain credible employment, and to be recognized as vital entities in their country. Women are becoming forthright in their attitudes, indicating that their role in life should go beyond the traditional notions of "stay at home and have babies and satisfy one's husband."[6]

Thus, many women's organizations which now exist in Macedonia are taking a stand against violence. During the Macedonia/Albanian conflict, the United Women of Macedonia met in the capital city of Skopje to organize a "peaceful silent

manifestation with a 'wall of peace, peace through peace.'"[7] This group of women and a few males met for ten hours a day in Macedonia in 2001 to demonstrate their views regarding the armed conflict; however, their meetings were stopped when the Macedonian Ministry of Internal Affairs forbade public meetings. The women said, "We are all peace volunteers,"[8] and they collected hundreds of signatures on their peace petition, which they sent to Kofi Anann of the United Nations and to Security Council members. This was their way of contributing to peace. Women are beginning to demonstrate and acquire a little clout in this country, even if it is in a diminutive way.

Another remarkable contribution from these women was to open an informational center for 15,000 refuges from Tetovo. They registered the people and assisted them in locating places to live. Some 60-plus refugee families were resettled in Skopje homes.[9] These women, most of whom had had little or no previous experience in leadership, formed organizations and opened doors for multitudes of other women and their families in an attempt to demonstrate their desire for peace in Macedonia.

Home Life for the Macedonian Women

Early one morning as the sun pushed back the darkness, we left the village where we resided to travel with Marcia and Sam to the capital city of Skopje. There we visited a Macedonian-Albanian home located just off a busy downtown intersection. We entered through a wooden gate situated between two decaying buildings. Then we immediately stepped onto a small concrete pad, walked a few feet, and began our descent down concrete stairs to an underground home. Our friends had brought Ann and me to visit this Muslim family, which consisted of parents and their two young daughters. As we walked down the stairs to the underground living area, we discovered that warm sunlight flooded down the stairs to illuminate an underground patio. The main portion of the house, furnished rather modestly, was neat and orderly and consisted of the living room and kitchen and a traditional Macedonian bathroom with an open shower (no cur-

tain) and an open drain into the floor. The toilet was a ceramic hole with carved indentions for the feet and a hose to rinse out the receptacle following its use, somewhat atypical for us Americans. To access the two upstairs bedrooms, the family walked up the same concrete stairs by which we had entered. This underground home was uncommon, but it was very pleasant and created a remarkable experience for us.

The ethnic Albanian couple and their daughters were close friends of Marcia and Sam and they often ate and fellowshipped together. They were welcoming and gracious, but since the Muslim family did not speak English, Ann and I were left out of most of the conversation. However, there were frequent smiles, which connected us. We were amused by the animated conversation of the Muslim woman as she conversed with Marcia, who spoke her language. We were graciously served tea and cookies, the usual hospitality afforded visitors. The cookies were little English-bought pastries, slightly sweet and crisp. We learned that the wife's Arabic name means "love" and her husband's name means "sunrise," and that the connotation of names is very important to the people of Macedonia.

Many of the Macedonian women are gifted with their needle-crafts such as tatting, crochet, knitting, and quilting, which provide a small income for them to supplement their family income. Our new Muslim friend crochets and sells exquisite crosses about two inches wide by three inches high, and Ann and I bought dozens of these beautiful ecru crosses to bring back with us as gifts for friends.

Living conditions for Macedonians vary, largely dependent upon whether a family lives in the urban or rural area. The rural homes are usually small and quite modest, while those in the urban areas are frequently more substantial. Many families live in the numerous high-rise apartments, which often have balconies that are utilized for drying clothes or storage. There are a few affluent homes in the cities, which are one or more stories high and open into scenic courtyards. Since Macedonia is a developing country, the standard of housing for most people is minimal.

One-fourth of the Macedonian population lives in the capital city of Skopje. Young people have migrated from the rural areas,

A Macedonian village home.

where 40% of the population resides, to Skopje and other cities, except for the Albanian and Roma youth, who tend to remain in villages with their families. Regardless of where families live, extended families and kinship ties are strong. The tradition of extended families in the urban areas appears to be diminishing slightly, but it remains constant in the rural areas. The extended family usually consists of parents and unmarried children, as well as married sons and their families. In addition, in rural areas there is also the kin group or clan, and this group is often considered a hamlet within a village.

The size of a Muslim family has changed remarkably since 1988, when Macedonian authorities placed restraints on the size of the family. The government felt the Muslim population was increasing too rapidly and ruled that Muslim families with more than two children might have to pay for their children's medical services; allowances provided for children would be restricted, and the family might be required to pay a financial penalty for the extra children. This constraint was limited to Muslim families.[10]

Macedonian women struggle with extensive inconvenience, especially in the rural areas, where homes seldom have running

Macedonian women chat near their homes.

water or electricity. Even when electricity is available, it is not dependable. Women in the cities also lack many of the amenities that we Westerners call necessities. For instance, we discovered that our hotel had no washer or dryer. The maids (only occasionally) washed our linens by hand and attempted to dry them by pressing them moderately dry with an iron. The damp sheets were then put back on the beds, and we found it necessary to remove the sheets and hang them near our small electric heater to dry. Since our room was small, hanging the sheets up to dry required some adaptation on our parts. We hung the damp towels on the towel racks to dry, but with the soggy and hazy atmosphere, they remained damp for what seemed like days.

Another problem for women in Macedonia is the constant rain, which slaps the ground almost daily, producing mud puddles and slush. The unpaved village roads showed ruts several inches deep, to the degree that automobiles and wagons were

parked and the villagers walked where they were going, picking their way by foot through squashy muck, especially up hills. The streets in the cities are mostly paved, but with wagons and cars arriving from muddy areas, even the paved city streets become mud-spattered and grimy. I do understand the practical custom of removing one's shoes before entering a home; however, this custom seems to be diminishing to some degree in the urban areas.

A concern that we encountered, but one that most Macedonians are accustomed to managing, is living with cold temperatures. Locals dress warmly, wearing sufficient clothing inside and outside. We learned rather quickly to dress warmly wherever we were. I am sure the cold is not as serious a problem for the people of Macedonia as it was for those of us who are accustomed to warm homes. The dawning of the morning sun always gave us a warm wash of relief.

One of the customs that I appreciated was the manner in which women greeted and bade farewell to each other. They greet each other with a kiss on the cheek and will even give a kiss to a stranger, if they are acquainted with the individual who has introduced them. We could also expect a warm hug and kiss from the women as we departed. Men, on the other hand, shake hands in greeting each other. Another cultural norm that I appreciated was the young people's honor and respect for older persons, although as the country becomes more modernized, I learned that some of the long-standing customs seem to be losing ground.

Although contemporary dress styles are creeping into most developing countries, the dress of the Macedonian Muslim woman has remained largely unchanged by modern trends. The Muslim woman's apparel and sexual mores appear quite structured and certainly influenced by her religion. Her headscarf allows a woman's face to show only slightly and folds softly into the long, flowing clothing that encircles her body. The aging Muslim women have a rather weatherworn complexion with face lines that give evidence to a life of hardship.

Although the Macedonian Serbian women's dress and behavior will also likely follow ethnic lines, the urbanization and mod-

Young Muslim women shopping.

ernization of their dress mode is evident. Many of the non-Muslim young women have adopted the current trends, wearing somewhat scanty clothing of a more up-to-date style. The mature Macedonian woman, however, adheres to a more modest approach in her dress, incorporating traditional mores. There is a constant clash when culture and mores of a country connect with modern trends, and ethnic Muslims are often offended by the lack of modest dress by some of the Macedonian women.

As Americans in a humanitarian role, we wanted to adhere as much as possible to tradition. Thus, we made every effort to dress modestly and observe acceptable decorum to the best of our knowledge. However, that did not limit stares from both men and women everywhere we went. There was no hiding our Western appearance and, of course, our lack of proficiency in their language. Although Ann and I shopped unescorted in the villages and cities, we later learned that being unescorted was unacceptable by some of the more conservative groups. We learned that especially women from other countries should not move about unescorted; however, we felt safe, perhaps unrealistically so, as we shopped and toured the villages and cities.

On most shopping occasions, we felt comfortable because we had learned how to use Macedonian money to make purchases. Most items were of lower quality than we would find in America but were very economically priced, especially food. We had an awkward experience in trying to buy postage stamps in order to mail our postcards home. At the post office the woman kept asking us something regarding the purchasing of stamps. We struggled for several minutes, trying to explain that we just wanted stamps for each card. At last, she waved her arms like a bird, and then we knew she was asking if we wanted to send the cards "airmail." Some of the people had picked up a little English by watching television, often enough to be able to understand us, but not the post office lady.

With the moist smell of the rain-soaked soil constantly with us, we drove to a village, then walked about a half mile up a hill for a visit to my favorite Macedonian Muslim family. Because of the incredibly mucky streets, we had to park our car some distance

Farmers rely heavily on horse drawn vehicles.

away and walk up a cascading village road that was coated with several inches of mud. Ruts, created by wagons, carts, and cars, were burrowed deep in the squashy dirt. There were no sidewalks, so we just stepped over the puddles on the precarious road and inched our way up the hill to their home.

Wooden fences shielded most of the homes from street view, except at the gates, where little children and sometimes their mothers peeked around to watch us strangers picking our steps rather precariously up the hill. The homes that we could see were rather meager in appearance, but inside they probably were clean and more accommodating. This had been true for several of our previous visits to seemingly paltry homes: the inside of homes were more attractive than their outside appearance indicated.

As Ann, Sam and I arrived at the village home, we, of course, removed our shoes before entering. I really thought we should just discard our shoes altogether, but then I realized there would be a return trip to our car later in the afternoon. The home was made of rough concrete materials with unframed windows and doors, which made the house appear unfinished. This extended family consisted of the parents, a daughter, three sons and their wives and numerous children. The family owned 800 sheep, which they kept in the mountains nearby. The father and mother of the home were out of town on a trip, so the eldest daughter-in-law was in charge of arrangements for our visit. (A custom is that the elder daughter or daughter-in-law is in charge in the absence of the mother of the home.)

Two of the sons' wives wore vivid scarves around their heads and colorful striped skirts that fell to their ankles. One of the women wore a flowered blouse that looked as if she was clothed in spring flowers, while another wore a faded blue blouse with her long skirt. Their clothes fell loosely over their slightly overweight bodies. The other daughter-in-law, who was quite attractive and slimmer, seemed to be somewhat more liberated. She tied her long black hair behind her head and wore a black leather jacket, presenting a more contemporary image.

With Sam as interpreter, we were able to speak with the women regarding their traditions, activities, and concerns. The children sat quietly as we talked and appeared mesmerized by our

Winnie attempts to eat goat cheese in Macedonian home.

presence, watching our every move. As expected, we were served refreshments. First, we were served Turkish coffee (which still contained the coffee grounds). Next, we were served a large portion of their homemade goat cheese, probably three pounds of it placed in front of us on a coffee table. We knew that we had to make some dent in this wedge of smelly cheese. It was creamy white and rather crumbly with a powerful aroma. With the first whiff, I knew my stomach would soon go on strike. I strangled and coughed all the time I ate the cheese, trying to be pleasant regarding their hospitality. I struggled through eating some of it, but my fingers always hesitated before I placed the next bite of cheese in my mouth. I prayed, as a friend once said, "Lord, I put it down, now you keep it down." Later, we drank a glass of orange soda and were offered a glass of goat's milk, but we declined the milk on the grounds that it was time to leave. I was sure the milk was unpasteurized, and I had run out of being amenable to strange foods for the day.

The young women of the home persistently made attempts to show warm hospitality toward us. We had already heard of their graciousness and their excellent handiwork, and we were de-

lighted when they brought out gorgeous pieces of crochet and tatting, products of many hours of work. They informed us that it takes one person up to twenty days to make one of the petite table scarves. I was delighted to purchase one of their scarves, which is about 6 inches square for $16. It is an unbelievably striking piece of crochet and one of my precious treasures.

The visit with the women left me with a warm inner glow of sisterly love but some perplexity. In spite of its being a very pleasant visit, the day had been a revelation to me regarding the predicament of Macedonian women. I knew that these women lived a subservient life and that each day they were confronted with challenges and constraints which cause them tears. I wanted to embrace each of them with love and give them hope, empower them to express a strong and exacting sense of themselves, and encourage them to strive for a voice in their future. I left with my eyes filled with unshed tears.

As we departed, the clouds were showcasing the sunrays, and the winds had sighed and rested. I longed for sunrays that would enter the lives of these women. With a thirst for a better life and more reasonable opportunities, these and other women in Macedonia could revolutionize the dilemma of servitude faced by multitudes of other women in the country.

Marriage as an Expectation

Traditionally, Macedonian parents have selected mates for their daughters, but as with numerous other traditions, this way of life is now in transition. Young people in the urban areas often seek their own partners and determine whom they will marry. Even though these young people may have input into their marriages, they normally do not cross religious lines in the selection of a mate. For example, a Macedonian Serb would never marry an Albanian or Turk. To sustain pure ethnic lines, the church allows intra-clan marriages after three generations. It is expected that the bride, especially in the rural areas, will be a virgin when she marries; however, if a girl does become pregnant, the couple will usually marry.

It is customary for everyone to marry, even though it may cause hardships for the bride's family to pay the dowry expected by the groom's family. A dowry may cause a strain on a family's finances, but it is necessary to assure the daughter's marriage. Because everyone is expected to marry, it is difficult to find an adult who has never been married. In fact, some Muslim men practice polygamy and have several wives. Divorce and remarriage are regulated by civil law and now occur more frequently than in past years.

After babies arrive, they are swaddled and moved about in a cradle, which also serves as the baby's bed. If the mother works away from the home, her child is usually cared for by the grandmother, older siblings, or a neighbor. However, in the urban areas, the children are more likely to be placed in a nursery school or kindergarten.

When a woman marries, she accepts the tradition that she will not receive an inheritance, since the family's possessions normally have been left to the elder male of the family. In many groups or clans, the land has been held in common by the extended family, but is also handed down through the male lineage. There is a movement today, however, for children to inherit equally, which has no doubt fractured the bastion of male superiority.

Few Frills for Women

One Friday evening as we sat in a restaurant eating dinner, I looked about the restaurant and observed that even though there were at least twenty tables occupied with diners, all were men except for one other woman. I asked Marcia and Sam, "Where are the women? Why are they not here with their husbands?" I was told that the women, after working outside the home all day, were at home taking care of the children and attending to housework. After all, that is what a woman is supposed to do in Macedonia! Most of the women do not have the same kind of opportunity for socializing that the men do. For example, at a major soccer game, with some fifty thousand in attendance, only a handful will be women. Women's attendance at these sports events is almost

unheard of, and I learned, in fact, that there are no athletic activities provided for girls in the schools.

One evening, we heard a group of men partying on the hotel premises until well after midnight, and I was curious to see if any women were involved in the socializing. When I peeped out our window, I observed that the crowd was composed of about 30 men but no women. It appears that the men think that women have little time or energy or even desire for such frills as socializing and participating in fun activities. The prevailing culture, archaic yet very much alive, is a major factor in keeping women from being involved in social activities, especially those involving men. A woman's shared life usually involves communicating with a neighboring woman, a friend, and/or her extended family members as opportunities arise, while men leisurely enjoy mingling and partying on a regular basis.

Men lead a more relaxed life, as is evident by the casual loitering of men and older boys on the streets in villages and cities. This is the same male mindset that was prevalent in the neighboring country of Albania. It is a good life for men, and why should women be given freedom to have pleasure and have parity with men? Half of the population in Macedonia experiences inequality, a great mockery of justice.

Greek Cuisine Popular

Perhaps it is because many Macedonians possess a Grecian heritage that Greek cuisine seems to dominate Macedonian food. Most of their specialties are very pleasing to the palate. They use an abundance of tomatoes and cucumbers marinated in oil and vinegar and absolutely bury their salads, as well as many other dishes, with feta cheese. Their meats are highly seasoned and often are accompanied by potatoes and French bread, which is laden with butter and cheese and grilled until the cheese is melted. Another favorite dish is fish with white baked beans in tomato sauce and pasta with spaghetti sauce. There is also pizza with cheese and ham placed between crusts. Their national dish, a basic Macedonian food, is a bean casserole (tvche-gravche)

served with bread. Since most of their food is prepared just before eating, women spend much of their time shopping and preparing family meals.

Macedonians have a rather relaxed schedule for eating. In fact, I was usually starving before the 9:00 A.M. breakfast, which is the typical time for serving the first meal of the day. This meal may be served to workers in the field, at factories in the city, or in the office. Breakfast often consists of bread, cheese and eggs. At breakfast in our hotel, however, we were served a wide variety of foods, including a meat that resembled bologna, omelets or boiled eggs, honey, and peach juice, a far more elaborate breakfast than average families are served. Dinner, the main meal of the day, is eaten about 2:00 in the afternoon and is followed by a siesta. Supper comes late in the evening, usually about 9:00.

At Christmas, the Macedonian Serbs who are Christians follow the tradition of serving some kind of fowl for Christmas, while lamb is served for Easter. The Muslims, on the other hand, slaughter a lamb for Kurban Bayram, a special holiday celebration. Desserts are usually reserved for holidays and special days such as weddings and funerals. Another tradition regarding food is related to a bride's virginity prior to marriage. If the morning after the wedding night, it is determined that the bride was a virgin prior to the wedding, her uncle will serve Blaga rakia, a hot sugared fruit brandy, in celebration. Food plays a significant role in the social life of Macedonians.

One morning as we drove through a village, our car came to a standstill due to the congestion of wagons, cars, and people in the street. While we were waiting to move forward, I thought that I would take photos of some of the people, so I rolled down my window and asked a man standing nearby if I could take his photo. Immediately, he said to his male friends in a rather enthusiastic manner, "Americans, Americans," and began opening our car door saying, "Come to tea, come to tea." I was astounded at the invitation from this stranger and tried to hold the door shut. Sam, understanding Macedonian language and customs, said in an unruffled manner, "Sorry; it will take too long," and we drove on. Everybody wants to serve tea to visitors, I observed. Even when

we made a purchase in a store or went to pick up developed film, we were invited to tea. I loved the hospitality offered to us as strangers and several times accepted the cordial gesture, especially if it did not entail leaving the store.

Being in numerous homes and partaking of their food, even if it were only tea, coffee, and cookies, was always delightful to Ann and me. One of our most unique experiences was having tea with the Macedonian lady who owned the house where we spent days sorting clothing for the Kosovo refugees. She rented out the lower floor of her home for storage and lived upstairs with her daughter and grandson.

Our interpreter told us the lady would like Ann and me to come for tea. We were always cold when we were working with the clothes, so even without an interpreter, we happily accepted the invitation, assuming her rooms would be warmer than where we worked. At the appointed time, we went upstairs to enjoy tea and cookies. However, we found it to be a rather frustrating experience, since we were unable to communicate except smiling,

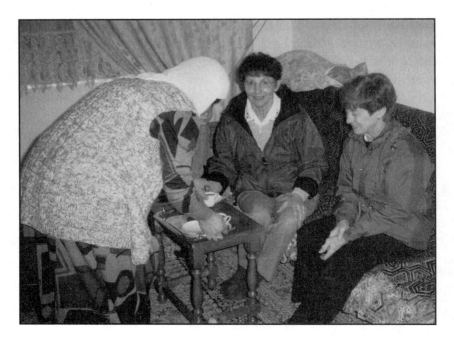

Winnie and Ann enjoy tea in a Muslim home.

pantomiming, and using lots of body language to indicate how much we appreciated her hospitality. It was awkward, but since her four-year-old grandson was present, we watched him play with his one toy.

Though they could not understand our English, we talked in pleasant tones, trying to let our hostess know we appreciated having tea in her home. The grandson seemed more baffled with us over our lack of communication than did his grandmother, especially the long silence when we all just sat. However, in spite of feeling rather uncomfortable, we were happy for the experience. Next time, however, we made sure we had an interpreter when we interacted with Macedonians.

Working Mothers

Traditionally, men and women both work in various areas of agriculture, in pastoral work or growing crops such as sugar beets, sunflower, cotton, rice, tobacco, grains, and even opium poppies. Women worked alongside the men when tending their gardens, fruit trees, livestock and field crops, and women were the keepers of the home, in addition. Now that the country has become more industrialized, however, women work more in factories, developing crafts, such as weaving colorful blankets, and making pottery, such as glazed terra cotta utensils, urns, pitchers, cups and bowls.

Women also work in the tourist industry. One very positive aspect of women working in Macedonia is that pregnant women are allowed up to nine months of paid leave and are permitted to return to their job up to two years after a maternity leave. Perhaps this is a result of their strong principles regarding the sanctity of the family.

Even though the Macedonian Constitution provides women with equal rights, in reality it is far from what actually happens. With a patriarchal matrix entrenched in the lives of men, women are really second-class citizens with very limited access to civil liberties or parity in job placement. Men outpace women in the private and public sectors, including the academic fields of science and engineering, in politics and business, and in most leadership positions. Women have difficulty in securing non-traditional po-

sitions, regardless of their training and potential. Few professional women are prominent in government or have position of power, especially in the public arena. Women by no means have representation in proportion to their number in parliament or any other ruling body.

Ethnic Albanian women have more difficulty with job placement than do Macedonian women. They do not have equal opportunity for employment or education and are limited in their opportunities to qualify for many vocational positions. In many cases, Macedonians have refused to allow the ethnic Albanian women to work in factories. When a factory near Tetovo, a stronghold of ethnic Albanians, was in need of workers, rather than employing some of the 20,000 unemployed Albanian women in the city, the government transported workers from Skopje to work in the factory. This is another example of anti-Albanian policies that have hindered not only the Muslim women but also all Albanian Muslims in Macedonia.

Inadequate Health Care

Since the 1990s, health care has been undergoing dramatic reforms in Macedonia. However, real reform appears to be stymied due to the influences of the Western world, a constant turnover of health ministers, and disagreement among medical people as to how the health system should function. Also adding to the quagmire is the assistance by the World Health Organization in developing new approaches that many doctors resist. Previously, medical services in Macedonia followed the Yugoslavia model, where a variety of specialists were utilized rather than using general practitioners. Pediatricians, for example, point to the advances in the past thirty years, such as moving the mortality rate from 10/1,000 to 1/1,000. Doctors fear that if they adopt Western reforms, the present mandated programs, such as state-sponsored vaccinations for children, may be hampered. Though health treatment is considered more up-to-date in urban areas, there are still many traditional folk healers, usually elderly women, who treat the sick with herbal medicines and perform rituals for healing.

In spite of progress in the general health care system in Macedonia, research for women's health concerns is usually at the bottom of the health continuum. Even the relief of pain during childbirth has been neglected. Needless to say, health care decisions are made through the patriarchal system, which appears to accept the premise that "suffering is what a woman does."

Barriers Women Face

Even though the constitution guarantees the rights of every citizen, irrespective of race, religion, origin, or gender, Macedonian women face discrimination as pronounced as in almost any country of the world. Men dominate every aspect of a woman's life, whether in politics, economic decisions, home issues, or the woman's social life, and women have few alternatives to accepting this domination.

In "Women Can Do It: Women Empowerment in a Patriarchal Country," the author states, "The country breathes the patriarchal spirit. Unfair treatment in hiring and sexual harassment are just a few of the obstacles women encounter in Macedonia's democratic society. ... It is clear that the democratic institutions fail to function properly, the voices of women remain unheard, their wishes unfulfilled. We are facing the dissolution of society rather than integration."[11]

A major problem for Macedonian women is domestic violence. Although there are procedures for coping with criminal rape, there are few, if any, procedures in place for dealing with marital rape and violence. Cultural mores prohibit women from reporting rape or domestic violence. Protection against domestic violence is not considered a civil right for the woman, since the husband maintains superiority over his wife. Domestic violence is not publicized in the media, nor are there shelters where women may go for protection. The government shows little interest in changing the cultural oppression of women in domestic abuse, so there are few options for the abused wife.

Perhaps the greatest resistance to women's gaining parity comes in the political arena. Men are considered the foundation of Macedonian society, and women's participation in the political

structure has been almost nonexistent until recently. In 1990, of the 120 elected members of parliament, only five were women. However, in 2002 there were twenty-two women elected to parliament, which is encouraging, even though women are considered to have little clout in parliament. However, their presence offers possibilities for women to be involved in decision-making processes, especially in those areas that relate to family issues. Though women cannot make major decisions or significant changes at the present, it is a strong beginning.

Women are becoming more educated as voters, searching for candidates to run for political offices, and studying the political process. Organizations such as the Union of Women of the Republic of Macedonia are instrumental in organizing women for political purposes. Since subservience for Macedonian women is and has been embedded in the culture for centuries, attempts to remedy this tradition are met with strong resistance. With women representing half the populace, they have the potential of making a significant impact at the voting polls. Even changes on paper are significant gains, but implementing new guiding principles, such as securing women's human rights, is the goal. It is a tedious process and one that is often circumvented by males.

Sex trafficking is a gruesome crime committed against women in Macedonia. The government inadequately addresses these crimes, which are perpetuated not only by the traffickers themselves, but also by local people like policemen and taxi drivers. Macedonia has become a transit route, as well as a destination for hundreds of women, who have been kidnapped or tricked into prostitution. Women are told that they are coming to an area to work as a dancer, waitress, or clerk, but once they arrive in Macedonia, pimps confiscate their passports, which prohibits them from leaving the country. The women are often held in slave-like conditions.

Illegal traffickers are attracted to Macedonia because of the availability of money that has come into the country as a result of Macedonia's assistance with the Kosovo refugees. Countries around the world have provided funds to aid these refugees; thus, large sums of money are on hand, and traffickers pursue these dollars. They have brought women illegally into the country

from countries like Romania, Bulgaria, and Ukraine and sold them to criminal networks in Albania and Kosovo for as little as a thousand dollars.[12] The network for receiving and placing women as prostitutes, both in the country and in other countries, is a strong one that keeps these women helpless, and the situation desperately needs addressing.

Another barrier encountered by the women and all the residents of Macedonia is the problem of pollution, which is complicated by an inadequate infrastructure that fails to deal effectively with contaminated water and waste disposal. However, the industrial pollution is even more appalling. For example, people living in Veles, Macedonia, suffer significant health problems as a result of pollution produced by fifteen companies over many years, and the city is considered the most polluted one in the Balkans. According to the Environmental News Service, "45% of the children in the city suffer from blood or urine problems with levels of lead, cadmium, and zinc five to twenty-five times greater than legal limits."[13] The mayor of Veles has sued the state of Macedonia regarding the contamination and vows that if the toxic conditions are not eliminated or lessened, he will take his case to the European Court of Human Rights."[14] Others are joining to

A child cuddles a teddy bear in Kosovar refugee camp in Macedonia.

fight the pollution concerns in Veles, as well, including an association of women's organizations and 120 non-governmental agencies.

One of the factors that limit women's progress is their lack of education. If a woman feels unworthy and sees no alternative to living her life subject to the dictates of males, she is not likely to seek change. However, as she becomes educated, she feels a greater desire to discard the patriarchal bindings. Education is the key to awakening women's self-esteem, unlocking their binding of subjugation, and eliciting new beginnings.

Although education is compulsory through the 8th grade, in 1996 the literacy rate was only 89% for Macedonians. Education for women is inadequate in the cities, but it is even more deficient in rural areas, especially for ethnic Albanians. Many Albanians, who speak only the Albanian language, have been forced to attend classes where only the Macedonian language was spoken, thus limiting their education. In 1989 the Albanian secondary school enrollment plummeted from 8,000 to 4,000 students, due largely to the Macedonian authorities closing the secondary schools. A large number of elementary schools were also closed and many of the students suffering from these closures were females. Without an education many women are not cognizant that equal rights for women are available, and also required by law.

A great freedom that could be given to women in Macedonia would be the opportunity to drive automobiles, a freedom that is afforded few Macedonian women at present. Men are treacherous drivers, I found. Perhaps the greatest danger I felt in the country came with riding in cars and observing the haphazard driving of the Albanians, mostly the men. Their irresponsible driving caused my heart to race almost every time I traveled, but especially on the main highways. One stretch of road of perhaps 30 miles, leading southeast of Skopje has had numerous accidents. Each month, I was told, some twenty-five people are killed on this road, mostly due to drivers passing on curves and hills. The driver of passing cars not seeing an oncoming car ran us off the road more than once. Our driver simply took it in stride and maneu-

vered the vehicle back on to the road, and I tried to get my breath again. I am confident that women would not take these same risks in driving as the men do, and driving would provide them a degree of freedom they have never known.

Many women have come to the realization that their plight will never improve unless they themselves seek to change the patriarchal spirit of their country. A change must come not only in the thinking of men but also of its women, who have for generations been indoctrinated to believe that they exist to please men, bear children, and graciously accept whatever harsh punishment men give them. The process of educating women of their human rights is mammoth. Numerous organizations, both local and international, have begun in Macedonia, seeking to unite women to promote gender equality. They are advocates for women's civil rights, desiring the elimination of discrimination toward women in society and at home.

The Devastating Clash of Religions

A distinctive attribute of an individual living in Macedonia relates not so much to the language the individual speaks but to the religion he or she follows. Most often the Macedonians and Serbs, who make up 66% of the population, belong to the Christian Macedonian Eastern Orthodox Church. On the other hand, the Albanians, Turks and Roms, representing about 30% of the population, are mostly Muslims and followers of Islam. While the national religion is considered to be the Macedonian Eastern Orthodox Church, there are small groups of Roman Catholics, Protestants, and atheists. There is also a small contingency of Jews, but the majority of them were deported or killed by the Nazis.

Significant differences exist between the Eastern Orthodox and Islam religions, the basis for the ongoing hostile conflict. Eastern Orthodox followers, with their Bible written in the Macedonian language, are similar to the Catholics. They accept the virgin birth of Jesus, as do the Roms, who celebrate Christmas much like the Orthodox but also enjoy the tradition of lighting bonfires and singing on Christmas Eve.

A Muslim man wears a skullcap as he travels in his village.

The Muslims, on the other hand, give their allegiance to Allah, practice animistic worship, and believe that Jesus was only a prophet. They also believe that their bodies will be reincarnated; thus, they refrain from smoking or drinking alcoholic beverages. Their rituals occur at the mosque, the cemetery, and in their homes. Special days for the Muslims are Ramadan and Kurban Bayram. Ramadan, one of the five pillars of the Islam faith, is a month-long celebration when the Muslims fast. Bauryam, on the other hand, is a period of feasting and sharing of food and fellowship with family and friends, and "baklava" is a rich dessert that families often serve during this period. Also during this celebration, Muslims slaughter a ram as a sacrifice to please God and to receive forgiveness for their sins.

With such extreme diversity between the Macedonian Ortho-dox and Muslim religions, religious intolerance escalates daily. The mistrust and hostility developed through the years continue to be a primary cause of conflict in the area, and political parties follow ethnic lines to draw leaders from their own ethnic follow-

ers. Since the majority of the people are of the Macedonian Eastern Orthodox faith, they tend to inflict extreme harsh conditions upon the Muslim people. For example, authorities have refused to allow mosques and minarets to be constructed by the Muslim people. On one such occasion, the Muslims proceeded to build a mosque anyway, and when it was completed, the Macedonian authorities destroyed it with dynamite. Another example is the authorities prohibiting young people under the age of fifteen from attending Islamic gatherings, hoping to halt the growth of Islam in Macedonia.

Not only do cultural practices differ among the ethnic groups, but various folk beliefs are also reflected more with the conservative rural population than the urban dwellers. For example, after a person dies, the family will devote effort to keeping the appearance of the grave in an acceptable manner. The family will probably visit the grave often as they grieve for the departed, and place food, light candles and incense, and pour libation water on the grave in the belief that these practices will prevent a corpse from becoming a vampire. Also, since marriage is such an important part of the culture, an unmarried young person who dies may be dressed in wedding attire.

One of the lovely symbols in Macedonian culture is the bronze statue of Mother Theresa placed prominently in the capital city of Skopje. Mother Theresa, a former resident of Macedonia, was a world-recognized Catholic nun who dedicated her life to serving the poor in India. As I looked at the bronze statue of Mother Theresa and several children, I thought of how she epitomizes a life of service, love, and peace, symbols of justice that seem to escape the hearts and minds of so many Macedonians. Though they claim her as one of their own and have honored her for her charity work, they have failed to demonstrate to each other the peace and justice that were ingrained in her heart.

Aspirations for a Better Quality of Life

Numerous women's organizations, especially the Non-Governmental Organizations (NGO), seek to inform political authorities of the unfair marginalizing of women in Macedonia. Accord-

ing to the Directory of Women's NGO, there are sixty-nine orga-
nized groups that address specific issues related to women. One
of the efforts of these organizations is to persuade the government
that through the utilization of women, they will expand an un-
tapped economic and political resource that could potentially
bring extra "muscle" to Macedonia. In order to drive home their
point, women have become resourceful through activities to en-
hance their visibility—participation in street walks, petition-sign-
ing and display of signs, in addition to lectures and discussions on
women's issues and drama productions showcasing the abuse of
women.

One of the newer organizations, founded in 2000, is the
Macedonian Women's Lobby, a Gender Task Force that hopes to
promote peace and security for all Macedonians. With the country
more or less engaging in civil war, this non-political, non-ethnic
organization seeks not only to promote tolerance regarding ethnic
issues, but also promotes equal participation of women in every
aspect of their country. They denounce violence, especially the
attacks by armed groups of extremists on ethnic groups. They
believe that Macedonians are capable of resolving issues through
tolerance and peaceful resolutions.

Through direct contact with one of the leaders of the Union
of Women's Organizations of Macedonia, founded in 1994, I
learned of their multi-ethnic network. Their vision is to achieve
gender equality, to guarantee women's rights, and to eliminate
discrimination for women in the family and society. Their goals
are (1) support for women both as individuals and members of
local women's organizations, (2) women's increased participa-
tion in public life and project development, (3) creation of new
society relations, cooperation, and mutual support, (4) promo-
tion of women's rights and opposition to violence, abuse, and
trafficking of women, (5) women's participation in all spheres of
society, (6) encouragement of tolerance and dialogue within the
country, (7) promotion and protection of peace in the region, (8)
greater participation of women in the government and decision-
making, and (9) improvement of women's social-economic posi-
tion and entrepreneurship development. (Their web site is

www.sozm.org.mk.)[15] Their mission is ambitious, but they are unyielding in their resolve.

The proliferation of women's organization is often the outcome of tragic events such as war in a country or unusual conditions that cause women to rise to their potential and throw off restraints. It is unfortunate that sometimes it takes a catastrophic event before changes occur for women, such as the case in Kosovo when husbands were killed and out of necessity women were thrust into leadership roles. With Macedonia in the throes of a potential civil war, a crisis situation occurs, and women appear to be more anxious for a peaceful settlement than do the men. Many women have "stepped up to the plate" for the first time. With the foremost concerns being the oppression of women's rights, international agencies have come to assist women in coping with some of these significant issues, including ethnic prejudices. These organizations, along with local efforts by women themselves, have motivated other Macedonian women to seek peaceful solutions to their country's problems.

Aspiration for a better life is the desire of most women in Macedonia as they seek to change their lives through education, participation in redefining their domestic roles, and becoming involved in decision-making processes. Until the last few years political and social inequity was accepted as part of the culture, but with education many women desire to play a part in their destiny. They are beginning to redefine their responsibility in the family as the sole caretaker of the family and seek affirmative action in the arena of employment. Understanding their self-worth and receiving an education will facilitate the removal of women from the quagmire where they find themselves. However, it is a mammoth endeavor to overcome the cultural environment in which women have existed for centuries. Men, and some women, are comfortable with the status quo; thus, it may take years of education and information before this culture is altered. Boys and girls will need to be taught early that females are significant human beings and should be treated with dignity.

Under most circumstances, women of Macedonia have no alternative but to accept poor treatment and violence from their

spouses. Laws are not enforced that address exploitation and women have few, if any, alternatives but to endure the brutality, as it is meted out by husbands. If a woman has the option of supporting herself, she is not as likely to endure the cruelty of a husband. Women, through acceptance of abuse, give husbands the ammunition to control, dominate, and to keep them submissive. Altering husbands' attitudes toward their wives is difficult, and we can only hope that education will provide opportunities to alter the behavior of women by helping them love themselves, develop a worthy self-esteem, and avail themselves of alternatives through education and vocational training. Macedonia will be a better and stronger country when its women are liberated and educated. They will contribute more significantly to their country's economy and its political process, plus they will become better mothers and homemakers when they are viewed as significant persons in the eyes of all people.

3

Kosovo—Scene of Carnage

THE UNKEMPT CHILD, not more than three years of age, walked hesitantly toward me as I offered him a small, blue, stuffed teddy bear. Frightened by my presence, he quickly grabbed the little bear and rushed back to his mother, wrapping his arms around her legs and snuggling his face in her worn and faded dress.

This child was one of the thousands of Kosovar people living at Chegrane, a refugee camp for families in Macedonia. Some

Kosovar refugees spent many months living in tents.

35,000 people had inhabited this camp during the height of the Kosovo war, but now (1999) there were less than 5,000 individuals since most had returned to their war-torn homes in Kosovo. Many of those who left the camp took their tents with them in order to have shelter while they rebuilt their homes. These families, ethnic Albanians, had sought refuge in this neighboring country of Macedonia during the genocide of the Serbian-led war. On this cold, foggy and damp day in October, several of us from the United States had taken clothes, food, and teddy bears to distribute to these refugees.

I was touched as I observed the small children squeezing and hugging these stuffed animals to their chest for a warm, fuzzy feeling. These bears, made by caring churchwomen in Texas, were the only toys available to these children because the families had so hurriedly left their Kosovar homes that they took little more than the clothes on their backs. Most of these children had observed atrocities from strangers and were fearful of anyone coming into their area. In some tents we left quickly because the children cried out for fear we would harm them. However, there were smiles and words of "thank you for the gifts" from the mothers and some of the older children.

This refugee camp was located on a large flat area in northern Macedonia near the city of Gostivar. These families had crossed the Kosovo-Macedonia border only a few miles away to escape the terror of Serbian soldiers. Every living plant in the area had been removed in preparation for the construction of this tent city by United Nations troops. Gravel was placed between the endless rows of tents, providing a semblance of a road. The tents were dripping in the aftermath of never-ending rain, and the earth was coated with slushy red mud from the rains. Water spigots had been placed every few hundred yards, so in those areas additional mud puddles were created with the refugees filling their water jugs. Toilets were small tin buildings with wooden slat floors and seats made by cutting holes in a rough wooden board. Just after I made a necessary visit to one of these toilets, a crew of UN soldiers came by in their truck and proceeded to pressure-wash the outside and inside of the toilet. I was really glad that I had made my exit prior to their arrival.

Visiting the inside of one of the small refugee tents, which housed as many as ten individuals, was a depressing experience. The canvas tents, only about ten-by-ten feet in size, had no windows or ventilation except the flaps of the canvas door. Small oil stoves, situated on pieces of canvas covering the ground, gave the refugees warmth and provided a means for cooking. Inside, the tents were stifling with the smells of dirty clothes, pungent body odors, and traces of food cooking. A family slept on two-inch pads at night and used the same pads for sitting during the day. These scant accommodations certainly were not comfortable, but the tents provided protection from the elements and, most of all, provided the refugees a safe haven from the terrorizing they had experienced in previous months. Outside each tent, a family placed a small cardboard sign to indicate their family name. These signs gave thousands of people, who had lost contact with their loved ones and who searched continuously for them, a means of locating their family.

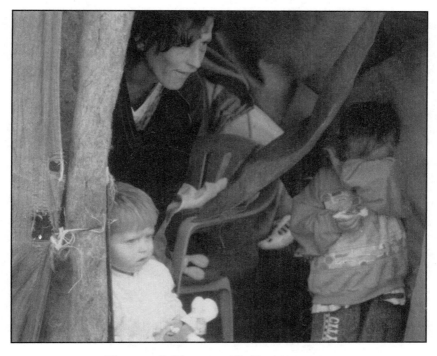

Kosovar children terrified by strangers.

Their memories were still fresh regarding their harrowing experiences at the hands of the Serbian paramilitary—memories of seeing family members killed and of being driven from their homes to spend cold nights in the hills with no food or shelter. Many arrived at this tent city empty-handed, being stripped of money, identifying papers, and possessions before they crossed the border into Macedonia or other refugee camps in the country of Albania. It is a memory that will not fade, even in years to come.

Being a mother and a grandmother, my most immediate concern lay with the children who had been so harshly taken from the tranquility of their homes to a new environment without sufficient food and clothing and almost no sense of security. In addition, some of them were without parents, most often the father. My prayer was that just maybe something soothing and cuddly like a teddy bear could bring a little warmth and security to these exiled children. Some ladies from a Baptist Church in Texas had made hundreds of these little teddy bears and are most likely unaware of the real difference they have made in the lives of these Albanian refugee children. I desperately longed to see the healing of these children's physical and emotional wounds, their safe return to their homes, and their renewed trust in people. I wished for arms long enough to reach around these beloved

Refugee girl accepts stuffed bear from Winnie.

children and say, as Christ did, "Inasmuch as you have done it unto one of the least of these my brethren, you have done it unto me."

The Making of a War

The small country of Kosovo has a population of only two million people in its area of 4,000 square miles. It is considered one of the least developed areas of Serbia, in spite of its fertile soil and sought-after minerals. To the north of Kosovo is the Yugoslavian republic of Serbia, to the west are Montenegro and Albania, and to the south is Macedonia. These neighboring countries played influential roles in the Kosovo-Serbian war of 1998-99. The major cities of Kosovo are Mitrovica and Pristina, the capital.

Serbians claim that Kosovo Polje, near Pristina, Kosovo is the Mecca of the Serbian Orthodox faith, and for years they have dreamed of returning the country to a pure Serbian republic. The area is the location of numerous Serbian mosques with their silver domes, spindly minarets, and dark stone towers, and it is the home of sacred places like Gracanica, a monastery of the 14th century. Serbians claim that Kosovo has been the spiritual and cultural center of their heritage since the Middle Ages, that it is their ancestral land or their "Jerusalem." This heritage has played a major role in Yugoslavia's vision for a pure Serbian state, which it has tried to achieve through ethnic cleansing.

Serbian kings ruled this area prior to 1389, when the Turks arrived to overthrow Serbian reign, giving leadership to the Ottoman Empire for the next five centuries. However, the Serbians still believe this area to be their land. During World War II, with the realigning of the Balkan area, the Serbs of Yugoslavia established Kosovo and several adjacent countries as part of their republic.

The Serbians say that Albanians came across the mountain chain that borders Kosovo and Albania during the 18th and 19th centuries. During World War II, the Nazi Germans occupied Kosovo, as did the Italian Fascists, and forced the resettlement of many of the Kosovar people into Serbia. It is reported that during this period more than 100,000 Kosovar Serbs were evacuated from their homes, which allowed Albanians to begin to move into their

vacant homes. By 1971 the Albanian population had doubled in Kosovo due to unlimited immigration. Prior to the 1990s conflict, 90% of the Kosovar people were Albanians.

Albanian Muslims reveal a somewhat different slant regarding the occupation of Kosovo. They claim that following World War II, when borders were drawn for the Balkan countries, a portion of Albania was cut away and labeled Kosovo. That portion of Albania which is now Kosovo was then placed under the Yugoslavian Republic.

When Slobadan Milosevic ascended to the presidency of Yugoslavia, he vowed that the Yugoslavia republics would be one great Serbian nation. Thus, he attempted to cleanse Croatia, Bosnia, and Herzegovina by killing entire groups of people because of their race, religion or ethnicity. Even though he was not successful in his attempt, thousands of people were killed during his reign of terror. He then proclaimed that Kosovo was the heartland of Serbian heritage and that he would cleanse Kosovo of the ethnic Albanians to create the desired pure state of Serbians.

The Albanians in Kosovo have long desired to be independent or to be aligned with their ancestral country of Albania. They led peaceful rebellions for years, seeking their freedom, and in 1992 overwhelmingly voted to secede but were not allowed to do so. During the late 1980s Slobadan Milosevic, president of Yugoslavia, began placing severe limitations on the Albanian Muslims, and by 1998 the Albanians were ready to use force to gain their independence. The opposing viewpoints of these Albanian Muslims and the Serbian Orthodox Christians led to bloodshed and atrocities, and after peace negotiations were unsuccessful, the United Nations entered the war to alleviate the mass slaughtering of the Albanian people by the Serbs. Thus in 1998–99 the war began.

The Life of Pre-War Kosovar Women

Prior to the war with Serbia, typical Kosovar women believed that their primary roles in life were those of wife and homemaker, and this long-held expectation seemed acceptable to most of

them. Women, especially those in the smaller villages, lived under this philosophy of men being dominant and women being allowed only limited participation in public issues and leadership. Traditional mothers taught their daughters to be submissive to their husbands, listen to their husband's bidding, and develop the skills necessary for being a good homemaker and mother. Seventy-seven percent of women were dependent upon husbands or someone else for their support.

As a result of the recent war, however, this traditional role and attitude has been significantly altered. Although Kosovar women have usually worn long skirts or dresses covering their ankles, I observed that in the cities and larger villages, younger women and girls are often wearing slacks. Older women also tend to adhere more strictly than the younger ones to the Muslim custom of wearing white scarves to cover their hair and loose-fitting, unadorned clothes in muted shades of gray, brown or black. The younger women and children, on the other hand, are often seen wearing clothes more typical of Western dress in both style and color.

More than half of the families of Kosovo live below the poverty line, and in fact 12% of the people live in extreme poverty. Fewer than half of the rural homes have running water, and living conditions are grossly inadequate. In the cities, however, 72% of the homes have running water, which makes women's lives somewhat more comfortable than for those living in the rural areas. With the fact that electricity is available only about half of the time, families face additional inconvenience. Even in these difficult circumstances, though, women attempt to provide adequately for their families, which on the average consist of three children plus the mother and father.

A Kosovar wife will usually have three or four pregnancies during her lifetime, but while pregnant she will make only one or two visits to a medical facility. This lack of prenatal medical attention may be a large factor in the high rate of infant mortality in the country. The United Nations Population Fund Profile reports[1] indicate that 29% of the deaths in hospitals are deaths of infants in the first thirty days of their lives. According to this

report, only 8% of Kosovo women use modern contraception, and if a woman has only one child, it is three times more likely to be a boy than a girl. Male children are more desirable than a female child, as is true in most developing countries.

A young woman entering into a marriage, usually around twenty-one years of age, may be apprehensive, since she probably will not have any input in the selection of her husband. Even a male relative may arrange a marriage for her without her consent. If a woman had been raped, as many were during the war with the Serbs, she would be rejected, not only by her family but also by any approaching groom or her husband. This creates trauma for women who through no fault of their own have been physically abused.

The UN report also indicates that now only ten percent of Kosovar women are literate, although most boys and girls were enrolled in public education until the Serbians began closing Albanian schools. In the years after 1981, Serbians closed three-fourths of the Albanian schools, which included 14,500 primary schools and 4,000 secondary schools, and dismissed 862 university teachers. Prior to the crackdown on the Albanians by the Serbians, the educational systems functioned as separate, parallel school systems, using the Albanian language and Serbian language respectively in their systems. After the military occupation and the forced closing of their schools, Albanians struggled with make-shift classrooms that were often held in homes and private areas. When international pressure was exerted on the Serbians, many of the primary schools were reopened; however, with years of deprivation in the school system, educational opportunities, especially those for women, have been limited.

As I visited with Albanian people of Kosovo in the aftermath of the 1999 war, I flinched as I learned about insufficient funds to pay teachers and observed school buildings that had been burned, windows shattered, and school materials destroyed. One school I visited could have opened, since its blistered and smoked walls with blasted-out windows still stood, but there was no heat. Heaters cost about $50 (American dollars), but even that amount was unattainable for the community, so the school could not reopen. We took dozens of book bags filled with school supplies to

the fifty or so children who normally attended this school and witnessed their joy in receiving pencils, writing materials, rulers, crayons and other supplies donated by caring Americans. Caring individuals had provided these materials, but I received the joy of seeing the children accept the gifts.

Prior to the war, most women appeared content to accept the homemaker role. They enjoyed the deciduous forests and stunning meadows and pastures, as they worked on farms that grew such products as grains, potatoes, and grapes. They assisted with tending their sheep and cows, in addition to handling their household responsibilities. However, after the war more than a thousand women became the head of their household, and this presented a new and drastic change for the women. Just being a homemaker was no longer an option. About 38% of the women in Kosovo are now employed in office jobs, factories, developing

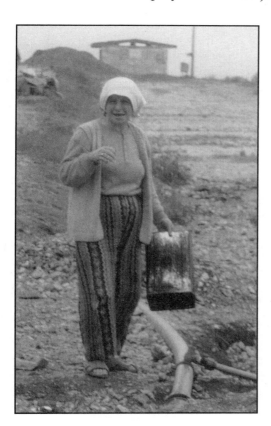

A Kosovar woman fills her watering can.

their own business, and even venturing into construction work, since so many homes had been destroyed. Women are being educated and trained and are being taught how to handle business operations and make political decisions, especially those decisions that have implications for women. A new way of life is emerging for many, many women.

The Associated Press reported the following incident shortly after my return from Kosovo in 1999:

> Fate Ademi covered her face with her headscarf and wept as she hugged the pictures of her dead men. The frail 69-year old woman lost all five men of her extended family when Serb forces swept through her village in central Kosovo, burned down its 80 houses and executed at least 46 people.
>
> Losing all of one's male relatives goes beyond grief in a village where horse carts haul hay down the muddy rutted path and water is drawn by buckets. Women who have never ventured beyond the walls marking a clan's compound or made an independent decision face a stunning new way of life—life without men.
>
> Many, like Ademi, plainly don't know what to do. Thrust into the role of family matriarch, Ademi admits she is incapable of the task of supervising the 15 people who sleep in her one-room stone house. She says it will be hard until that one grows up, pointing to her 12-year-old grandson. Then he will take care of the family. Dealing with the aftermath could forever alter the place of women in the province, according to human rights activists. Presently, the oldest girl who is 21 was making tentative steps toward responsibility for the mass funeral where her father, two brothers, an uncle and a cousin were to be buried. "We have to survive," she said, "somehow."

I heard almost identical stories from the women of Kosovo. To see their faces as they related their stories moves one to tears. Even strong American women would probably stagger under this load of woe.

Butchery of a People

Almost a year prior to the United Nations entering the Kosovo war in 1999, the Serbians were involved in major terrorist activities to cleanse Kosovo of the ethnic Albanians who were led by the

Kosovo Liberation Alliance. The KLA, who the Serbians referred to as "terrorist rebels," had been initiating hostilities toward the Serbs, since their peaceful negotiations over the years were futile. Milosevic's paramilitary was ordered to terrify, intimidate, and kill Albanians to the degree that it would cause the Albanian people to leave Kosovo. His soldiers were better trained and equipped than were the Albanians, so they met little resistance. There was no one to stop him, and he almost succeeded in evicting or displacing nearly two million people, until the United Nations reluctantly entered the conflict.

The impact of the war on women and their families took a heavy toll. By early 1999, over one million ethnic Albanians had been driven out of Kosovo. In only seven days, some 51,000 people were herded on foot from Djakovica to a remote border crossing in the mountains, according to the United Nations High Commissioner for Refugees. As the massacres began, Serb residents placed a sign on their door that read "aspska kuca," marking a Serbian house which soldiers were not to harm. However, for the Albanians, there were no signs and no compassion. The exodus involved use of force, threats of harm, and acts of savage violence, such as shooting and killing of women and children. Fear appears to have been the Serbs' most potent weapon. In some cases the people had only ten minutes to pack their belongings before being placed in cars, flat bed trucks, buses or trains or setting off on foot to the borders of Macedonia or Albania.[2] Serbs killed Albanians in the streets, at work, and in their homes. Bodies were mutilated with ears cut off, eyes gouged out, and symbols such as crosses scratched into their mutilated bodies. If the Albanians offered any resistance, the Serbs were told to shoot, and this happened in village after village.

News of the atrocities traveled fast from village to village, and some Albanians began vacating their homes even before the Serb soldiers arrived. As they fled to Macedonia, however, they were entering a country that disliked Albanian Muslims almost as much as the Serbs did. The Macedonians did not want the Albanians to enter their country, especially as refugees. However, that attitude did not hinder the Kosovar people from entering Mace-

donia and establishing large refugee cities, up to 35,000 people in
one area. These refugee cities presented quite a culture mix. They
included country women wearing their head kerchiefs and gath-
ered skirts or flowing trousers known as "shallvar," city women
with their delicate dresses and fancy shoes, young women in their
jeans and t-shirts emancipated from their Muslim habit, smoking
and drinking coffee with the men. Along with the women were
farmers, laborers, and professional men who were most fortunate
to have escaped death. Many of these dazed people sat crying,
with their hands covering their faces, wondering how all of this
came to be.

As people left Kosovo, they sought refuge not only in the
camps but also in private homes, especially in Albania. A poor
country itself, Albania was unprepared for the influx of thousands
of immigrants, many of whom migrated to the isolated town of
Kukes, which is surrounded by jagged, snow-capped mountains
and served by a single road closely resembling a goat path. When
I was in Albania, two years earlier, I had traveled over some of
these rough roads in the northern region of the country, one-lane
roads peppered with large stones and deep crevasses caused by
erosion. It was not an ideal place for refugees to travel, but it was
a road to a sanctuary.

In the Albanian refugee camps, life was problematic, and the
major obstacle was the scarcity of food. The story is told of an
Albanian Kosovar woman who approached a Red Cross station
with her small daughter, attempting to secure bread. After stand-
ing in the continuous line for what seemed like hours, she learned
that the allotment of bread had been handed out before she
reached the front of the line. A local Albanian woman observed
the incident and approached the woman saying, "You can come
to my house. We will give you a place to sleep." Though her family
had very little in the way of food, she said to the refugee, "We shall
divide by half our bread, and we shall stay together. We are
family, we are all Albanians."[3]

Sometimes there were as many as twenty immigrants occupy-
ing a one-bedroom flat in an Albanian home. Women in these
homes revealed alarming stories regarding their escape from

Kosovo. One woman, shedding tears, saw fifty people killed at one time and said that the Serbian soldiers shouted, "Don't cry or we will kill you, too." A grandmother lamented that two of her neighbor's daughters were found with their throats cut.

In Racak, a woman tells of seeing a ravine filled with their men, all dead. The forty-five men, old and young, had been marched into the ravine, while Serbian soldiers stood on the banks of the ravine and shot each of them. Some were farm workers who wore muddy boots, but now their boots were red with blood. Old white-haired men, with their traditional Muslim white skullcaps still on their heads, lay dead in the red-stained snow. This mass execution was the major incident that finally gave the United Nations incentive to enter the war.

Almost one and a half million Kosovar people were evicted to Macedonia and Albania, and more than 500,000 displaced individuals remained inside of Kosovo. They hid in forests and mountains, as well as other isolated areas. More than 500 villages were emptied of residents, and their homes burned.[4] As ethnic Albanians were pushed across borders, their identity papers were often confiscated, making them ineligible to return to their homeland. In the refugee camps, individuals searched for their families, since many had been forced to leave their homes without members of their immediate family. Filled with desperation and gloom, these refugees became a people without family and nation.

More Bloodshed of Village Women

Four months after the peacekeeping agreements were negotiated between Kosovo and Serbia, a small group of us—a friend and I, two American humanitarian associates from Macedonia, and an Albanian Muslim family from Macedonia—drove to Kosovo on a humanitarian mission. We drove from Skopje, Macedonia, to the Blace border, a distance of only ten miles, but it took hours to complete the necessary paperwork required for entry into this war-torn country. Cars were in a holding pattern as trucks loaded with food and other necessary supplies took prior-

ity over cars. Nearby, on another road, however, was a line of trucks bringing in various supplies, such as building materials. Trucks in these lines, which extended for miles, sometimes had to wait as much as seven days to enter Kosovo. Drivers remained with their trucks, eating and sleeping in their trucks, waiting for inspectors to approve their materials. Inspectors were in short supply, thus creating this unbelievably long waiting line. Many times only thirty-five trucks were allowed to enter on a given day, so the rest remained in line for their turn to deliver supplies to the Kosovo people. These supplies were coming from countries all over the world as people learned of the horrifying state of the living conditions that the returning refugees faced upon returning home.

Once we entered Kosovo, the United Nations peacekeeping soldiers, laden with heavy military equipment, including army trucks, tanks and hovering helicopters, were swarming in every direction. The presence of these troops was reassuring, not only to the Kosovar people but also to Serbs, who anticipated possible retaliation from Kosovo civilians. The troops also provided protection for those of us who came to bring supplies or assist in the reconstruction of homes, public buildings, bridges, etc. These soldiers, from countries like Greece, Germany and the United States, differed in ethnic background, race, and political persua-

Military vehicles provide security for Kosovar people (and visitors).

sion, but they were united in their effort to keep the peace in Kosovo.

As we entered Kosovo, I observed five busloads of soldiers being transported into Kosovo who appeared to be of Arab ethnicity. These soldiers were more diverse than were the Serbians and Albanians, yet they were at peace with one another. I found consolation in having soldiers nearby, yet it was frightening to consider that, if they were not there, the atmosphere could be quite perilous.

The old orange van in which we traveled was in such pitiful condition that each time we started or stopped the van, the driver had to raise the hood to tinker with the motor in order to get it running or to stop it from running. I had grave doubts that we would make our trip without major car trouble...but we did. We traveled on both hard-surfaced roads and dirt roads where the van would spin and slide, especially as we went up an incline. Usually the driver maneuvered rather skillfully over the water-soaked, slick ruts, but occasionally we would slide nearly off the road into ditches or fields.

On our visits to the villages in the area, we were loaded to capacity with people and supplies such as blankets, baby clothes, school supplies, vitamins, and cookies and candy. It was advantageous to have an Albanian driver who knew the territory and also was in touch with the Kosovo Albanian Muslims and could serve as an interpreter. The Kosovar families would have been more reserved in their comments concerning their plight had we not been with a person whom they knew or could relate to.

As we entered Kosovo, I grinned out loud as I observed the dazzling mountains weighed down with vibrant burgundy and golden and chocolate brown autumn leaves rustling in the chilling wind and drooping somewhat from the drizzling rain. As we drove into this war-torn country, I observed the incredible glow of the meadows that lay sprawling upward to touch the rolling hills. A few sheep grazed on the lush green grass waving their slender and delicate blades in the bluster of the nippy breeze.

Within less than an hour after entering Kosovo, I saw the first evidence of many heartrending incidents that I would see and

Hillside where hundreds of Kosovar people perished.

hear from individuals who had experienced unbelievable terror. We approached a precipitous hillside, which from a distance, appeared to be an ordinary hill touched with a few trees. On the steep side of the hill there were muddy trails that jutted up the mountain. I learned that these trails were made by Serbian paramilitary (soldiers) forcing Albanian men and women to run up and down the hill until they collapsed from exhaustion. As they fell, the Serbian soldiers shot the Albanians and pushed their bodies into the ravine creating an enormous grave. As I observed this massive grave, I was almost traumatized for I could not conceive such brutality. The devastation for these people's families was incalculable. I wondered what could possibly cause people to be so ruthless as to slaughter innocent humans. It was just the beginning of what I would soon learn regarding the atrocities of the Serbians, especially as in regards to the viciousness heaped upon women.

Land mines were everywhere. Narrow yellow plastic strips had been tied around trees and strung along the roadside to indicate the presence of land mines or where there was suspicion

of a land mine. "Do not step off the paved road for any reason," I was told numerous times. Individuals, even four months following the close of the Kosovar War, were discovering land mines in fields, yards, along the road or wherever Serb soldiers had been. A news release of the previous week related how a fourteen-year old boy was instantly killed when he stepped on a land mine. I tried to be vigilant regarding this warning at all times!

Driving into the countryside and villages, we continued to see the ravages of war. Some of the houses that had been attacked with phosphorus bombs had walls remaining but had no roofs. The phosphorus bombs used by the Serbs on the masonry houses left a white powder substance along with other scorched and blackened remains. Automobiles, tractors, barns and other outside buildings were charred as well. We occasionally could see a tent near a burned-out house where a family lived as they attempted to restore not only their houses and farms but their lives as well.

There were no restaurants open or restrooms available that we could find, but occasionally we did find a small country store

Graffiti on burned-out home says, "Thank you USA."

where we could purchase a soft drink. After spending several hours at the border and having spent hours visiting and delivering our supplies, I found it necessary to find a restroom. No such place was to be found. I suggested to our driver that we stop along the side of the road for a rest stop in the nearby woods. "Absolutely not, land mines are everywhere," he said with no uncertainty in his voice. As the day continued, my urge increased. We stopped to take photos of the graffiti on the wall of a burned-out house, which read, "Thanks Americans for your help." I told my companions that if I don't go to the restroom soon there is going to be an explosion right here on this road. I chose, in spite of resistance from the group, to walk behind the burned-out house to nature's restroom. Unable to persuade anyone to join me, I walked ever so cautiously behind the shell of the house, stepping over holes where land mines had exploded. My heart raced loudly with every step I took. I was fearful I would find a land mine that had not yet exploded. My traveling companions stood anxiously awaiting my return from my outdoor adventure. When I finally returned safely to our little group, smiling I said, "You all just suffer," because I knew their needs were as great as mine— and they did suffer until we arrived at our next destination hours later, at the home of one of our driver's relatives.

One of the first villages we visited was Komogllave, which will be forever etched in my mind. The driver of our van located the "head man" or mayor of the village who would be our escort as we visited with families who had endured extreme hardships at the hands of the Serbian soldiers. These Albanian families were returning from refugee camps in hopes of creating a new life in their old home place.

The homes were enclosed behind six-foot wooden walls with wooden doors for an entrance into the compound. It was a rather dreary day with light rain falling as we sloshed through several inches of mud to enter the compound. We immediately saw that everything had been destroyed except for one room of their former home, which remained in livable condition. In addition to the house that had been burned, we saw their charred tractor, their burned-out car and the well that had been poisoned. Later we learned that not only had the well been polluted with poison

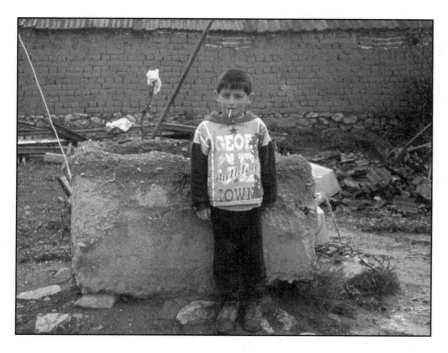

A Kosovar boy stands by a well contaminated by Serbian soldiers.

but dead bodies had also been deposited in the well. It created a hardship for the family since now they had to secure water from a distant well.

The matriarch of the family, an old lady named Lydia, greeted us graciously as we entered the compound. Lydia's layers of rumpled clothing reminded me of a gypsy costume with strings of her red hair protruding from under a colorful scarf that she tied behind her head. The few teeth remaining in her head appeared to be rotten. Other family members immediately joined her in the invitation for us to come inside. Twenty members of this family were living in this one room plus a tent that they had brought from the refugee camp. The room was rather dimly lit without electricity and with only one set of double windows providing light.

We sat on pads that were placed on the floor around the wall, the same pads that were used for sleeping at night. Through the interpreter the family willingly shared some of their experiences

This residential compound was destroyed except for one room.

with us. In fact, they seemed anxious that we know of the atroci-
ties they had experienced in recent months. Lydia told us story
after story while her adult daughters busied themselves with the
children and prepared coffee for us. I prayed that the water was
boiled sufficiently to kill bacteria. We knew that it was necessary
to drink whatever was offered to us. Along with a cup of coffee we
were offered a cigarette. This custom was usually afforded only to
men, but because we were Americans I guess they wanted to
extend this hospitality to us women as well. However, only the
men in the room smoked.

As we drank our coffee and chatted, five or six children, who
were seated on the floor around a small table about a foot high,
were eating a noon meal. It looked something like a pizza but of
course, it wasn't. It was a round piece of bread topped with
vegetables and a sauce. When the children finished their meal,

they sat very quietly observing we Americans while one of the mothers wiped crumbs from the table and placed the round table on its side, rolling it against the wall. It was the only piece of furniture in the room except the recently acquired wood stove which not only was used for cooking but provided heat as well. Flies swarmed almost as thick as the odor that engulfed the room. The cigarette smoke along with the odors of cooking food and body odors in a warm room without proper ventilation were rather ghastly. This one room was their bedroom, their bathroom at least for bathing, their kitchen, as well as their eating room and sitting room. They were doing the best they could with the limited accommodation available to them.

Later during our visit we were served an orange drink in small glasses, but my traveling companion, Ann, said she just could not swallow it. So rather than offend the family I drank mine, then inconspicuously traded glasses with Ann and drank hers. Later my stomach was slightly upset, but it was small price to pay for trying to relate to this caring family. All in all, this family faced a rather bleak situation. The Serbs had created a destructive situa-

Ann and Winnie distribute blankets to refugees.

tion for them, but they are strong people who have overcome adversity before and they would do so again, even without their family men.

Lydia is now heading her household, a role she was unprepared for but assumed out of necessity, since the men of her family had been killed. She said that she would remain the leader of her family until her grandson, now eleven years of age, becomes old enough to become the family leader. One of her greatest concerns, however, was the loss of their tractor, for it not only provided a means for cultivating the fields, but it also afforded transportation for the family. We later walked out in the yard, and she showed us the charred tractor.

Lydia's daughter Kama told us of one of the heartbreaking stories in their family. As she cuddled and calmed her baby son, Kama spoke of the dreadful separation from him the night he was born. Following his birth, members of her family wrapped the baby boy in warm blankets and placed him in the arms of Kama's teenage son, who then fled over the mountains in search of a safe haven for the baby. Kama was physically unable at that time to hike across the hills with her sons.

The Serbians assumed that if parents believed their babies were going to be killed, the entire family would leave Kosovo prior to the babies' birth. It was a terror tactic that often worked. In this case, though, just the baby son and a teenager left. Kama said the baby was three months old before she saw him again, and at five months of age, he could not hold his head erect. As I observed the baby boy, I knew he had suffered deprivation. He appeared underweight and did not seem to be thriving, and I realized that this baby has probably experienced irreparable injury due to the detrimental conditions in which he lived in his early months of life. The humanitarian workers who accompanied us had been ministering to this family, providing vitamins and other supplies to help not only Kama and her baby but also other members of this family. This little boy was the reason we had brought the baby clothes and diapers.

Without a tractor, this family's primary means for making a living was no longer possible. I asked the humanitarian workers

This woman gave birth to her child on a hillside to escape war threats against her baby.

who accompanied us what would happen to this family without a tractor. "Life will be very difficult for them," she replied. She told us that $3,500 had been collected toward the $5,000 needed to purchase a tractor and that she hoped the additional $1,500 would be contributed.

Sometime later, when we were in Skopje, Macedonia, preparing for our return to the United States, we had the chance to meet with an incoming volunteer team for dinner. This was a team of volunteer carpenters from a Mississippi Baptist church who had come to help in the reconstruction of homes that had been destroyed in Kosovo. As we talked of the dreadful plight of the people in Kosovo, the construction team leader handed the humanitarian worker $1,500 that his Sunday school class had sent to help with projects for Kosovar people. We all sat in stone silence, for we knew that this was the exact amount needed to purchase a tractor for Lydia's family. We were surprised that our prayers

were answered so quickly. I hope the men who graciously gave this $1,500 learned how very valuable their gift was toward the purchase of a tractor for a special family. The gift would bring newness of life not only to this family but also to many others, as the tractor would be shared with other families in the village as well.

The torture and killing of people and burning of homes left the residents of this little village more than just distraught; it also unraveled all their traditions and their sense of well-being. The plight of this one family was not an isolated occurrence but rather a representative one, as we encountered many more families and villages like those of Komogllave.

As we drove from one village to another, we stopped at country stores to refresh ourselves with soft drinks and to ask directions to our next destination. At one store, two teenage Kosovo girls walked up to our car and began talking of incidents of atrocities by the Serbians. It seemed that the mayhem committed by the Serbs was the priority of every conversation, and understandably so.

The humanitarian worker gave several bottles of vitamins to the girls who appeared pleased to have them. One of the girls stated that her uncle was very ill and said these vitamins would be most helpful to him. During the discussion, several teenage boys arrived and joined in the conversation. One of the girls commented to the boys, "The lady gave us vitamins." A Kosovo boy responded with, "But why? Most who come take from us rather than give." The humanitarian worker replied to the boys, "We love God and God loves you. He cares about you." It was a high moment for me, as I saw the attitude of these teenagers becoming more tolerant of strangers in Kosovo.

Another home we visited belonged to the extended family of our guide, the "head man," where he had lived since the Serbs destroyed his former home. This country home was a large and pleasant stucco structure with several outside buildings, and numerous farm animals grazing in the yard. This family had earlier vacated their home when an attack by the Serbians was imminent, but miraculously the home had not been torched. Now

the family had returned to some semblance of a normal life, and members of their extended family had joined them.

We talked with a very handsome young man of the home who had escaped to a neighboring country. He knew that death would have been inevitable had he remained in his village, but now that the war was over, he had returned home. During the war, one of the pregnant women of the family, fearing that Serbs would kill her baby, fled into the mountains and delivered her baby on the hillside. As she told her story, she lovingly embraced the tiny boy to her breast. The little boy, maybe six or seven months old, had the worse case of cradle cap that I have ever seen, his little head almost white with the flaking of his skin. The faces of the baby's mother and her father were seriously inflamed, but I did not inquire as to their health. The grandfather wore the typical white skullcap of the Albanian Muslims, along with a black suit coat that is so typical of the older men. And so the stories go on and on.

Traveling to Begrac was another adventure. The roads were no different from those we had previously traveled, just two muddy ruts and more muck than one can visualize, creating a roadway that made passing another car almost impossible. We observed numerous buffalos, which are used for their milk and meat and also for pulling ploughs. The buffalos grazed on scattered grasses and grains on land that appeared to have been cleared recently. It looked as if the erosion from these fields had created much of the disarray of the roads. Although I was told the soil of Kosovo is usually fertile, many of the fields we saw were strewn with rocks, which hampered the growth of crops. The landscape and surroundings were just as we had previously experienced, eye-catching scenery blighted with the ruins of shattered homes.

As we entered a home in Begrac, we removed our shoes as was customary and were cordially invited for tea by the ladies of the house. This home had regular sofa chairs, so we did not have to sit on the floor as we had earlier. The house was rather dimly lit because the day was cloudy and the home had no electricity. We visited with this extended family and learned of tragic events similar to those we had heard about in other homes. We encoun-

tered another young man in his twenties who had escaped the country during the war but had now returned to his family.

Outside, the cow was housed just a few feet from the front door, and the chickens and ducks pecked in the mud near the cows' hooves. The fence that surrounded the front yard was constructed from sticks and brushes to form a rather interesting conglomeration of patterns, but it was sturdy enough to keep the cow, ducks, and chickens in the yard.

I have so many more stories of women that should be told, but I will share just a few additional incidents regarding the nightmares of the Kosovar women. A mother told of the night when a woman with Down's Syndrome was burned to death in her house and the other women of the house taken into the street and their bodies mutilated. Another woman told of having her nipples cut off by the Serbian soldiers. Another story we heard was of the soldiers' gunning down an old woman and a teenaged girl to encourage everyone in one village to quietly board the buses and leave town.

A father recounted his experience of coming to the family compound and discovering the bodies of everyone in the house burned to death, including his fifteen-year-old daughter. He learned that his wife pleaded with the Serbs not to kill the children, but they did so anyway and then killed her. One of the children, just six years of age, hid in a closet, but upon discovering her, the soldiers shot her and then set fire to the closet, engulfing the house in flames. The man sat with his head in his hands, crying as he told the story.

Women were often strip-searched and manhandled and even had their underclothes removed, but even worse was the surrendering of their babies to either be killed or sent in opposite directions from their mothers. Relinquishing possessions to the Serbs could be endured, but separation from family members, especially from the children, caused the women tears of rage and despair. Not knowing whether a husband or father could be among the thousands who already lay in mass graves or whether he might be in another refugee camp was the awful uncertainty a family confronted daily. The more influential people and those

from more prosperous families were targeted for killing first. The Serbs wanted no leadership or resources left among the Kosovar people.

Perhaps the most agonizing sight that I observed was the mass graves of hundreds and thousands of Kosovar people slaughtered by the Serbs. No one knew how many old people, women, and children were placed in the graves along with men. When NATO investigators entered the area in helicopters, they discovered fresh earth and became aware of the massacres. Most of the surviving Kosovar people had left the country and did not know the magnitude of this slaughter. NATO personnel assisted in identifying bodies and removing some of the corpses for burial near families.

I knelt to mourn the deaths of these people as I looked at these massive graveyards. Most of those killed are now buried in individual graves marked with little white crosses all in a row, an endless chain of graves. Even unidentified bodies were placed in individual graves and given the simple white cross to commemorate their sacrifice. Many of the graves were decorated with flat arrangements of flowers covered in plastic to preserve them from the elements. Most resembled bowls turned up side down with flat flowers on moss. I thought, "I cannot bear to see or hear another story," but I did. Over and over again I heard of the ordeals, especially of the Kosovar Albanian women.

The Associated Press in June of 1999 reported the following atrocities committed by the Serbs against the Albanians in Kosovo:

- Villagers in Poklek, a few miles west of the capital of Pristina, reported a massacre in which Serb police officers and paramilitary members herded sixty-two ethnic Albanians, mostly women and children, into a room and threw in a grenade, then killed any survivors with machine guns.
- In Bruznik residents said that a shallow grave held the bodies of at least sixty people, and dozens of large plastic bags near the grave appeared to contain more bodies.
- A mass grave near Dakovica held the bodies of as many as 150 Albanians.

- Twenty charred bodies were found Tuesday in a house in Velika Kruse, a village in the southwest. The burned bodies are believed to be from a mass execution of Albanians.
- British troops reported finding 81 graves behind a gasoline station. The townspeople said the victims died in a Serb killing spree.[5]

Before the war ended, some 90 percent of all ethnic Albanians in Kosovo would be expelled from their homes. Approximately 900,000 were driven across borders, 51,800 of these on foot, and an additional 500,000 displaced in Kosovo. A minimum of 4,600 Albanians were tortured and killed, and throughout the country countless homes were destroyed.[6]

Rape: A Lasting Scar

Rape is considered the most horrible crime that a male can commit against a Muslim Albanian woman; however, the Albanian culture allows no mercy for a woman who is raped, even though she had no means of preventing the rape. This places an unbearable burden upon a woman and is one of the most unjust traditions I have ever encountered. A husband or a woman's family will most likely disown a woman if she is raped.

Even during the war, this stigma was so dreadful that it was thought that many women would not report being raped for fear of being abandoned. The Serbs took advantage of this cultural tradition by using rape as a war tactic. It was a weapon of war, deliberately used as a means to terrorize the nation and intimidate families to leave Kosovo.

A husband expressed his feeling regarding his wife, if she were to be raped, "I could not accept my wife, and she would be dirty, evil, the castle of the enemy." It is most difficult for a husband to accept the reality that his wife has been raped or a family to accept a daughter's having been violated, and some men will take their children to another place to live without their dishonored wives. Occurrences of rape have left a legacy of shattered lives and devastation when families are torn apart by

this crime. As one man commented, "In Kosovo, in our culture, death is better than rape."

Rapes of the Kosovar women took place wherever women were found, when they were in their homes or villages, when they were held in detention, or when they were attempting to escape from their villages. Serbs forcefully entered homes and raped women in front of their families, even their children. Some families were asked by soldiers to produce money or were told that their women would be raped. In some instances, the families reportedly gave the soldiers all the money they had and the women were raped anyway. Other women were taken to temporary places, such as abandoned barns, and repeatedly raped by soldiers.

In the city of Pec, it was reported that six armed Serb men entered a house and raped a twenty-eight-year-old mother. Her sister-in-law witnessed the event and reported what happened: "They were wearing military clothes and had black scarves on their heads. They took my sister-in-law into the front room, and they were hitting her and telling her to shut up. The children were screaming, and soldiers also screamed at the children. She was with the paramilitary for one half-hour. She was resisting, and they beat her, and the children could hear her screaming. I could only hear what was going on. I heard them slapping her. The children did not understand that they were raping her. After they raped my sister-in-law, they put her in line with us and shot her."[7]

In Drenica, according to the 2000 World Report, a group of twenty-seven women were held by Serb paramilitaries in a small barn. One of the women, who was gang-raped by the Serb paramilitaries, was twenty-one years old and pregnant. Here is her story: "They put us in a small barn with hay in it. Then the four men came into the barn and slammed the door and pointed machine guns at us. They asked for gold, money, and whatever we had. We gave whatever we had. But they were still torturing us. They would take a girl, they kept her outside for half an hour, and after that they would bring one back and then they would take another. Then they took me. I was pregnant. I was holding

my son. They took him away from me and gave him to my
mother. They told me to get up and follow them. I was crying and
screaming, 'Take me back to my child!' They took me to another
room. It was so bad I almost fainted. I can't say the words that they
said. They tortured me. Because I was pregnant, they asked me
where my husband was. One of them said to another soldier,
'Kick her and make the baby ABORT.' They did this to me four
times—they took me outside to the other place. Three men took
me one by one. They asked me, 'Are you desperate for you
husband?' and then said that they were there for me instead of my
husband."[8]

According to Associated Press reports from Djakovica, Serb
soldiers allegedly took women from their families to an army
camp where they were held and repeatedly raped. In Pec, it is
alleged that a local Serb commander held women at a hotel and
scheduled times for soldiers to come see the women. Even at
factories as many as 100 women were allegedly being held for
purposes of gang rape.[9] Reports from the World Health Organiza-
tion state that as many as 20,000 women were raped during the
war, and it is estimated that 100 rape babies were born in just one
month.

It appears that not only did the Serbs use rape as a war tactic,
but there is evidence that Albanian soldiers were involved in
raping Serbian women as well. Regan E. Ralph, Director of the
Women's Division of Human Rights Watch, documents rapes of
Serbian, Albanian, and Roma women by ethnic Albanians, includ-
ing the Kosovar Liberation Alliance.[10]

The Ending of the War

Was the war over heritage, religious shrines, and the seeking
of an independent state, or was it over ownership of the billions of
dollars worth of minerals that are in Kosovo? Whatever the reason
might have been for the war, women's rights were violated. This
was evident when the United Nations accused Slobadan Milo-
sevic of the worst crimes against humanity since World War II.
Many, many of these crimes were against women.

It was not until June of 1999 that a peace agreement was negotiated with Milosevic and the Yugoslav officials to accept a proposal of peace. The agreement called for the withdrawal of Serb troops from Kosovo and a subsequent halt to the air campaign by NATO. Refugees were to be returned to their homes and an international peacekeeping force headed by NATO was to head the international peacekeeping efforts. Efforts were made to return the country to normalcy, but it would take a lifetime for the Kosovar people to recover from the emotional scars of this malicious and vindictive war.

The United Nations prosecutors have accused Slobadan Milosevic of war crimes of great magnitude. The prosecution for this genocide case, which is presently underway, is presenting more than 180 witnesses regarding crimes in Bosnia, Croatia and Kosovo, but the trial has been delayed several times due to Milosevic's mental and physical health. Regardless of the outcome of the trial, the horrible scars of war will forever penetrate the hearts and minds of Kosovar men and women.

The Aftermath of War: Women Seeking New Roles

The ravages of the war have profoundly affected Kosovo's Muslim women as they have dealt with rape, the massacre of family members, the destruction of their homes, and the loss of their possessions. The cost is incalculable, and these acidic shadows will linger in their minds daily as they seek some ordinariness to their lives. These women deserve to be treated with dignity and afforded human rights. The devastation of war, especially the Serb's ruthlessness toward women, has highlighted the plight of women in Kosovo, motivating national organizations to address the dilemma of human rights there. Without the glare of national publicity, the plight of these women would have gone unnoticed, as it does in other countries. International organizations like the United Nations are now making an effort to address not only the war issues but also some of the impositions placed on women as a result of the Muslim culture. Efforts to alter the subservient role of women are commendable; however, it will be a long and arduous

process. Perhaps the two factors that most hinder the progress of women in Kosovo are their deficiency in educational skills and the patriarchal culture of men's supremacy.

The quagmire of the postwar era is evident. For some women it is the beginning of a new role as head of the family and possibly raising children alone. It means rebuilding homes and schools and being trained for jobs with only minimum education. It means women seeking employment in nontraditional jobs and shattering the stereotype. All of this takes place in a society without a structured system of laws to prevent crimes or exact significant punishment for those who participate in extortion, robberies and crimes. These crimes are not violations of international humanitarian laws that were agreed upon in 1999, but these are acts by local citizens that have helped to create uncertainty in the country.

Many areas of public policy are being addressed regarding justice for women, such as laws regarding the inheritance of property. It has been traditional that male relatives receive the family inheritance, and this is being reviewed in an attempt to bring justice to women. Also, issues such as the inferior status of women in regard to salaries and employment opportunities are being addressed. Laws will need to be altered to allow women parity with men in employment and property ownership. Empowerment for women will arrive only when they grapple with financial issues that result from equal employment.

Numerous groups are assisting the women of Kosovo. Perhaps the most prominent aid comes from the United Nations, which has created a gender unit headed by Dr. Roma Bhattacharjea. Among the many tasks this group is dealing with is police training for women, considered a significant culture breakthrough for Kosovar women. Police work gives women employment, and an added benefit is that women find it easier to approach a female police officer to report a rape or domestic violence than they do speaking with male police officers. This occupation not only allows a woman to assist her family with their many financial needs but also is significant in assisting her with improving her self-esteem.

Serving as a policewoman indicates that women have begun to penetrate the hitherto-unrealized world of employment in Kosovo, where previously they were considered capable only of domestic undertakings. Some of the leading women activists have requested that the United Nations insure that women are involved in the political and economic reconstruction programs for Kosovo, and only time will tell if this happens.

Another group that assists the women of Kosovo is the Human Rights Watch, which seeks to minister to women who have suffered high levels of trauma due to rape and violence. They encourage women to testify in courts and assist them with witness protection. When these women are testifying at The Hague, for example, regarding the crimes of Slobadan Milosevic, they need protection and assistance in retaining personal legal counsel. It is hoped that not only will Milosevic be convicted for crimes imposed on the Kosovar people, but that the domestic Kosovar courts will prosecute the thousands of soldiers who committed sexual crimes during the war. Human Rights Watch desires to secure justice for women as well as secure aid for their psychological and/or medical assistance.

Dr. Flora Brovina, President of the League of Albania Women, states that a lack of education and entrenched patriarchy are major barriers to change. She says, "Women should not just be a decorative piece in a political party. I want women to have a respectable voice, but their voices will take time to resound. Women have problems distinct from those of men, whether in the house, at work in villages, or in parliament—so women should support women." Slavenka Drakolic of the Network East-West Women has said, "Democracy without women is no democracy."

The expectations are high that women will participate in the political process in Kosovo-wide assembly elections. The international community is supporting women candidates through a series of women-empowering activities, including an organization called "Women in Politics," in which forty female politicians have participated. Other non-governmental agencies, such as the National Democratic Institute, are providing training on public policy and teaching women the process of campaigning. Another

organization is focusing on voter education for women, encouraging them to consider policies on gender awareness as election issues.

Some are advocating the establishment of a Ministry of Women's Affairs in the new government to promote women's advancement, since women's participation in the legal process is minimal. Others are promoting geographical representation so that women at the local and national levels will represent all areas of the country to insure that women are included in the political process. Some are promoting quotas for women. Advocates have cited Sweden and Norway as examples of countries that set female quotas in their parliament, stating that today there are more women in their parliament than the original ratio.[11] The momentum for change is divided between the traditionalists who advocate that women should remain in the home and the modernists who want to move Kosovo's society toward democracy. Change is sure to come to this area, but it will not be easy to alter a way of life that is so entrenched in the culture and lives of the people.

Another organization that is assisting Kosovo women is the Women for Women International, an agency working in areas of the world where women are undergoing social, political, or economic upheaval. This group is involved in Kosovo in such areas as giving information on micro credit loans, teaching courses in family, politics, and economics, and giving assistance with employment. More that 1,000 women have enrolled in seminars such as the one entitled "Renewing Life Skills for Women."

Still another of the helps afforded women is the "Autonomous Women's Center Against Sexual Violence," a counseling phone center based on the feminist principles of psychological counseling. The center, founded in 1993 to assist women who are experiencing fear, terror, and/or pain, offers an avenue to connect women with other women via telephone. This support system attempts to assist women in overcoming fear that has occurred as a result of trauma, primarily war-related. Some of the comments of the women are these: "I am in a horrible fear," "I fear the night," "When the sirens begin, I feel nauseated," "I sleep all dressed up,"

"It is killing me that I cannot work at anything any more," "I feel like leaving this country forever; it is so nauseating," and "New fears are coming." This service has been available for all women, including Serb women, many who have also experienced panic during the war. Serb women feared the bombings by NATO, and the Albanian feared the Serbs.[12]

The World Bank and the European Commission have assisted with funds for vocational schools that will include training women in the area of hairdressing, journalism, farming and raising chickens. There is also a non-governmental organization called the Norwegian People's Aid that is training a group of women to be miners, another first for women of Kosovo.

War is horrible and devastating, yet life must continue, despite the hardships imposed by senseless acts of terrorism. People of the world rallied behind the war-stricken people of Kosovo, knowing they had experienced some of the most horrible crimes imaginable. I stood in front of mass graves where men and some women and children had been executed and bunched together for burial. When families had the bodies moved nearer their homes, it brought some closure to them regarding the horrible acts of war. They now know where family members lay, and they mourn, but they have lifted their eyes upward to hope for a new day.

War is cruel and hurtful, not only to those on the battlefield but also to innocent families that have been scarred both physically and emotionally. Even in the aftermath of the war, I observed more wreckage and heard more shocking stories than I could internalize. I've heard stories of families who have been exposed to behavior that no person should have seen or experienced, especially when it was seen through the eyes of a little child. I observed one of the results of the aftermath of war when I visited an orphanage of beautiful children left without parents. I was told that some of the children's parents were killed and that for others no one had been able to locate their parents due to the forced separations. I could see why the children in the refugee camps clung to their mothers when they saw strangers. The massive graves, the villages with more than half the houses

burned, the fields and tractors destroyed, and thousands of land mines still lying in wait to be exploded—these things still prey on my mind. The agony of these people, especially the anxieties of women, has churned in my soul and penetrated my heart.

War is sinful and damaging. Its effects are everlasting in the lives of women and their families in Kosovo. We can only hope that out of the ravages of this war, maybe, just maybe, a humanizing uprising will begin in their society, but it is so sad that it takes a war to identify the deficiencies in human rights. Can this degradation and the merciless condition of women not be recognized without the horrifying annihilation and butchery of a people?

4

Australia's Aborigines

Meeting My First Aborigines

I STOPPED IN MY TRACKS at the sight that unfolded just twenty feet in front of me. An old man, his lower body draped in a red cloth like a diaper and his black body decorated from head to foot with white tribal designs, sat on a pallet of animal skins sewn together to make a floor covering about the size of a large quilt. The man's murky hair fell in ringlets just touching his shoulders, and his head was encircled with a russet-colored braid adorned with tassels of feathers and ornaments. His mustache was a mixture of black and gray, and his shaggy beard hung down over his protruding belly.

This Aboriginal man was sitting on a street in Sydney on a large paved area adjacent to a park frequented by both tourists and locals, and he spent his days playing assorted native musical instruments and seeking handouts from passers-by. His instruments included a guitar and a hollow wooden instrument called a didgeridoo. Also on the animal skins lay a pair of sunglasses, a knapsack, and canvas shoes. While he presented himself in his tribal costume and played native instruments, he was also making use of products of the Western world. This juxtaposition is seen often among the Aborigines as they seek to preserve their traditional heritage yet are captivated by contemporary culture. This conflict has created havoc for the Aboriginal people.

123

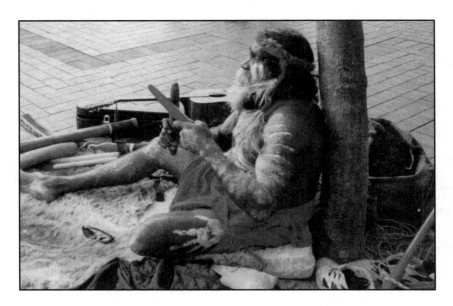

An Aboriginal man plays assorted musical instruments.

The old man, friendly and conversant, was tolerant of my curiosity regarding his people. After I had talked with him several times, he introduced me to his daughter, who arrived one day with her husband and two-year-old daughter. His daughter, perhaps thirty years of age, had long dark hair and chocolate-brown skin lighter than her father's, and she held her child securely in her lap most of the time. Unlike her father, she and her husband were dressed in Western clothes and bore no signs of tribal markings. She was cordial as we chatted, yet reluctant to reveal to a stranger much personal information regarding her life. She represented my first acquaintance with an Aboriginal woman.

Australia—Land of Beauty and Magic

The flight to Australia, "the land down under," was an arduous one; however, even before the plane touched down, I knew that I was going to be captivated by the magic of this great sprawling country. Approaching Sydney from the air was a splen-

Aerial view of Sydney, Australia is incredible.

did event as my husband, Woodie, and I observed the coastal sea lapping at the countless beaches jutting in and out along Sidney's coastline. It was a most striking topography. The inlets, bays, creeks and peninsulas seemed to snake right into the residential areas, giving the impression that most families in this city had private docks for their boats right in their back yards. Australia, I learned, has 12,000 miles of such coastline.

Along the coast of Australia are situated several major cities, vibrant and Westernized, with soaring buildings and massive structures that give evidence to their first-rate economic status. Sydney is probably the best known of Australia's cities, with its Harbour Bridge and celebrated Sydney Opera House. The Harbour Bridge, built in 1932 and nicknamed "The Coat Hanger" because of its shape, towers majestically near the Opera House as it spans the harbor of Sydney. The Opera House, famous with its "arches and sails," was built in 1973 and is considered one of the most popular performing arts centers in the world. More than 2,500 events are held each year at the Opera House, attracting more than two million people with its dazzling artists and events.

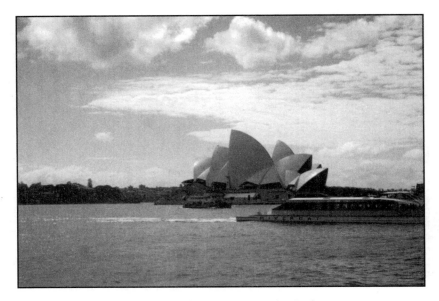

The celebrated Opera House in Sydney
is adorned with arches and sails.

In great contrast to the affluent coastal areas is the Outback in the center of Australia, a land where great plains of deserts and silence hold sway. The terrain reflects an uncouth kind of beauty that lures the adventurous to observe its expansive vistas of red sand punctuated by high mountain peaks and termite mounds. Some of these red sandstone plains stretch 400 miles from east to west with the mountain peaks well over 4,000 feet in height. Visitors to the area hope they do not encounter one of the five or so sand storms that appear yearly. Some of these areas are the driest deserts on earth, except for Antarctica, and temperatures can be dangerously high, ranging up to 130 degrees F, especially in northwest regions. Moreover, sporadic rains come, often in downpours, causing flash floods and great erosion, as evidenced by the awesome gorges in the barren red terrain. This erosion uncovers huge boulders and the ever-present white quartz pebbles, which in turn has unearthed pockets of iron ore, diamonds, gold, bauxite, and uranium suitable for mining.

In addition to its vast desert, Australia possesses huge areas of rain forest and grassland in various regions, which produce a

large number of trees, including the olive green mulga, the willow-like eucalyptus, and the strangely-shaped boab, which can flourish in infertile soil either alone in the desert or as a part of an immense forest. Sadly, 40% of the forest has been cleared in past years for farms or logging, including 75% of the rain forests, which have essentially been destroyed. Removal of the trees has not only produced erosion but has also caused the water table and the salt table to rise. About 4.5 million acres have been lost to this salt seepage.

Among the most astonishing sights in Australia is the Great Barrier Reef. As we flew in a small seaplane from the Gold Coast to the Southern Ladies Island of the Barrier Reef, I absorbed the splendor of the Australian terrain. Woodie and I and two young Japanese couples had chartered the seaplane for the two-hour journey, and about an hour into our flight, I realized that the seaplane was beginning a descent. When I scanned the area below, I could see no water for landing. When we boarded the seaplane, I observed its two floats for landing on water, but I did not see wheels for runway landing. Now, though, we were definitely headed toward land. My heart pounded as I assumed we were headed for a crash landing. I clutched the armrest and braced my feet for the inevitable collision but managed to ask the pilot, as calmly as I could, "Why are we descending when there is no water in sight?" With a smile he said, "We are low on gas, so we are going to make a stop." "But we have no wheels and there is no water anywhere," I said. "We do have wheels," he said, "I will lower them below the floats prior to landing, and we'll be fine." I learned a lot about seaplanes on that flight.

We landed at a small runway and taxied up to what appeared to be a "mom and pop" kind of airport. I was interested to note that a high mesh wire fence surrounded the airport, which I learned was put up to prevent kangaroos from bounding onto the runway. Shortly after refueling, we were airborne again and on our way to our adventure on the Great Barrier Reef.

As we approached the reef area and began circling this naturalist's paradise, we were speechless. Below us were flat bluish islands of coral with turquoise and teal hues, which seemed to lie just beneath the surface of the crystal water. It was a feast for

A view approaching the Great Barrier Reef.

the soul. This natural wonder stretches along the northeast coast of Australia for more than 1,200 miles with some of the reefs stretching out as far as 160 miles into the coastal waters. From the air we could see many of the almost 3,000 reefs that are a haven for marine life and some of the 600 islands that provide a natural habitat for wild birds and turtle nesting.

The seaplane made its descent near the coral reefs into fairly rough waters. Even though the pilot set us down gently, the plane began sloshing about in the choppy waves. Approaching us was a glass bottom semi-submarine boat that would transport us around the area for a close-up view of the reefs. With support from the pilot and the captain of the small boat, we were helped into the swaying boat for an awe-inspiring view of the coral and the marine life abundant in the reef.

Coral, a tiny marine polyp with more than 400 variations, feeds primarily on plankton and grows in warm climates, providing a haven for thousands of sea creatures. Coral thrives in crystal-clear salt water and sunlight but does not flourish in polluted waters, which is one reason it is not found near most seashores. The coral reef consists of both whitish dead coral and the live coral

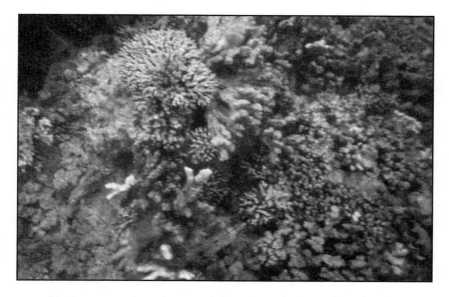

Underwater view of some of the 400 variations of coral reefs.

that glows with an amazing palette of pastel colors. The varying depths of the reef cause the colors to be diffused, thus creating more hues than a field of flowers. The shapes of coral are as varied as the colors, and together they create a majestic underwater world.

Swimming in the coral reef were more than 1,500 species of fish, sea snakes, worms and sea turtles. The fish were of the deepest hues of red, canary yellow, blue, and royal purple, some with stripes and others with dots and intricate lines on their bodies. They varied in both size and shape, some gracefully beautiful and transparent, others grotesque with mouths as large as their bodies and protruding eyes the size of eggs. The fish, snakes and worms moved gently among the 500 species of ragged seaweed that swayed with the breeze as the sea creatures gently flowed past them.

Even though the reef has natural enemies such as the crown of thorns starfish, and natural disasters like hurricanes and storms that stir the sand and seaweed and bring pollution from the coast, the tides and currents do the most damage by sweeping away the

benevolent sediment from the coral. This Great Barrier Reef is an integral part of the sea that is to be appreciated and protected, and it is obvious that man could never have created such a terrestrial treasure and majestic accolade to the kingdom of nature.

Aborigines in a Land of Conflict

Into this region of pristine sea and unconquered land came the Aboriginal people some four to five thousand years ago, representing the longest unbroken culture in existence. (It is the Aboriginal women that are the focus of this chapter). For centuries these people lived freely, sleeping under the stars and living off the land. While inhabiting this immense and sometimes harsh land, they devised their own mythologies of Dreamtime, believing that their ancestors developed and shaped the land. The earth and man became sacred, for they became as one. The Aborigines embraced the concept that creation is the result of their ancestors moving over the land to form mountain ranges, deserts, rivers, rocks, water, and trees, and once that creation was complete, the creators entered the elements. The land, to the Aborigines, is alive with their ancestors.[1]

Then in 1831 the British came to occupy the land. In looking for people to populate this newly acquired territory before either France or the Netherlands could establish colonies, the British Government sent convicts from England to live in New South Wales, Tasmania, Western Australia, and Queensland. Thus, with the majority of the immigrants coming from Britain, most people in Australia today are Anglo-Saxon, although other immigrants have come from Europe and Asia.

The arrival of the settlers and their cattle in 1860 posed a threat to the Aborigines, and that conflict continues today. Settlers referred to the Aborigines as animals, "like dingo dogs" they said as they massacred them. The Aborigines retaliated with spears, which were, of course, ineffective against the British guns. It has often been told that the British settlers even attempted to eliminate and undermine the race by giving the Aborigines blankets infected with smallpox and raping their women, forcing the men

to watch. With these actions, the settlers were successful in humiliating them and confiscating large portions of the sacred Aboriginal Dreamtime land, creating an untenable situation for these self-reliant and carefree people.

As years passed, the Australian government took the position that the Aborigines with their nomadic way of life were inferior and incapable of adapting to the white culture and, thus, were declared wards of the state. This attitude developed primarily because the Aborigines lived in squalid conditions, wandered aimlessly without holding paying jobs, and appeared to lack aspirations for improving their status in life. The common Australian belief was, "They live on governmental handouts, receiving free rations for doing nothing." One Aborigine described their plight as "living on crumbs from the white man's table." Resentment swelled within the Australian white communities regarding the handouts given to the Aborigines, and this resentment is still evident today.

Although the Australian Government is legally responsible for the welfare of the Aborigines, the individual states of the Australian Commonwealth administer projects for the people. With varying opinions concerning the Aborigines apparent within the country, it is clear that these programs are often administered unevenly and ineffectively.

Not until the 1960s did the Aborigines acquire full citizenship rights. Prior to that, they were not recognized as citizens and so were unable to vote, own land or purchase alcohol. Even after being granted citizenship rights, they were and are still considered second-class citizens. Prior to 1960, if a white man lived with an Aboriginal woman, it was considered a punishable offense, yet white men could sexually exploit the Aboriginal women with no retribution. The subordinate role of the Aborigines was highlighted in 1957 when Albert Namatjira, a member of the Aramanda tribe in Alice Springs, became one of Australia's best-known artists. His exhibitions were enthusiastically received and his paintings were sellouts, yet he could not own a home. Because of public outcry over his lack of civil right to purchase property, the government finally granted him and his wife citizenship.

They became the first Aborigines to be granted such status. He was even allowed to buy alcohol; however, when he served the alcohol to his friends, he was charged with breaking the law and placed in jail. He died soon after being released from prison in 1959. Following the publicity of Namatjira's abuse, Australian citizens demanded additional laws giving Aborigines civil rights.

With this publicity regarding Namatjira and a growing awareness of the plight of the Aborigines, the Australian people became aware of the social injustices the Aboriginal women and men had been subject to. Gradually, as the Aborigines began to be granted civil rights such as ownership of land, they began to regain access to the land indispensable to their Dreamtime worship. On the west coast, where the Aborigines once had 8,000,000 acres of land, their acreage has been reduced to 308 acres. Without privileges to their ancestral land, the preservation of their culture and religion was threatened, which could mean extinction for the Aborigines.

It was thought by many that the Aborigines would be assimilated into the Australian culture and would eventually lose their distinction as a separate group, but that has not happened. In fact, the Aborigines are growing faster than any other segment of the Australian population. In the minds of old Aboriginal people, who are the keepers of the stories of their existence, they and their land are inexplicably coupled, and as their access to their ancestral lands grow, so do their people and culture. Nevertheless, racism is still present in the treatment of the Aborigines by the white Australians.

Australia, which is about the size of the United States, has a population of approximately 20 million, including 16,000 Aborigines. Thus, Aborigines are only a small fraction of the "multiculturalism" of Australia. There is great diversity among the overall population with 22% of the population born outside of Australia. The government calls for people to maintain their own cultures in a peaceful way, and most do so in spite of their diversity. Violence with rival groups is not allowed.

Various explanations are offered as to why Australians have been unsuccessful in assimilating the Aborigines into the present Australian culture. The major factors are their inadequate educa-

tion, lack of vocational skills, insufficient social development as deemed by a white society, perceived lack of ambition and motivation, insufficient managerial skills, and their confrontation with a highly racist Australian mindset. Indications are, however, that the Aborigines desire for Australians to respect their culture, including Dreamtime. The Aboriginal people roam freely and live under the stars and worship as they choose; however, many want to enjoy the comforts and benefits offered by the government.

The antagonism and hostility between the Aborigines and the white people of Australia is never-ending, primarily due to their cultural differences. As the Europeans arrived, they dammed the rivers, mined the natural resources and cleared the land for grazing and growing crops. The Aborigines accused the Europeans of driving their Dreamtime ancestors into oblivion and spoiling their resting places. Today the struggle continues, and the courts now decide land rights. Far too often, land developers, mining companies, ranchers, and farmers seem to feel that their rights are abdicated in favor of the Aborigines. Two major judgments of the High Court of Australia (1993 and 1997) ruled in favor of the Aborigines.

Pauline, a young Aboriginal girl, was sent to a government girl's school where she lived until she was eighteen. "The whites tried to make us be like them," she said. "Today we must still fight to retain our identity, our language, and our pride in who we are. The white government is still trying to assimilate us, to make us disappear into their world. Please try to fathom our great desire to live in a way somewhat different from you."[2]

J. T. Patton, an Aboriginal man who founded the country's civil rights movement, said, "Our self-respect has been taken away from us and we have been driven toward extermination. We have been called a dying race, but we do not intend to die. We intend to live, and to take our place in the Australian community as citizens with full equality. The white family must be made to realize that we are human beings, the same as themselves. We do not wish to go back to the Stone Age. And we don't want charity from the white people; we want justice. We intend to work steadily for this aim, no matter how many years it may take."[3]

Dreamtime—The Aborigines' Religion

Dreamtime is thought to be the oldest continuous culture/ religion in existence. It involves the merging of the ancient past and present and living in balance with nature. This concept embraces the spirits of the Aborigines' ancestors, whom they believe inhabit such natural elements as trees, rivers, animals, and rocks. They listen intently to the various languages of the natural world of wind, fire, rain, sun and moon, rocks, and water and see marks of Dreamtime in the land, its form, a trail or even a watering hole.

Their concept of creation is that creatures came from the sea and formed life. Man and animal were interchangeable; men were made into animals and animals into men, and men were embodied into stone. They believe that people are free and good and live in total harmony with the land. It is deemed inconceivable for Aborigines to destroy any portion of nature, for they live in unity with all, both inanimate and living matter. In losing even a part of their land, they presume that part of their life has been squandered. As they move about the land, they often sing songs

Aborigines believe the creator enters the elements.

that correspond to landmarks, such as mountains, rocks, or watering holes, which they believe were created by sky heroes in their ancestors' time. They follow paths called "songlines," where they believe their ancestors walked.[4]

Their core religious meetings called "corroborees" are times in which they sing ritual songs, dance, and tell stories. It is here that the Dreamtime concept is passed on to the next generation through the sharing of stories; however, they are cautious about maintaining the secret rites of Dreamtime. Singing, dancing and clapping accompanies tribe members playing didgeridoos, which are tubular horns of varying lengths and tones made from tree branches hollowed out by termites.

To an Aborigine, a sacred site is a story or a song that should be passed to others. Hence, an Aboriginal may "go bush," go into

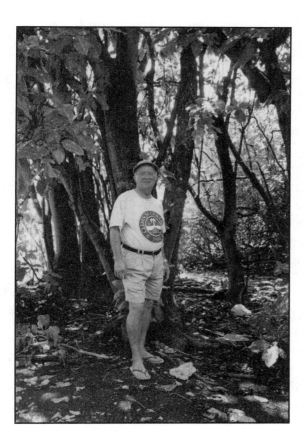

Woodie follows sacred trail of the Aborigines.

nature to gain sustenance from the swamp, the sky, the silence of the forest, the song of a bird, the whisper of the wind, or the strength of a rock. A mountain may become an eagle or a trail may become the coiling path of a serpent. Nature, they believe, can heal and restore one's body and soul. Dreaming defines a person and his clan. An Aboriginal elder from Injinoo tells of a sacred place where he can "go bush." It is a ridge from which he can see the beach with waves frothed by stiff winds. "I was born under that tree," he said, "that coconut palm. And when I was born, my mother took the placenta, wrapped it in wax and buried it there."[5]

Preserving the sacred land of the Aborigines is a political topic, which is very difficult for the government to resolve. This land is an economical asset to miners and developers, but when ancient carvings, painted figures and symbols of Dreamtime are present on caves, rocks and mythical poles erected around graves, the government must decide whether the Aborigines do have legal rights to the area to preserve their heritage.

With the arrival of Europeans came Christianity and the building of churches, some of the first buildings in Australia. These settlements provided the stage for the predominant religion of Australia today, Christianity. Though 27% of the people are Catholics and 23% Evangelicals, about 30% are agnostic or atheistic. Some but not all Aborigines follow the Dreamtime religion. Many of the immigrants have brought their own religions, so Islam and Buddhism are also present. Devotion to religion appears to be on the decline with Australians. The oath of allegiance can be made to either God or to the flag in special ceremonies. Effort is exerted to see that discrimination is not shown against anyone because of one's religious inclinations, but one ponders if this includes the Aborigines.

The Struggles of Aboriginal Women

When the European settlers arrived in Australia, they always sought the Aboriginal men's views rather than the women's views, and that practice remains in effect today. Even if an issue relates to the Aboriginal women, it is the man whose opinion is

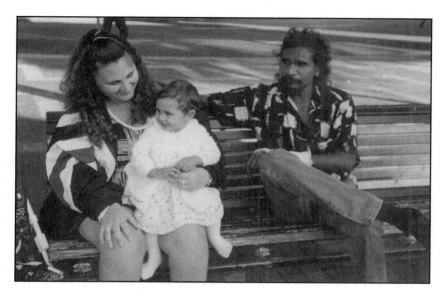

An Aborigine family.

asked. The women are almost non-entities in their society, without a voice to adequately express their view regarding ill treatment, housing, education, or health.

Little progress is made toward helping the Aboriginal women, it seems, since most individuals in influential positions are unsympathetic toward the Aborigines, especially the women. With the Aborigines representing such a small percentage of the population, they have few advocates, and their welfare seems inconsequential compared with the larger picture of economic development in the country.

Aboriginal women are often abused. An article in the *Albany Law Review,* Spring 1997, discussed a case of domestic abuse. In the report, the sounds of fighting could be heard throughout the camp, and the Aboriginal woman ran towards a nurses' quarters, blood pouring down her face and one arm hanging limp, her male attacker in close pursuit. As the nurse struggled to open her door to the woman yet exclude the attacker, she read on the woman's T-shirt, "We have survived 4,000 years." The nurse wondered, "Yes, but will you survive the next forty years?"[6]

In 1993, however, the Western Australia government initiated the Chief Justice's Task Force on Gender Bias for the purpose of investigating prejudice toward Aboriginal women. This task force studied such issues as women's limited access to the court system, their imprisonment for non-payment of fines which happens more than to any other group, and the significant communication and language problems between these women and police. The focus was specifically designed to offer recommendations to the courts, resolving dispute resolution, family violence, restraining orders, access to legal advice, service and police relations. Although this report was presented to the Western Australian government, funding to implement the recommendations was lacking. It becomes apparent that the prevailing philosophy is to ignore the issue and hope it will disappear.[7]

Aboriginal women are over-represented in the prison population. The Australian Law Reform Commission in 1994 stated that 14% of male prisoners and 18% of female prisoners were Aborigines, when the population of Aborigines is less than two percent. Another issue is the harassment and mistreatment of women while detained in police custody. The women, according to studies released, state that sexual abuse occurs by police, even to the point that police officers detain women at bars and offer them to males for sex.

Aboriginal women are also abused by the men in their families, but when confronted, the men's attitude is, "This is tradition." They discourage the women from making complaints to the police for fear of "shaming their communities." Often the greatest violence occurs when the men are drinking heavily and sexually abuse the women, as well as attacking them with knives, stones, and hammers, sometimes fatally. There is much evidence indicating that the Aboriginal males use force to maintain male dominance in their relationships with women.

Elspeth Huxley in *A Journey Through Australia* describes the behavior of young Aboriginal girls in a town called Silverton, where they "live like rats in a rubbish dump. People come out here from Broken Hill on weekends. You wonder why. Then you see part of the answer in the shape of a young aboriginal girl, coming in to buy wine. Slender, smooth-skinned, firm-breasted, she car-

ries the flagon with a swagger. They're finished when they are twenty, you know. A bottle of brandy is the usual fee for a girl's weekend services."[8]

Penelope Andrews writes in the *Albany Law Review* of the "desperate struggle for survival of the Aborigines," saying, "but for the women it's a struggle that has greater urgency. Their subjection has reached epidemic proportions. They suffer because of their race, gender, the after-effects of colonialism, the minority status of Aboriginals, the unequal access to societal resources and consequent unequal development of Aboriginal Communities."[9]

My own observation confirms her view of the dilemma of the Aboriginal woman. Winsome Matthew shares the story of what happened to her sister more than twenty years ago. Winsome was seventeen years old when her sister gave birth to a little girl. While the baby's mother and father were drinking to celebrate the birth, the father requested that they go to a party. When the new mother refused, he began to beat her violently and she fell, hitting her head on an object. The young mother died, even while numerous people observed the incident and did not intervene. Whether the blows to her body or hitting her head on an object caused her sister's death was not known, but the incident was never reported to the police, and the three-day-old girl was placed in the care of her grandmother. Recently, when this girl celebrated her 21st birthday, Winsome felt it was time to reveal the incident. "What happened to my sister is nothing compared to what goes on out there every day," she said.[10]

An eighty-year-old man in Kowanyama, an Aboriginal community of about 1,200 people, tells this story, "When I was six, my mother was captured, raped, chained up and they shipped us (her children) away. I remember my mom on the jetty, crying over (our) footprints in the sand. The only trace left of her children. I lost her (my mom) forever."[11]

The Domestic Side of the Aborigines

The contrast between white Australian's existence and that of the Aborigines is major. For the white Australians, nine out of ten

live with their families in cities or towns with 70% of the people owning their homes. Their houses usually consist of a single-level home with manicured yards, boasting swimming pools or having a nearby community swimming pool. With prevailing warm climates, swimming, cricket, and football are the favorite sports. The size of their families appears to be declining. As I traveled to various areas, I asked to see where poor white people lived, and it appeared to me that ample quality housing was available for most of those in the cities.

In contrast, the Aborigines may live in a dusty lean-to house built of broken junk, supported precariously by an oil drum, or in a hut built on short stilts and painted in pastel colors. Others say their "hat" is their home, while some may say, "I don't want to live anywhere else but in nature because I put my trust in my ancestors." Some Aborigines are considered "fringe dwellers," living on the outskirts of the cities. In some regions such as in the wetlands and scrub forests, their houses may have corrugated metal roofs and have no electricity. Even when the government provides housing for the Aborigines, some choose instead to sleep under the stars and use the house for storage or make use of it only when the weather turns cold. In addition, although they're provided homes, many have not learned how to care for them.

For many Aborigines, pastimes include drinking, smoking tobacco, playing cards and sexual activities, although sports activities have been initiated to help fill the void left by long ritual ceremonies and dances. Some women, according to reports, prostitute themselves and drink alcohol along with the men. There is a prevailing belief that most of the Aborigines have not developed the ability to control their drinking or manage their money and thus live in destitute circumstances.

Some of the complaints by the white Australians are "the Aborigines have no ambition, are unreliable, and when you need them to work they may 'go walkabout,' or they may go to town and drink until they land in jail." Others will say their lifestyle is ingrained. In addition, there are problems such as juvenile delinquency, infant mortality, disease, and premature deaths. Aborigi-

nes in general live twenty years less than other Australians, and infant mortality is double the national average.[12] Some or many of these problems, it must be said, are exacerbated by the Aborigines' lifestyle.

Many of the Aboriginal women go barefooted and wear soft cotton dresses or loosely-fitted skirts, but others work in the villages and wear cool sporty clothing with sandals. Some cook fish, wild animal meat, or birds over an open fire, but many have moved to the city and forsaken their nomadic tradition of gathering roots, nuts, worms, alligator eggs and larva for food. They will sew their dresses from materials they have purchased, quite a contrast to the sewing of possum skins in the days of their ancestors. The mornings will find women sweeping the dusty ground outside their homes where their children play, oftentimes one child with dark skin and another with white, an indication of a white father.

For over a hundred years, some attention has been given to the education of the Aborigines. Mission schools provided some early training, but due to lack of funds and unqualified teachers, these schools were not very successful. In the 1920s the Australian government forced most Aboriginal parents to give up their children for placement in orphanages, children's homes, or church missions for their education. The hope was that the Aborigines would forget their nomadic lifestyle and eventually become assimilated into the Australian culture. This period has become known as the "stolen generation." Once the children were removed from their homes, many never made contact with their parents again. This action is one that some Australian citizens have asked the Aborigines for forgiveness for, but the government officials refuse to offer a formal apology.

The establishment of fourteen outstations today facilitates education and health care for the Aborigines in the bush or permanent camps scattered throughout the Outback. Here teachers visit periodically during the year to teach Aboriginal children living in the area, and nurses are flown in at set intervals to provide medical care for the children. In the towns and cities

children received a more standard education. More Aboriginal young women have begun studying and entering the professions as teachers, social workers and nursing.

While a few Aboriginal women pursue vocational training, others are homemakers. Amidst the flowering trees and bougain-villeas at a small park in an Australian village, some of the home-makers and their children come to socialize with one another while their older children are in school. It is a two-mile walk from their home in the desert to the village, but that is a small price to pay for companionship with friends. Mostly, these women are unwashed and overweight and wearing dirty, worn dresses, but their brown faces usually sport friendly, generous smiles. The color of their children ranges from white to brown to black. The white people no longer come to the park because they say the women are dirty and carry diseases.

The Aboriginal men who work on the large ranches are called "stockmen," and they are mostly half-breeds, with one parent black and the other white. These lounging horsemen wear slouched hats, heeled boots, tight jeans and low-slung belts and

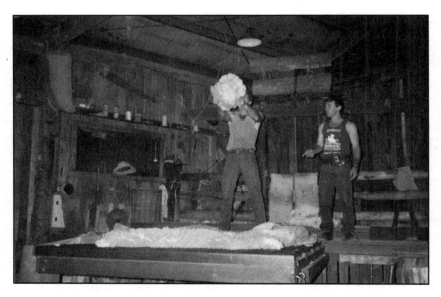

Men working with sheep's wool.

usually have a cigarette dangling from their lips. Work is usually available for the Aboriginal men, but with their desire to pursue their own culture, working is not always a priority. The government will provide subsidies for them, but there can be no "sit down money." They must work to receive money by employment such as working in stores, repairing houses, and working on the roads.

The Aborigines have their own unique language, much of it related to their relationship to the earth. There may be as many as fifty words to describe a color and ten to fifteen to portray the sky. There were over 250 Aboriginal cultures, each with its own unique language, when the Europeans arrived, but today only 100 languages are spoken and most of those are close to extinction. English is the common language of Australia, but it does include many Aboriginal words, especially the place names. The children usually speak the tribal language and learn English only when they begin school, which inevitably puts them behind other children.

The Aborigine women lack adequate health care, especially when they live in the bush country. There are home treatment kits with medicines such as sedatives, antibiotics, tourniquet and even forceps provided for the Aborigines, and flying services provide emergency transport to hospitals in cities. Although missionaries began medical air services many years ago to bush country, these services today are still inadequate. Some of the problems women deal with are ear infections, scabies, boils, syphilis and diabetes. With limited fresh vegetable and fruit, their diet is insufficient to prevent some health problems. Rural stores have sweets and canned foods and staples but not fresh foods. The women who live on the outskirts of towns fare somewhat better with food selection and medical services.

Dingoes and the "Two Dog Night"

The "dingo" is a wild Australian dog, which has long been associated with the Aborigines. It is believed that the wild dogs were brought from Asia when the Aborigines came to Australia

some 5,000 years ago. The dingo, also referred to as "wild wood," is an obstinate dog to tame; yet the Aborigines have formed a unique association with it. The dogs are featured rather prominently in Aboriginal folklore, such as the belief that a mythical dingo called Mamu captures and eats the spirit of any child who may wander away. Some tribes have adopted the howl of the dingo as a lamentation for the dead. The government has made a concerted effort to eliminate the dingo, but it continues to exist in the wild.

On cold winter nights, the legend says, dingoes are used as blankets for warmth as they sleep with their owners. If it is a freezing desert night, it might be called a "two-dog night," meaning that the family or individuals needs two dingoes to keep them warm. Folklore says that the Aborigines and the dingo have lived together in such harmony that dingo pups have been found nursing Aboriginal women. However, it is not known if any truth lies in the story.

Other animals that have an impact on the Aborigines are the marsupials—the kangaroos, koalas, wombats and possums—animals carried in their mothers' pouches for the first part of their

Kangaroos possess a powerful kick and can run 30 miles an hour.

lives. Woodie and I took a safari trip to the Blue Mountain Wilderness to observe animal life and walked within a few feet of kangaroos. We were able to take close-up photos of kangaroo mothers with their joeys resting in their pouches. The babies are only about an inch long when they are born, and soon after birth crawl up their mothers' bodies and into the pouches to nurse for many months.

We observed the red and gray kangaroos, the largest and best known of the kangaroos, as they ate in the forest and grasslands. We watched them use their powerful hind legs to run and were amazed to learn that they can clear up to forty feet in a single bound and reach speeds up to thirty miles per hour. We observed them resting during the day, grazing, and occasionally using their powerful hind legs to scuffle with one another.

My favorite of all the animals was the koalas, which look adorable and cuddly but, I learned, can be cantankerous. As I posed for a photo shot beside a koala, I was warned to keep a fair distance to avoid being bitten or scratched. Koalas are nocturnal creatures and eat only eucalyptus leaves. They, like the kanga-

The nocturnal Koala bear, cute but cantankerous.

roos, live in their mothers' pouches for months and afterward ride on the mothers' backs until they are able to survive on their own.

Another group of animals is the monotremes, which includes the duck-billed platypus. These water creatures with webbed feet have a mouth shaped like a duck's bill, with furry bodies and a flat beaver-like tail. They lay eggs and yet suckle their young. Other wildlife that fit into the natural environment of the Aborigines are wombats, emus, snakes (such as the brown taipan and the green python and death adder), poisonous spiders, hopping mice, birds (such as the sulfur-crested cockatoos), bee-eaters, golden-shouldered parrots, as well as crocodiles and goannas (iguana-like lizards). Some of the species among these wildlife creatures have become extinct due to disease and the introduction of the buffalo, cats, dogs, foxes, donkeys and camels into the natural life cycle.

Being able to see some of these indigenous animals was breathtaking as we traveled inland to the Blue Mountain Wilderness. Walking in the leafy shadows of the forest, hearing a riot of birdsongs and caws, I could almost relate to the Aborigines' belief about the significance of possessing the land. It was a peaceful experience as we listened to the sounds of the forest filled with swaying ferns and exotic plants. It is heart-rending to think that in the past 200 years more than 90% of the rain forest in Australia has been lost, that species are becoming extinct and the exotic plants no longer have a home. As we sat to eat our lunch, we could hear the cockatoos shrieking and the kookaburras and other birds chanting in their natural surroundings. The sheer cliffs hanging with wildflowers and the rugged mountains with their unsurpassed loveliness reminded me of Dreamtime. The famous Three Sisters, a giant rock formation towering over Australia's Grand Canyon, was probably a concept of Dreamtime, which, in the minds of the Aborigines, merges the ancient past and present, living in balance with nature.

The Aborigines' Spiritual Expression Through Art

While in Australia I purchased two pieces of Aboriginal art, which I appreciate daily. The art is symbolic of my observations of

the Aborigines, but to the Aborigines it is a sacred component through which they are able to communicate their spiritual commitment to Dreamtime. It symbolizes a part of their culture which connects them with nature and their heritage. Since their heritage was not recorded in language, it has been portrayed through carvings and paintings on rocks and cave walls, and some of these works of art are believed to be five thousand years old.

Their art subjects include sketches of trees, animals, people and spirits and are drawn largely in reddish ochre and charcoal. When Europeans came, they added ships and guns to their art, and later subjects such as grasses, hands on stone, and men spearing animals became popular subjects. Following this period, the x-ray style became prominent and continues to exist today. The x-ray type of art, for example, depicts the picture of a fish with its internal organs painted on top of the fish. That is the theme of the art that I purchased. One of the pieces is a conglomerate of circles and lines, plus fish (presented in x-ray style), turtles, snakes, ostrich-like fowl, koalas and stick men, all portrayed in dazzling, cheerful colors.

Not only is art an inspirational medium for the Aborigines recalling their culture, but it also represents their hope that through sharing their art with others, a platform will be created for confronting social issues such as reconciliation between the Aborigines and the white Australians. When viewing the art, people often ask questions about the Aboriginal culture, and the artists have the opportunity to share information regarding their people, their hopes, and their lives. The artists also believe those who buy the art experience some empathy with the Aboriginal people when they understand a story or a song that is depicted in the art. In developing an understanding of their culture, one comes to a deeper appreciation for their people.

Aboriginal art is now considered as some of the world's greatest art treasures. Among the most well known artists is Albert Namatjira, mentioned earlier in this chapter. He developed new techniques for the Aborigines' art by using watercolors in his depiction of Dreamtime themes and the sweeping plains of Australia. Other mediums now used for painting include tree bark,

canvas, paper and cardboard. However, even though the "canvas" may consist of more contemporary mediums, the Aboriginal artists always connect their subjects to their heritage and Dreamtime.

Women Who Have Made a Difference

To be successful in sports in Australia usually means being white, thin, and healthy. Very few Aboriginal women could meet these criteria, for they typically come from environments which limit their opportunities in athletics. Most are practical, down-to-earth women who are neither slim nor beautiful by white standards. The following Aboriginal women beat the odds.

YVONNE GOOGLONG CAWLEY excelled in tennis and became Australia's champion in 1974, 1975, 1976 and 1977. She was the first Aboriginal tennis player to win at Wimbledon, winning in 1971 and again in 1980. Often referred to as the most graceful female tennis player, she won the French Tennis Championship in 1971 and was also runner-up for four years in the United States Tennis Championship. Contrary to stereotyping, Yvonne is a slim and attractive light-skinned woman with powerful strength and determination.

CATHY FREEMAN has also brought honor to her people and her country by winning an Olympic silver medal in 1966 for the 400-meter in Atlanta, and the next year winning an Olympic gold medal.

JOANNE NANGA has gained worldwide respect for her acrylics on canvas, as well as her artwork on didgeridoos, boomerangs, emu's eggs, and music sticks. Joanne was one of the Aboriginal children taken from her parents to become a ward of the state, and after her father discovered her location, he seized her and returned her to their family. Most of her childhood they traveled in a caravan with her father as he pursued roadwork in Western Australia. Joanne was fortunate in having an artist mother who taught her early how to paint, and today she sells her art in Sydney and Melbourne, as well as Holland and Germany. She paints scenes from the bush country and remains loyal to her

heritage. In 1996, she was awarded Australia's Indigenous Creations Gallery Best Female Artist.[13]

OODGEROO NOONNUCCAAL (Kathy Walker) is the first Aboriginal writer to be published in Australia. Her name means paperbark, which is a small tree indigenous to Australia. In 1988 she took a stand against the celebration of the bicentennial of the white settlement in Australia. As a strong advocate for her people, her motto is "Don't hate, educate." Her three sons have established the Couran Cove Island Resort at South Stradbroke Island near Brisbane's Moreton Bay, which aims to preserve the natural beauty and preservation of Aboriginal culture. Here one can see performances and share in ancient Aboriginal culture.

Hope or More Suppression

Although the history of Aboriginal women has primarily been one of suppression, some strong matriarchal families have made their impact on the culture of the Aborigines, and there is hope that more of these strong women will step forward to intervene for their sisters. With the passage of the Sex Discrimination Act and the Affirmative Action for Women Act, which address violence, pay equity, and other issues, there is some optimism for lessening the problems of Aboriginal women. However, progress is ever so slow. In various villages justice councils, composed of community elders, have been established to deal with offenders, which has aided in the alleviation of some of the abuses of Aboriginal women and the lessening of juvenile delinquency.

Aboriginal women's needs abound, the major ones being

- To discover how the democratic process can be utilized for liberating them from life-long oppression by teaching women how to register to vote and become informed about political candidates who support Aboriginal women's causes.
- To work for improved housing and become good caretakers of their possessions.
- To seek a quality education and vocational training to enter the work force.

- To encourage the Aboriginal men to develop more positive attitudes toward their spouses and other females to prevent male violence and ill treatment.
- To become involved in seeking reconciliation with the white population which subsequently will lead to affirmation for the Aboriginal women's causes.
- To become a strong advocate for an appreciation of Aboriginal culture.
- To acquire skills in parenting, education and training for their children.
- To develop a self-determination to take control of their lives.

Today the effort of the government to assimilate Aborigines into the Australian culture is at a minimum, perhaps non-existent. Now the government has concluded that the honorable and just procedure is to honor the Aborigines' Dreamtime culture and make efforts to protect their ethnicity. Though improvements are being made regarding the redistribution of land, these days continue to be wearisome times for the Aborigines. In 1992, when the High Court ruled that indigenous people could claim and gain title to their previously occupied land, a great obstacle to maintaining their Dreamtime mores was removed. In some areas five to thirty percent of the land would be reclaimed.

Although the struggle will continue with the miners who want to remove minerals from the land, the Aborigines have the right to be custodians of a portion of their ecological heritage. Along the eastern coast, nine million acres will be given to the Aborigines to manage as a result of the creation of the Cape York Peninsular Conservation Zone. This distribution of land will not solve all of the Aborigines' problems, but it is a beginning in mending relationships between blacks and whites.

There is sufficient evidence to indicate that some of the Australian people have developed and are developing an authentic appreciation for the Aborigines. Though prejudice cuts a deep swath for most of the populace, there are those who openly state their regrets for the government's handling of the removal of children from their homes in the 1920s for assimilation into the

Australian society. Scars run deep and resentment does not lessen for many; however, many believe that a statement of apology from the government would facilitate reconciliation. That is a dream for the future.

Dreamtime endures for the Aboriginal people. The Aboriginal women are survivors as well, but still suffer at the will of Aboriginal men and the Australian society. I believe that the Aboriginal men will fare much better in modern Australia than will the Aboriginal women unless there is a deliberate effort by advocates, not only in Australia but worldwide, to support the Aboriginal women's rights. As the numbers of the Aboriginal people increases, so does the number of women oppressed by their society. The men say they feel their "ancestors spirits" returning to their homelands as they gain land rights, but will this spirit bring independence and free will to women in the same manner? I fear not.

5

Guatemalan Women— Slaves to Tradition

I TREMBLED AS I STOOD AT THE RUINS OF LAS CAPUCHINAS, a Catholic convent constructed in 1736 in La Antigua, Guatemala. Even though the day was windy and quite cool, my uneasiness was not due to the weather but was the result of what I was hearing from an unofficial guide regarding the treatment of the nuns who resided in this convent during its early existence. This most captivating colonial site, now only partially intact, had circular sections with small rooms surrounding an open patio. It is believed that the convent had running water for the nuns living area and indoor toilets; however, it also had rooms where nuns were placed in solitary confinement when rules were broken.

I stood near the Tower Niche, part of the remains of this crumbling convent, and observed an indentation in the exterior stone wall of the building about two feet deep and three feet wide. At the top of this indentation was a small opening which was used to facilitate water torture. There was also a dungeon below the nuns' living quarters where accused nuns were placed two days prior to their death by water torture. Their crime, we were told, was sexual contact with a priest who made contact with nuns through a secret underground tunnel connecting the nearby monastery to the convent. When one of the nuns became pregnant, her sentence was death by water torture following the birth of her baby. If the baby were a girl, then she would also be put to death, but if the baby were a boy, he would be allowed to live.

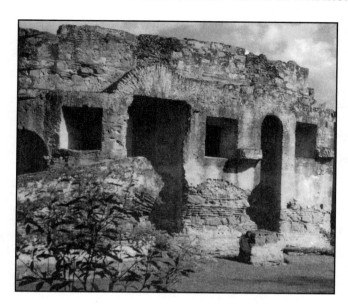

Ruins of Las Capuchinas, a Catholic Convent.

What was the fate of the priest who impregnated the nun? It was the woman who was punished for such sexual encounters, and the men assumed no responsibility. Although I have no written confirmation of this double standard, several individuals in Guatemala confirmed the validity of the story to me.

A Land of Contrast

I was in Guatemala to assist with mission work among the children and to learn about the plight of women in this lovely country, which is located south of Mexico and north of Honduras, the Pacific Ocean to the west and the Atlantic Ocean to the east. In between these oceans lies a country smaller than the state of Tennessee, filled with a wide diversity of topography—virgin jungles, chilly alpine plateaus, rain forests, desert valleys, and lush green hillsides. Its population is larger than any other Central American country with seven to eight million people, and it has the largest city in Central America, Guatemala City. Guatemala is the only country in Central America that has a predominantly Indian population, mostly descendants of the Mayan people and often referred to as Indians or the indigenous people of Guate-

mala. Guatemala City, at some 5,000 feet above sea level, is located near the central part of the country and serves not only as the capital of Guatemala but also as its industrial center.

The name Guatemala has several possible meanings and derivations. It may have come from the Aztec word describing the country as the "land of the trees" or "mountains vomiting water," but others say its name means "the Land of Eternal Spring." The latter two descriptions refer to the eruption of water rather than lava from Aqua volcanoes during earthquakes.

Guatemala is a country with variations of temperatures, depending on the altitude; however, in general the temperatures are mild and the climate tropical. The country is divided into three main regions: the Northern Plain, the Highlands, and the Pacific Lowland. The Northern Plain is sparsely populated and is disadvantaged in its economic development. This area has many hardwood trees, including the tree that produces a gummy substance called "chicle," which is used in the manufacturing of chewing gum. There are also lush jungles as well as substantial areas of grassland for raising cattle. Also in the Northern Plain, amid tropical forests, lie the famous ancient Mayan ruins, Tikal, which is a favorite tourist attraction. The Highlands consists of a series of mountains across Guatemala that lie in an east-west direction and is known for its many volcanoes, some of which are still active. Many Guatemalan people live in this earthquake-prone area, growing coffee and corn, while others live in Guatemala City and are involved in occupations related to factory and commercial work.

Most Indians live in the Western Highlands while most Ladinos or Mestizos (mixture of Indian and European races) live in the Eastern Highlands. The Pacific Lowlands are densely populated with forest and farmlands where cotton and sugar cane are grown and cattle are raised. Many of the people here are destitute due to the lack of employment and insufficient water.

Early Mayan Civilization

The Mayan Indians and their mother civilization, the Olemec, are considered one of the oldest civilizations in the Americas. The

Mayans, who are thought to have originated in the Northern Plains of Guatemala, developed an advanced civilization as early as 250 AD. Numerous cities were connected with paved stone roads and bridges, and there was a social order with powerful priests at the pinnacle, followed by the noble class, who lived elegantly. At the very bottom of the social order were the farmers and slaves.

These ancient farmers lived a hard, generally inflexible life, growing food for the upper classes as well as for themselves. A woman on the farm experienced a grueling life. Her day began early with the building of a fire in her mud hut to prepare tortillas for the family breakfast. Then, well before the birds began to sing or the sun rose over the horizon, she and her family began trekking out to the fields, where they labored throughout the day, even when the temperatures were so high that one could almost hear the sound of the heat. Late in the day she returned to the hut to prepare her beans, squash, or corn for the family's evening meal and attend to the routine chores that belong only to a mother. Life was hard and cruel, especially for the women of the family.

Some details of the early history of the Mayans, a culture dating back to the third century, can be determined from the stone reliefs in Tikal, the capital of this early civilization. The population of Tikal was at one time as high as 100,000, and it is here that one can observe Mayan drawings such as warriors with spears, and writings such as descriptions of the Mayan social system of theocracy and militarist rule. In this area also are traces of pyramids, an acropolis, and temples constructed of limestone where people worshiped gods of the sun and rain and other elements of nature. There is good evidence to show that, not only at Tikal but in numerous other large cities as well, highly developed civilizations existed in this Northern Plains region even before Columbus came to the Americas.

It was a horrific day in 1524 when the Spanish appeared to conquer and enslave the four Mayan tribes, the Quiche, the Mam, the Cakchiquel, and the Kekchi. The Spanish soldiers destroyed all that was dear to these people, including their temples and pyramids, and dispersed the Mayan citizens. Some were enslaved

while others fled to the jungles, causing the loss of the Mayan cities and their civilization.

Today Tikal, the ceremonial city of the Mayan ruins, lies in a sparsely populated dense rainforest, and the area has become a popular tourist attraction, a reminder of the disappearance of a major tribal civilization. However, the Mayan Indians have, throughout the years, remained in a subservient role in Guatemala. Few of them have owned property, while seventy percent of the agriculture land is owned by two percent of the Mestizo population. Even though the Mayan people represent more than half of the population of Guatemala, they have never recovered from centuries of discrimination and repression.

Huge tracts of Mayan land in Guatemala have been taken from the Indian people for the cultivation of tobacco and sugar cane, and many of the Indians forced into labor. Since most of them do not speak Spanish, the national language, they have been unable to adequately defend themselves. Most of them work small acreages of farmland, while some of the women have become domestics or factory (maquilla) workers. Although the Guatemalan constitution recognizes ethnic diversity and voices a commitment to respect all of its citizens, it is evident that racism in relation to the Indian people is widespread.

Guatemala Today

Exuberant species of flora and fauna abound in this beautiful country. At every turn, I observed the rich color of flowers like the bougainvillea with its radiant crimson blossoms and poinsettias so tall that I had to look upward to appreciate their scarlet display. I also listened with delight to the magical songs of exotic birds I had never heard before. In spite of its poverty, it is a country that is enchanting and luring. The colorfully decorated "chicken buses" that transport people (not chickens) were amusing to watch as they seemed to bulge outward with large numbers of people traveling to their destinations. Luggage and merchandise were usually strapped to the top of the buses, and oftentimes they were so crowded that many of the travelers had to hang onto the outside.

Perhaps the most exciting geographical aspects of Guatemala were the 300 plus volcanoes that are mostly dormant. There is excitement in hearing of the past eruptions of some of these volcanoes that today stand majestically, just waiting for another opportunity to spurt sparks and puff clouds of smoke. It was fascinating to hear individuals sharing their escapades of climbing to the crest of the volcanoes to view the craters. For most of my visit, I was in view of one of these colossal volcanic peaks and felt a sense of anticipation at the possibility of an eruption at any time.

Three volcanoes could be viewed from Guatemala City and La Antigua at all times due to their extreme height. One is able to see Aqua, Fuego, and Acatenango volcanoes, which through the centuries have brought devastation to the lives of residents. Fuego was active less than three months before we arrived, and I could occasionally observe it belching smoke, which looked like puffs of clouds rising from a mountain.

While on a tour, we approached the lofty and hovering Aqua volcano. Our guide, a native of La Antigua, told us how as a youngster he and his friends climbed for seven hours to reach the top of Aqua, where they played soccer on the inside of the flat crater. He said that Aqua is the most popular volcano to climb. One of the other volcanoes nearby is called "fire" and often spews flames, so it is not quite as popular to climb since no one knows when it might belch.

The most scenic volcano area was in southern Guatemala near the town of Solola. The eruption of numerous volcanoes had produced sufficient volcanic ash to dam a valley many centuries ago, creating an azure body of water called Lake Atitlan (Logo de Atitla'n). Local people call it the most beautiful lake in the world, and I concur. This mammoth calderas lake (a large crater formed by a volcanic explosion) is located at the base of several volcanoes. On the day we visited, gritty winds were whipping up waves that rolled and sparkled in the sun, and I glimpsed the volcanic peaks mirrored in the lake. With an appreciative gaze, I stopped to savor the beauty of the scene, for me an instant of connecting with my maker. I felt, as Henry David Thoreau did, that "We can never have enough of nature. We must be refreshed by the sight of vast and titanic features."

Lake Atitlan—formed by volcanic eruptions.

Volcanoes have produced devastating consequences even for the political capital of Guatemala. About 200 years ago, La Antigua was the capital of Guatemala, and it was one of the oldest and most beautiful cities in the Americas located near Aqua, Fuego, and Acatenango volcanoes. The city experienced numerous volcanic eruptions and earthquakes, but an earthquake in 1773 especially devastated the city. The Aqua volcano erupted, spewing the earth with water (rather than fire), drowning 75,000 people and causing mass destruction, and city officials petitioned the king of Spain to move the capital to safer ground. After enduring 187 volcano eruptions in its history, the capital was finally moved some forty miles to higher elevation in Guatemala City.

However, many of the La Antigua people did not desert the bougainvillea-draped ruins completely. Colonial churches, mansions, the president's mansion, public buildings and haciendas continue to exist in spite of the earthquakes and volcano eruptions. These structures, built around a central square according to Spanish tradition, give evidence of many natural disasters but still maintain their unique architectural charm. Surrounded by the cobblestone streets, they have weathered earthquakes, floods, and fires, yet still stand as a memorial to their colonial history.

Though earthquakes and volcanoes still impact the capital city, there has been less destruction wrought in recent years than

in the past. Destructive earthquakes in 1917 and 1918 almost destroyed Guatemala City, and a devastating series of earthquakes occurred in the central region in 1976, producing enormous floods and mudslides and leaving thousands dead and many others homeless. Since many of the homes are poorly constructed, almost any size earthquake can demolish residences and cause a high death toll.

Guatemala has been referred to as the "sons of the shaking earth," and the slogan aptly describes its shaky political system as well. In addition to Guatemala City's being the largest urban area in Central America, it is the major political seat of Guatemala and the center for transportation and religious, economic, and social activities. Its broad avenues are lined with modern hotels, office buildings, and shopping centers that attract its populace of more than one million people. The city is overcrowded, especially with its countless poor people who live in ravines on the outskirts of the city.

Guatemala City sprawls across flattened areas and tumbles into the surrounding valleys. In the city, the chaotic marketplaces are filled with hundreds of trinket vendors, the streets are filled with disorderly traffic, and the sidewalks are flooded with people. It is a much different city from La Antigua with its colonial buildings and slow pace.

Guatemala is a fascinating country with alluring charm and beauty, but even more fascinating are the people who call Guatemala home. In the rural areas, farmers grow corn, cotton, sugar cane, bananas, and some of the best coffee in the world. Beginning a day with their wonderful, strong coffee was as pleasurable as the warming rays of the sun. Most mornings I had breakfast in the home of a Mestizo coffee farmer, so we had access to superb coffee that came from the southern edge of the mountain regions. Because of its excellent quality, much of the coffee grown there is exported to the United States and numerous European countries. In addition to farming, many of the people living on the grassy slopes and plains areas near the Pacific Ocean grow beef cattle. However, even though many crops and fine cattle are produced in Guatemala, three-fourths of the people living there still suffer from malnutrition.

The Civil War's Effect on Women

Eighty percent of the refugees of the world are women, and this includes Guatemalan women. One of the major reasons for this staggering statistic is that following a war, women are left as widows with poor odds for anything but marginal survival. Guatemalan women, especially the Indian women, are typical refugees in that thousands of them lost husbands during the long civil war in Guatemala between 1970 and 1996. The women were left to try to restore some semblance of order to their lives during and following these many years of civil war conflict that devastated their very existence. Because these women followed the cultural tradition of subservience to their husbands in almost every aspect of their lives, they were not qualified to be the provider or caretaker of the home. As a consequence, they have experienced serious difficulty in providing the household income and taking the role of leadership in their family. Many of the women, especially the Indian women, have been relegated to a deprived widow status.

Many widows are refugees as a result of years of war.

I learned of the plight of some of these war widows through my conversations with some of the Guatemalan people. I was told that many of these women have no income, live in straw huts, and barely have access to clean water. Survival, without sufficient food and suitable shelter, is an everyday challenge. Several groups from the United States have helped these widows by digging water wells and constructing one-room block homes costing only a few hundred dollars per house. With financial contributions from two groups in my home church, First Baptist Church, Clemson, South Carolina, $600 was provided for the construction of some of these wells, which will be completed under the auspices of a Wesleyan church in Guatemala City. Along with the church providing clean water, these widows will hear the message of "living water" for the soul. As the pastor of the Wesleyan church said, "We provide living water for the body and for the soul."

Power struggles within Guatemala began in the 1960s and 1970s and led to numerous coups, serious political unrest, and a malicious war against the Indians. Even though a peace accord was signed between warring factions in 1996, political instability continues to exist. In fact, my trip to Guatemala, which was scheduled for November of 2003, was delayed a month due to the political unrest created by the November presidential elections. The situation was so volatile that it necessitated the closing of major airports in Guatemala for a month before and after the elections. Even when we arrived in December, we saw remnants of volatility as soldiers with shotguns and/or pistols were on guard in restaurants and hotels, on the streets, or wherever people were found.

The civil war, in its early stages, was between Ladinos and the government regarding left- and right-wing political issues. However, in the 1970s when the National Revolutionary Group (or guerillas, as they were referred to by the Guatemalan government) was in the Highland area, large numbers of Indians began joining forces with them. The Indians joined the "Army of the Poor" (the National Revolutionary Group) to try to lessen the discrimination against them and to rectify the socioeconomic

disparity imposed by the government on the Ladinos and the Indians in the distribution of land. The atmosphere appeared to be one of prejudice with demeaning attitudes toward the Indians by the Guatemalan government, an attitude that has existed for centuries. Eventually 90% of the "Army of the Poor" consisted of Indians led primarily by disenfranchised Ladinos.

During this seemingly unending conflict, the Guatemalan Army killed and tortured thousands of Indians and other guerillas. Amnesty International, in 1979, estimated that some 55,000 people had died as a result of political violence during the 1970s. Later reports stated that 200,000 people were killed or had disappeared, and 250,000 children were orphaned. Entire Indian villages were destroyed in the government's attempt to discourage the Indians from joining the guerilla movement.[1] It was reported that as many as 500,000 Indians escaped to Mexico. Women found it necessary to abandon their traditional dress and wear Western dress to avoid being killed. This war, according to some, did as much to alter the Indian's life as did the Spanish conquest.

The 1996 Peace Accord was signed by both warring factors with basic tenets to eliminate discrimination in the economic, social and cultural aspects of Indian life, including an edict to eliminate discrimination toward all women.[2] However, in reality, the government has not successfully instituted mechanisms to fully enforce these agreements related to women or Indians, other than trying to integrate the Indians into the Spanish culture. According to Jean-Marie Simon (*Guatemala: Eternal Spring, Eternal Tyranny*), the elite of Guatemala still seek to dominate Indians in every possible way. He suggests that the Mayan Indians have sustained their culture for centuries, but it may not endure fifty more years.[3]

Women were significant players in the development of the Peace Accord. A group of thirty-two organizations called the "Women's Sector of the Assembly of Civil Society" sought to facilitate peace through providing equity for all races and genders. Their demands were that women's civil rights should be addressed, including the elimination by the governments of discrimination toward women as related to violence, poverty, the

uneven distribution of property, lack of health care, low levels of education and lack of political representation.[4] A major concern was (and is) that women are marginalized to the extent that countless women are unaware of their potential civil rights.

This group, however, demonstrates how a group of women from diverse backgrounds can, by working together, impact the national government regarding gender issues. Some advances have been made but women's status in Guatemala in general continues to be one of a second-rate class of people. The political rivalry that continues between the left and right seems to generally ignore the need of women, as well as those of the Mayan Indian people. Even though changing the culture of a people is painstakingly slow, women must attempt to lasso the inequities that persistently gnaw at them in hopes of breaking the logjam of the "old think."

Women in the Home

Ladino women who live in the rural areas of Guatemala usually have small one- or two-room adobe houses constructed of mud bricks and roofed with tiles. Other homes, including those of many of the Mayan Indians, are made of poles tied together and topped with palm leaves, straw, dried sugarcane, bamboo or palm thatch. In the areas subject to flooding, such as the Lowlands, houses are built on stilts for protection from floodwaters. There may be a mud-brick oven outside of the home or stoves inside. Most homes in remote areas do not have electricity or running water,[5] and eighty percent of the homes do not have indoor toilets. It is difficult to comprehend how many of these families can live under such difficult circumstances.

At the opposite end of the continuum are the elaborate homes built during the colonial period for the affluent, ruling class. These city dwellings are owned and occupied by a very small percentage of the population, since most Guatemalans are very poor. I observed these affluent homes primarily in La Antigua, the former capital of Guatemala, and noted that they are constructed with very thick walls essential to surviving the numerous earthquakes

in the area. The window openings are often deeply recessed and positioned at the corners of the buildings to allow for artistic expression in molded fenestration. Most of the white stucco homes and buildings have courtyards in the center and their windows and doors are studded with large brass designs and barred with either wrought iron or wooden grilles. It was difficult for me to validate these homes in a country where eighty percent of the people live in poverty.

There are few places in the world where I have observed women living in more pathetic conditions than those found in outlying areas of Guatemala City. Many of these women and their families have moved to the city, leaving behind small pieces of land in the Highlands that they had plowed with oxen and tilled with hoes, axes, pointed sticks, and machetes. Now they live in the squalor of the city, their dreams of overcoming poverty, malnutrition, illiteracy, and illness not having materialized. For most, living conditions have even deteriorated. These Guatemalans are among the poorest people in Latin America, with the indigenous being the poorest of the poor. It seems that the rich get richer, and the poorer are even more abandoned.

Many of these families who moved to the suburban area of Guatemala City referred to as "Hurricane Village" experienced real devastation in 1998 when Hurricane Mitch swept through the country and left 50,000 villagers homeless. Prior to the hurricane, the village was one of squalor with scantily built shelters, consisting of sheets of tin patched together, leaning one on another. The hurricane just added to the misery.

These shelters consist mostly of single rooms with a dirt floors and eroded dirt paths weaving among the many rows of quarters for refugees. It is certainly a stretch of the imagination to call these lean-tos houses. They have no toilets, and the city provides water for only two hours each week. There are no specific time schedules for receiving water, so families must fill water containers whenever water flows from the open faucets, day or night. Since the faucets are left open at all time, it is only when someone hears the flow of water that the villagers rush to catch their weekly allowance.

Hurricane Village, Guatemala City.

To help provide more water to these refugees, the Iglesia Adonais Wesleyan Church, located next to Hurricane Village, dug two water wells, one through the dirt floor inside the church and one located just outside the entry door. This was the church where several women from Virginia and I came to participate in a Vacation Bible School for some 600 children and youth. The church seeks a holistic approach to its ministry, participating not only in evangelistic endeavors but responding to human needs as well, and there seemed to be no physical need greater than providing clean, fresh water for these people.

On the second day of Vacation Bible School, however, the water pumps at the church refused to pump, so for the rest of the week we were without water for the two church restrooms and the kitchen where meals were being prepared for these hundreds of children. For the local church people, it was what they were used to, and they were just inconvenienced. But for us American women, it was a major concern, since we were at the church four hours each morning and were not accustomed to facing even a few hours without water. Sometimes, however, it is good to be reminded that our conveniences, such as an abundance of clean,

sparkling water, are luxuries for others. For the 80% of Guatemalans who are poor, 39% of these are the poorest of the poor. They do not share in the luxury of having pure water; in fact, even polluted water is unavailable at many home sites.

The middle and upper class of Ladinos, representing the upper 15-20 percent of Guatemalans, enjoy better living conditions. They live in modest but attractive homes and employ Indian women as servants. The living accommodations for our group met the criteria of an upper-middle class home, as we were housed in a nice white stucco building in rooms that were normally occupied by students on vacation from the University of Guatemala. The rooms contained four to six bunk beds per room but nothing else, not even a chair. Bathrooms were down the hall with hot water, most of the time. We ate most of our meals across the street in a charming white Spanish stucco home that was warm and welcoming. The home belonged to the Wesleyan pastor, his wife, and her father, a former pastor who now owns a coffee plantation.

The Mayan Indians, I found, wear distinctive clothing with special designs to identify their ancestral tribes. A Mayan woman may be identified by her long flowing skirt, called a "cortes," colorful sash, and attractive blouse called a "huipile" (WEE-pils). Her blouse will have full sleeves stitched with delicate multicolored embroidery reminiscent of the 16th and 17th century. The designs on her blouse indicate her tribe and may also have religious and magical significance. This tribal distinctiveness had its origins with the Spanish colonizers, who introduced different designs for clothing for each village so they could identify a person's tribe.[6]

As I observed and spoke with the Mayan women, I noted that many of them had an upper gold-covered tooth. Since most of these Indian women live in real poverty, I wondered how they could afford the expense of a gold tooth, but I was informed that this is a custom and a high priority for being stylish. I saw that these women, sometimes wearing brightly colored headscarves, traditionally carry items they are transporting on top of their heads. These may be containers with water or objects tied together in a piece of cloth to make a bundle, then placed on top of

their heads, some of the bundles quite heavy. Maybe, I thought, this is symbolic of the heavy load they bear in life.

The Ladino women usually wear traditional Western clothes, as do their children. However, I seldom observed Ladino women wearing slacks or short skirts. Occasionally young women could be seen wearing stylish Western dress in the cities, but older women wear the traditional long, flowing dresses.

The Guatemalan culture demands that women focus on performing the duties of the home and caring for the children. The legal system advocates that the husband is head of the family, regardless of the family's ethnicity. Until recently, women were required to obtain permission from their husbands to participate in any outside activities, including taking a job. Even though in recent years the Guatemalan constitution has been amended to declare that all people have the right to work, the "husband's law" appears to be the accepted tradition and usually overrules the law. Numerous women advocate groups are addressing this issue.

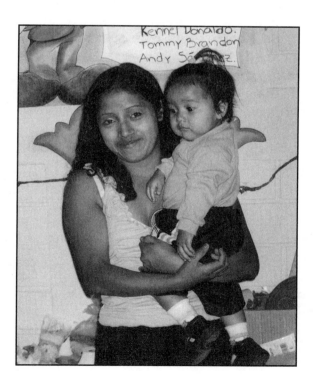

Urban women usually dress in Western clothes.

A young Mayan woman may legally marry at age fourteen; however, marriage at younger ages does occur as, for example, in the Kekchis tribe in which a girl can marry at age thirteen. Having a wife is considered an economic necessity for a man, even if he has to work for his father-in-law for several years to pay the dowry. The man needs someone to cook, sew, and help tend the farm animals, work in the fields, and raise children to contribute to the workload and family income. Once a young woman marries and bears a child, she is considered to have reached adult status. She learns early how to care for her family, even if she is only slightly older than a child herself. The husband spends most of his time trying to make enough money to buy food and the necessities for the family's survival.

When a Mayan Indian baby is born, the mother is placed in seclusion for eight to ten days while her family helps in caring for the newborn. At the baptism, the baby is given the father's name as his surname and a name derived from the names of plants, minerals or animals. The Mayan Indian women average over six children per family while the Ladino women average five. Many of these indigenous Indian families refuse assistance in family planning, since birth control is contrary to their beliefs and culture. They are suspicious of health personnel who discourage having large families, assuming that it is the Guatemalan government seeking to limit their numbers and assimilate them into Guatemalan society.

A major concern for the Guatemalan woman relates to health issues, not only for herself but also for her family. Although some improvements have been achieved in the area of health, Guatemala is considered to have one of the worst health programs in the Western Hemisphere. The Committee on Social and Cultural Rights in Guatemala reported to the government its serious concern about lack of safe water for the rural populace, the prevalence of endemic diseases, the inadequacy of social and welfare security, the shortage of housing, and the lack of access to health care.[7] Life expectancy for the men of Guatemala is sixty-four years and for women sixty-six years, the lowest in Central America.

The renowned Harbour Bridge at Sydney, Australia

The legendary Cathedral of St. Basil, Moscow
Photo by Dr. Sanford Beckett

Happy shoeshine boys of Ecuador

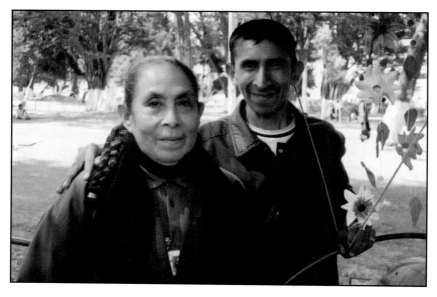

*An Ecuadorian couple from the Sierra region
designs and sells jewelry*

An Otavaleno woman of Ecuador crochets

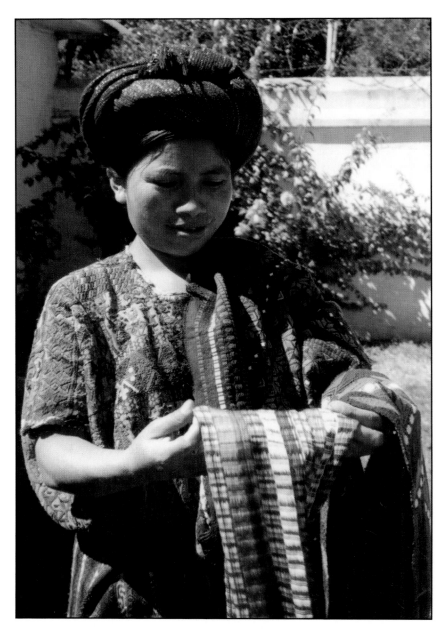

A Guatemalan woman examines her hand-woven material

A Guatemalan woman poses for a photo

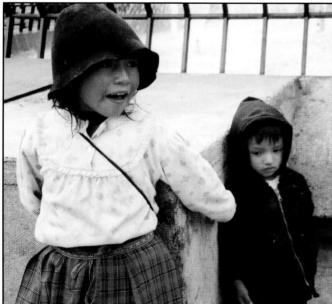

Street children of Ecuador beg for food and money

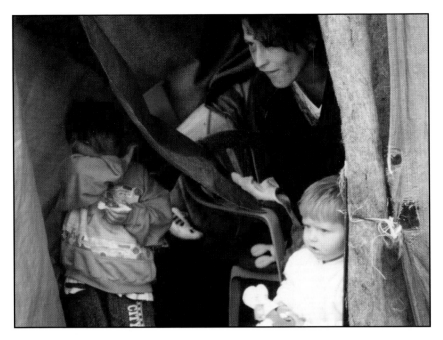

A Kosovar refugee mother in her tent home shields her children

Ann kneels near mass graves of those killed in war in Kosovo

Ann and Winnie deliver blankets to Kosovar family

Men of Central Baptist Church, Moscow
prepare to deliver rice (in background) to the poor
Photo by Dr. Sanford Beckett

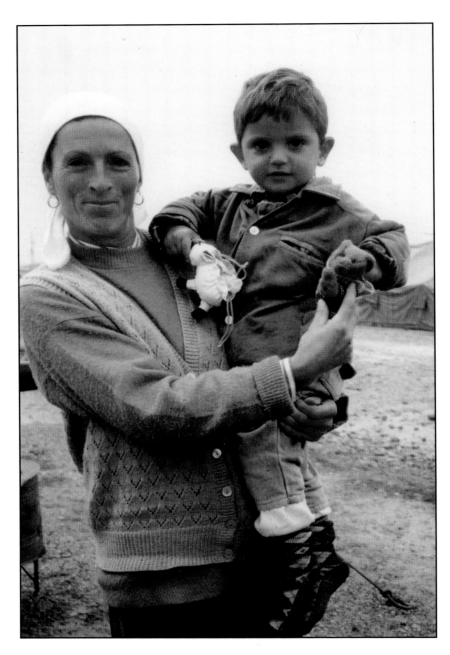

A Kosovar woman with her child in a refugee camp

Winnie chats with a Kosovar woman who lost seven members of her clan during the war

An Alaskan woman designs crafts to sell

An Alaskan Indian woman at an Indian exhibit

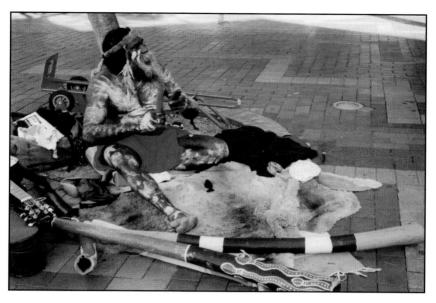

An Australian Aboriginal man displays his wares

Winnie charmed by an Australian koala

A young Guatemalan woman balances her craft on her head

An Ecuadorian widow shows evidence of years of toil

An Ecuadorian woman struggles with a heavy load of crafts

A sea lion soaking rays of sun in Ecuador

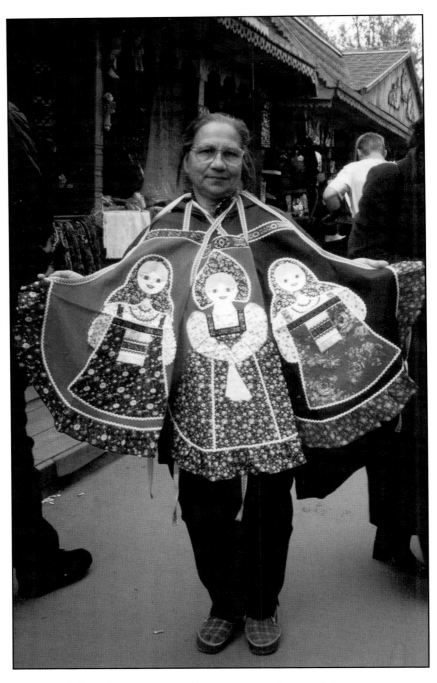

A Russian woman sells aprons at the market square

*One of the many
Russian women who
experience despondency*

Russian women sing to shoppers at an outdoor market

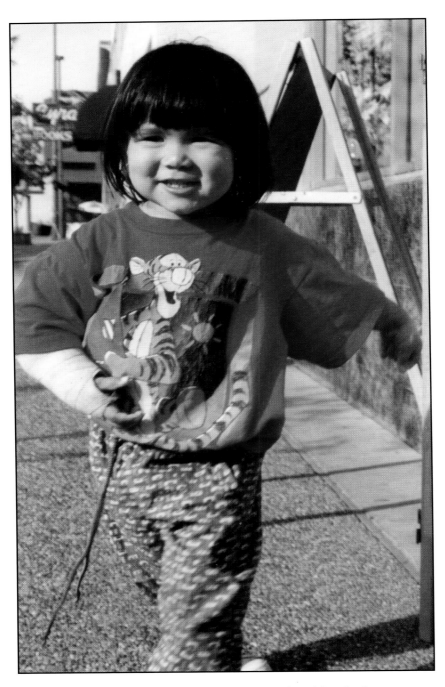

A child from the Alaskan Aleutian Islands with a broken arm

Even though the government has a reproductive health program available to everyone, it is not accepted in many areas. Even governmental officials have concerns regarding family planning, stating that, "Contraceptives have a negative effect on the family, leading to family breakdown and increasing the number of households headed by women." Abortion is an absolutely negative approach to family planning and is a punishable offense.[8] The most conservative churches are adamantly opposed not only to abortion but also to reproductive health programs. This is a country that has 44% of its children malnourished and people living on less than two dollars a day.

Providing food for large families is a major concern for most families, especially the 39% of the people who are the poorest of the poor. The diet for these families usually consists of beans, rice, squash, and maize, a corn dish. For those families with more money, foods like avocados, plantains, carrots, and cabbage are added. Corn is used for a variety of foods, including tortillas for tacos and a beer called "chica." If the family does not produce these vegetables and fruits at home, and if they have the money, they will buy them at outdoor markets, where they can purchase extras as well, such as corn fritters, sandwiches, fruit, and chips.

Food purchased for fine restaurants or for upper-middle class homes is usually purchased at grocery stores or at a market where there are a wide variety of food items. Our hostess in Guatemala shopped for fresh produce at markets as well as conventional stores and with help from her kitchen assistants, prepared tasty and attractive meals during our stay. We were served foods such as fried beans, a wonderful dish of tomatoes, onions and eggs, fruits such as watermelons, pineapples, avocados, delicious fried plantains, soups of ground vegetables, and a delightful chicken dish which she marinated for two days in lemon and lime juice. Our dessert, in addition to fruits, consisted mostly of sugar cookies or pound cake. Once when we were on a picnic, our hostesses prepared for each of us a roll with ham and cheese, a peanut butter sandwich, fruit, and chips. While we were eating, our hostess asked that we not throw away any of our leftover food, and I feel

confident our "leftovers" were consumed by some of those who helped in the preparation of our meals.

Food purchased in fine restaurants or prepared in upper class homes consisted of more exquisite platters such as "Subanik," a dish of chicken, pork and beef, and fine cuts of steak marinated in orange sauce. Many of the more tasty foods are topped with "recados" or sauces. Other entrees include turkey soup, stuffed peppers, and "tapado," a seafood soup with plantains and coconut oil. Another popular dish that is sweet is cambray and black tamales. To put an elegant touch to a meal, there is the rich Guatemalan coffee, which is often served with hot milk. It is an intense and overpowering coffee with an aromatic flavor that is so delicious that it demands a refill every time.

During my stay, I asked about the delineation of the class system among the Guatemalan people. What distinguishes a Mayan Indian from a Ladino, since their physical appearance is very similar? I learned that ethnic Mayan Indians have maintained their ancestral culture to the fullest extent possible, speaking the tribal language, wearing clothing indicative of the specific tribe, and focusing on community events more than national ones. The Ladinos, on the other hand, are generally considered to be a combination of European and Mayan ancestry. They speak Spanish, dress in Western attire, are more progressive in their attitudes, have a monopoly on the public education system, control the government, and are owners of most businesses.[9]

However, it is quite possible for an Indian to make the transition from the Indian class system to Ladino status by living in a community with Ladinos, wearing Western clothes, speaking Spanish, participating in businesses, and raising one's financial status. There does appear to be a gradual drift of the Indians toward the Ladinos' way of life, especially since the Ladinos' perspective has more to do with social class and income than it does Indian or Spanish origin.

However, the Ladinos generally demean and exploit the Indians and try to avoid friendships with them. They would never intermarry with them. The Mayans are traditionally deprived, have shorter life spans as the result of poor health care, and are

mostly illiterate. There is an immoral gap in society between the Mayan Indians and the Ladinos, which involves greed, prejudice, and a trouncing of human life.

Since many Guatemalan women do not use family planning, either for cultural reasons or insufficient knowledge of the methodology, there are many babies born into extreme poverty. Some of these children are legally adopted, often by Americans, and placed in homes with loving parents who have better incomes with which to care for them. Some children, however, are stolen from their Guatemalan parents and become pawns of illegitimate adoption agencies. Unscrupulous individuals, including lawyers, participate in this black market scheme that generates hefty profits for the racketeers.

Many Americans legitimately adopt these children who so desperately deserve the opportunity for a better standard of living than their Guatemalan parents are able to provide. While in Guatemala City, I encountered a lovely Christian couple from

Many children are adopted legally and illegally.

America who had spent thousands of dollars plus two years of processing paper work in order to adopt a four-month-old baby girl. This couple already has two young sons but wanted to share their loving home life with a less fortunate child. Also, as I returned to America, I encountered three other American couples on our plane with newly adopted Guatemalan babies. Each of these new parents cuddled their new family member with a devotion that left me with a warm inner glow.

This trend of Americans adopting Guatemalan babies seems to be on the increase. The U.S. Embassy in Guatemala issued more than 1500 immigrant visas in 2000-2001 to Guatemala children to come to the United States, and in 2002 that number increased by 50%. These adoptions benefit not only the children but the American parents as well.

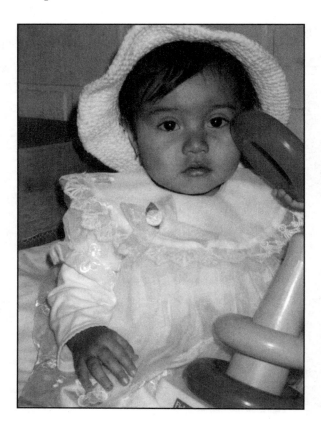

An adorable little girl attends Vacation Bible School.

Women in the Work Place

With the Guatemalan indigenous women's inadequacy in education and vocational training, coupled with an inability to speak Spanish, they have limited alternatives for employment. Traditionally, they have worked selling handmade crafts, worked as domestic servants in private households, and worked on farms, even though, until about 1980, they had to follow the "husband law" of seeking their husbands' permission to participate in these work activities.

Sellers of Crafts. An intriguing aspect of Mayan Indian women is the stunning handmade items they meticulously create. These items are often peddled to individuals on the street, sometimes sold at market places or at stalls on the side of the road. Selling on the roadside is a good option for those who live a long distance

Children often work with parents as sellers of crafts.

from the market place; however, going to the market is a significant event, for it is here that Mayan women meet and fellowship with friends, discussing family concerns and community events.[10] Most women will wear their traditional clothing to identify their tribe, but their colorful costume also attracts prospective buyers for their crafts.

The various Indian villages specialize in making different types of crafts. For example, the Nahuala village is known for making a smooth grinding stone known as "metates," while another village is well known for weaving colorful blankets. Another village will make a wide band to wear around the head called a "mecapal," and another will specialize in bending wires interspersed with tiny jeweled stones for eye-catching jewelry. Their gifts in weaving, designing leather goods, embroidery, and carvings are impressive.

Often women and children followed us for as long as thirty minutes, imploring us to buy their items. It was especially difficult when the small children clamored, "Please, please, madam." As we drove along the highways from one city to another in the country, we observed small craft and vegetable stands where women were selling produce and crafts. As they waited for customers to stop, they were busy weaving, sewing, or making their items to sell. Since walking is the main means of transportation, it was not unusual to observe a woman accompanied by her children walking along the highways with very large bundles filled with her craft items sitting on top her head. After a long walk, these women arrive in cities or villages to sell their craft, especially to tourists, and most can speak only a few words of English such as "Priced just for you, madam," or "Good price, madam."

Several times we went to large Indian market areas, where hundreds of stalls were lined up next to each other in a more permanent selling arrangement. Here we found men, women, and children selling items, but it was in the Parque Central of La Antigua that I encountered hundreds of Indians selling their crafts individually. Before entering the Inglesia de San Francisco Church, I stopped to look at some jewelry that an Indian woman had positioned on a piece of cloth near the edge of a sidewalk. I

was mostly curious and perhaps should not have stopped, even though I was aware that if I stopped to look at an item, I almost had to buy it. I did not buy anything from her, though, and felt sad that I could not purchase items from all the women I encountered. I was constantly aware that selling an item might have meant the difference in the person's eating or not eating dinner that night.

One little boy followed us for almost an hour, and even when we entered a Catholic Church adjacent to the square in La Antigua, he waited for us. He was not allowed to enter the church, but he waited patiently for us, and when we came out of the church, he pleaded again for us to buy his hand-woven dish-towels. I could not resist his persistent plea so I bought several of his towels. Such patience and endurance surely was worth the forty cents I paid him for each towel.

Another child, a boy perhaps nine years old, from a remote Indian village walked along with me, pleading persistently for me to buy a wood carving that I am confident he had made. It was a crude flat piece of wood, depicting the sun in orange and yellow tones. I kept saying "no" and continued to walk. Finally, after an hour of his unwaveringly pleading, I handed him some coins and said, " No, I don't want your carving." When he took the coins, I said, "Now leave me alone." I really did not know that he under-stood English until I saw the gloom in his eyes, as if I had discarded and rejected his efforts. He handed the money back to me, dropped his head and walked away. I did not see him again. Later, I was told that he probably was forced by his parents to sell items. How I wished I could have taken back my comments, which I am sure appeared sharp and painful to the little boy. I had failed in my globalist responsibilities and later recalled Sophocles' statement that "Ignorant men don't know what good they hold in their hands until they've flung it away."

Women as Domestic Workers. Women domestic employees of-ten begin working as teenagers and may continue in this role for many years. Half of the estimated 300,000 domestic workers consist of indigenous Indian women who are employed in middle- or upper-class homes. Domestic work provides women a

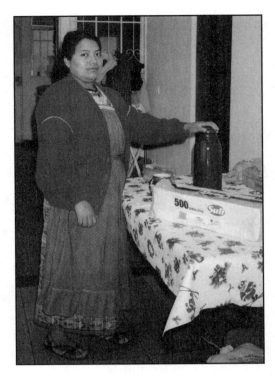

A woman works as a servant in a middle-class home.

salary, an opportunity to live in better-quality housing, and an opportunity to move to the city. However, her salary most likely will be inadequate for the long hours that she labors. There is no contract signed between the employer and employee, so an employee can be released without notice, yet, on the other hand, the employee may leave her job without serving notice. In an article entitled "Women's Role in Guatemala Political Opening," Valeria MacNabb stated, "Every Mayan woman is frequently considered to be or to have been a 'servant' or is treated or seen as one."[11]

According to Human Rights Watch, conditions can be deplorable for women working as domestics, since there is no governmental agency responsible for regulating the salary or working conditions related to domestic employment. Domestic work is considered to be unskilled and menial labor, with responsibilities such as fetching water, washing and ironing clothes (usually by hand), scrubbing and mopping floors, cooking, and caring for children. Thus, little time remains for a woman regarding her

personal needs, much less time for recreation or visiting with her family. There are documented reports of unacceptable treatment toward these women, such as sexual harassment and assaults, verbal and emotional abuse. Such treatment often comes with strong racial implications directed toward the worker by the adults as well as the children in the homes. Many workers complain of not having sufficient food or of being given food of lower quality than the food that is provided for the family. Most women work fifteen or more hours daily for six or seven days a week, and some say they are only allowed ten minutes to eat meals.[12]

Even though the labor code of Guatemala states that minimum wage must be paid to most workers, the law excludes domestic workers from these guidelines. An average worker earns about $96 a month, while domestic workers who live in a residence receive as little as $53 per month with no overtime pay or social security protection. Father Julian Oyeles is director of Conrado de la Cruz Project, an organization which is an advocate for domestic workers. He says, "When a girl of fourteen arrives to ask for a job, with all her ingenuity, her own world view and language, she encounters great obstacles to communication, a situation which is taken advantage of to lay the foundation and principles of servitude. This young woman's boss will define the salary she earns, the work she does, her working hours, the days she can go out, where she can go, and even what language she should speak in the home and how she should dress."[13]

Following are testimonies of domestic workers that have been documented by the Human Rights Watch: A fifteen-year-old young woman says that she arises at 5:00 A.M. and begins her day by preparing breakfast for the household and does not complete her responsibilities until 10:00-11:00 that night. For this work she is paid $67/month. Another domestic, who is now forty-three years old, said that she has worked as a domestic since she was twenty-two years of age. For the last eight years she has prepared and served breakfast for her employer, who is a director in a maquilla (sweat shop), and to his wife while they are still in bed. She does not finish her day until nearly 10:00 P.M., since her employers prefer a late dinner. She earns $107 per month. She has

worked in the same household for eight years and performs all duties related to the household including caring for the children.[14] Another domestic worker, Elisabeth, said, "The senor wanted to take advantage of me, he followed me around, he grabbed me from behind twice while I was washing clothes, I yelled, and the boy came out, and I left. I didn't tell the senora, because I was afraid. I just quit."[15]

Women as Maquilla Workers. Employment in maquillas (factories), or sweat shops, as they are commonly known, has become a piece of good fortune in some aspects, yet it has contributed further to the misery of injustice and bigotry for the poor women of Guatemala. In the maquilla the salary is higher than domestic work, the working hours are usually better, working conditions are sometimes improved, there is more freedom, and employers prefer the female worker. However, there are major concerns for 80,000 workers, 80% of whom are women, in the more than 700 maquillas.

A typical maquilla will assemble, fold, and ship merchandise such as clothing that has previously been designed and cut, usually in the United States. By paying low salaries to Guatemalan workers, American manufacturers can make enormous profits. The Guatemalan government encourages imports and exports, since they boost economic benefits to the unemployed, as well as to the country as a whole.

Although factory work began to escalate in the 1980s, it was in 1998 that the Guatemalan Congress voted to exempt the United States manufacturers from export and import tariffs on machinery, equipment, raw materials, and semi-finished products, and offered other incentives to encourage United States manufacturers to utilize Guatemalan sites. Manufacturers jumped at the chance to lower their production costs by utilizing the low-rate labor. In 1999, exports from Guatemala amounted to $407 million.

For women, the maquilla jobs present a double-edged sword. They provide employment for many of the poorest of the poor, yet discrimination is rampant and working conditions are generally deplorable. Workers are largely denied employer-paid health

care, and many of the labor laws, such as the right to an eight-hour workday or a forty-eight-hour week, are unenforced. The Human Rights Watch reports that the number of children who work long hours is high, and protection for young people from sexual abuse is inadequate.[16] A survey by the Central America Network of Women in Solidarity has stated that 12% of the maquilla workers consist of young women under the age of sixteen.

Another discriminatory element for women who work in maquillas is that women are often required to sign a statement indicating that they are not pregnant. Some have been required to take pregnancy tests before they are hired. Employers say that a pregnant woman cannot work as hard as one who is not pregnant. Too, the employer does not want to have a woman absent after she has been trained for a job, nor does he want to pay maternity benefits that are also provided for by Guatemalan law. The fines for firing pregnant women are so small that the maquilla boss usually prefers to fire the employee and pay the fine.

The Human Rights Watch[17] reports that among the 250 United States manufacturers whose products are made in Guatemalan maquillas are Target, The Limited, Wal-Mart, GEAR, Liz Claiborne, and Lee's jeans. All of these have "codes of conduct" or "terms of engagement that prohibit discrimination." What is desperately needed is for these codes of conduct regarding discrimination and unacceptable working conditions to be enforced. One step to the elimination of discrimination is the "governmental code," but without teeth for enforcement, it provides little recourse for improving the plight of women and other workers in maquillas. The situation could improve if U.S. manufacturers threatened to stop sending work to Guatemalan maquillas that discriminate toward women, and the Guatemalan government enforced the codes that already exist.

Women have attempted to unionize to improve working conditions, salaries, benefits, and number of working hours in the maquilla, but in most attempts they have been penalized for doing so. It is extremely difficult for women to successfully unionize because of the many cultural factors involved. A government representative made this statement to a committee studying dis-

crimination against Guatemalan women: "The notions of the role of women in the family should not be changed. A misunderstanding of equality would not benefit any society." So the status for women remains somewhat stagnated with the male bastion of the government seeing little need for change.

Women in domestic work and in maquilla situations want to know why they lack social security coverage and assurance of a minimum wage. Why do some jobs include women in these two areas of coverage and others do not? Why is there salary discrimination against women in the workplace? Why are working conditions so deplorable, such as having no restrooms? Why can women not join trade unions as men do? Answers to these questions may not be readily available, but the questions will not be washed away with the next rain. Actress Minnie Driver said upon visiting sweatshops in Southeast Asia, "The poorest people with the least are making sacrifices for those of us who have the most," and the same is true of the poor women of Guatemala.

Although women make up about 60% of the employed work force, only about 22% of them collect a pension, as compared to 71% of the men. Women work up to eighteen hours a day and bear the primary responsibility of a family, yet they shoulder the greatest part of the burden concerning the country's poverty. Life is hard for them, to say the least. *Human Rights News* states that, "Women workers are getting a very raw deal in Guatemala. The country's labor law has some major gaps, and in many cases it's not being enforced in any manner. The Guatemalan government has got to do a better job protecting women workers."[18]

Criminal Acts Curse Women

Dangers, especially from robbers, are prevalent for women and other local people, as well as for tourists in Guatemala. Those living in the area are more alert than tourists are to the dangerous atmosphere and know where crime is more rampant. As tourists, we were cautioned about crime in Guatemala but still were naive about the risks in the market places, on the streets, and even driving throughout the country. It came as a surprise when our host said soon after we arrived, "You women are brave to come to

Guatemala to be involved in missions work. We cannot get men to come." That statement made me aware of our vulnerability to the dangers that loomed around us each day. Just a few weeks ago (spring 2004), our hostess's brother was killed by a robber as he shopped in a local store.

One evening we rode into Guatemala City to shop at the Central Market, only a few blocks from the Capital, the National Culture Place, and the Central Park in the heart of the city. We were advised to put away our cameras, remove any jewelry we wore, stay close to one another, walk directly into the shopping square of little stalls, and not leave the shopping mall area for any reason. As our host cautioned us to be alert to potentially dangerous situations, I had to wonder why we were taken there to shop in the first place.

While visiting a village near Lake Atitlan, our tour leader suggested that we depart the city by 3:00 P.M. for the return to our residence in Guatemala City. We were not anxious to leave this most magnificent lake area, nor did we want to be deprived of time spent in observing and communicating with the Mayan Indians. When we asked about staying longer and returning later in the evening, our guide told us that not only are more buses and cars hijacked after dark, but kidnappings, rapes and assaults also occur more frequently at night. Since our returning journey would take three to four hours and we were scheduled to travel over a long stretch of road that was unsafe, we were encouraged to leave in a timely fashion. Without additional comments, we all hastily jumped in the van ready for the return trip. On one stretch of road we traveled between Chichicastenango and Guatemala City, we saw what appeared to be a dead man lying on the highway. A couple of cars were nearby, so our driver did not stop, which probably was wise. Perhaps an automobile had hit the person, or it might have been a trap, so our driver kept driving.

Since tourism provides a hefty source of revenue for Guatemalans, a major effort is made to assure the safety of tourists. Consequently, there are police and/or guards at almost every place frequented by tourists. A popular attraction is a cross, perhaps ten feet high, located at the peak of a mountain, standing guard over the city of La Antigua and the surrounding volcanoes.

A cross soars over the city of La Antigua and a distant volcano.

This cross was at the end of a curvy dirt road, off the normal beaten path, but police were there. As we visited a macadamia nut farm, we saw four police in the area with rifles or long shotguns, and during our visit to a local jade factory, we noticed that the guards kept their hands on their pistols at all times. Even in restaurants and shops, guards were present. These precautions seem necessary to assure the safety of the tourists and continue the inflow of dollars into their country.

Another major concern facing Guatemalan women and their families is the flow of illicit drugs in and out of their country. Since Guatemala is located adjacent to Mexico, it is considered a pass-through country for cocaine and heroin, and substances such as opium and cannabis that are consumed domestically.[19]

The continual problem of violence toward women exists in Guatemala to the same degree that it does in other developing countries. Violations of women's rights are verified over and over again in Guatemala and other countries without significant reprieve. UNICEF estimates that 76% of violence against women occurs in the home. A report by the Economic, Social and Cultural Rights of Guatemala voices its concerns regarding "the continuing problem of violence against women and the insufficient attention

paid to the problem by government institutions which has led to the invisibility of the problem of domestic violence against women."[20]

Another entity, the Governmental Committee on the Elimination of Discrimination Against Women, states that, "Political violence conditioned people to tolerate violence in general, which has an effect on attitudes toward violence against women." The report further states that the government is "trying to make peace efforts to ensure that women could enjoy well-balanced development free from violence."[21]

This same committee was asked why the Guatemalan government is indifferent to prostitution and why blame for prostitution is placed solely on the women, with no evaluation of the reasons they are in this questionable situation. It appears that the social and economic situation have often forced women into prostitution for survival. The government suggests that prostitution exists due to women's insufficient education and says it is attempting to train and find new work for these women.[22] The Agency also said that the government is "trying to amend the discriminatory portion of the criminal code that penalizes more heavily women than it does men for committing adultery."[23]

In my interview with Angela, an attractive medical school student, I learned that some young Guatemalan women are now openly expressing their opposition to the subservient role that tradition has imposed upon women. She said that most women never report an occurrence of abuse to the police, regardless of the seriousness of the offense. Abusiveness, she said, is the way of life for most women, bound by a culture that condones assaults in order to preserve the submissiveness of women. She also commented that men's consumption of alcohol exacerbates abusive relationships. She believes that males resent women who assume leadership roles, but she balks at the current culture. It will probably take several generations of women like Angela to overcome the cultural mores that regard women as little more than chattel.

Most of the women I encountered were warm and friendly, and we received many hugs and smiles from the women and children each day at the Wesleyan Church. In spite of their smiles,

though, I cringed at the thought of their going home each day to a one-room tin lean-to with their families of four, five, or six children and not having enough food to eat. I also feared for the circumstances they might encounter with abusive husbands or men they did not know, and I wondered how they were able to smile and keep on going. Perhaps there is no other alternative for them at this time.

Education—Entry to an Enhanced Life

One major means to lifting Guatemalan women from the dutiful role of compliance to males is to assist them in securing an education. The average education for a Guatemalan woman is 1.3 years of school, while the average for the entire populace is not much better at only 2.7 grades. It is thought that 60% of Guatemalan women are illiterate, and the Human Rights Ombudsman Office states that 70%-90% of the indigenous women are illiterate.[24] With so few literate women in the country, it is no wonder that most women are not cognizant of their legal rights. Their culture has produced women who are subservient, docile, and passive, yet they are diligent workers. Most of the women in the country are unaware that a better way of life could be theirs.

Numerous circumstances have contributed to the unacceptably high degree of illiteracy among Guatemalan women. One relates to children not attending school, either because of the lack of schools or the lack of available funds. Education is considered free for grades one through six, but students must pay for books, materials, and uniforms, which amounts to about $16 a month, so the schooling is not really free. Many families cannot afford to pay this amount, when the average income for a family may be only a few dollars a day. Middle school and high school students may be required to pay as much as $250 a year to attend school.

Maria, a little bright-eyed petite girl eight years of age, attended the Vacation Bible School where I worked. Since her parents were drug addicts, she lived with her grandmother, who was unable to pay the $16 for her school supplies and uniform; thus, she does not attend school. Families of the Wesleyan Church

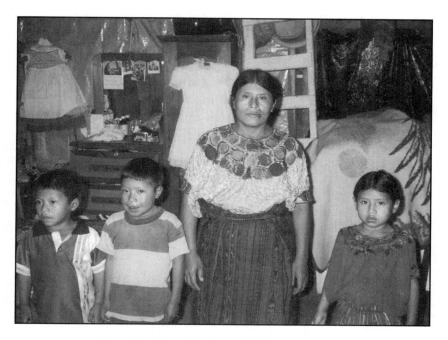

Most families of Guatamala live in poverty.

were attempting to secure funds to help Maria attend school in hopes that she may rise above the deplorable conditions of her present life. Maria is typical of the thousands of children who do not attend school.

For a child of indigenous Indian parents, it is even more difficult to receive an education. All public schools are taught in Spanish, since this is the official language of the country. In that these children speak a tribal language, most parents will not send them to the public schools. Even when an Indian child begins school, she may not remain in school for any length of time if she is unable to understand the language of her teacher. Over 50% of the Indian children never enroll in school, and only 1% of those who do enroll complete the 6th grade.[25]

There are indications that the government of Guatemala wants to assimilate Indians into Guatemalan society by teaching them Spanish and thus eliminate their tribal loyalty. However, this process has not been successful. With Indians being unable to

speak Spanish, they are, of course, unable to hold government positions, run for political office, or hold responsible jobs involving the national language. Many people fear that this control of the indigenous people is exactly the status desired by the Ladinos.

For some years Catholics and evangelic Protestants have expressed great concern for the lack of education for the Indian people. Thus, they developed materials in some of the tribal languages and began teaching the Indians. This was a tremendous improvement for the Indians, as it provided them more independence and improved self-perception as their children became educated. As they became educated, they grew more interested in learning Spanish and showed more interest in local politics and events outside their community. However, this did not set well with some Ladinos and government leaders, either on the local or national level. The government claimed that the Catholic priests and nuns were subversive in teaching the Indians to raise concerns about governmental policies, and soon some of these Christian teachers disappeared and others were found dead.

The Wesleyan Church would like to begin a Christian School in Guatemala at their church so that children in "Hurricane Village" and other poor children might have the opportunity of being educated. This arrangement would not likely be a problem with the government as Spanish seems to be the accepted language for most who have come to the Wesleyan Church in Guatemala City. However, due to a lack of funds, the church has been unable to begin the school.

To revolutionize the long-standing traditions of a society regarding the acceptance of women as significant and valuable individuals worthy of civil rights, an intensive educational program will be necessary for all of Guatemala. Such education needs to begin at home and in the public schools with a teaching of respect for gender equality. A mother must teach her son to respect her in the home, a difficult task when the father chooses to do the opposite, and women have to gain self-respect before they can demand respect from others. That which one does not have is difficult to give to others.

Winnie with children attending Vacation Bible School.

The Significant Impact of Religion on People's Lives

As the Spanish arrived and conquered the Indians, they successfully converted the Indians to Catholicism. Today 70% of the Guatemalan people are Catholic, and the other 30% Protestant. However, there is not a strict adherence to Catholicism, since many of the Mayan rituals have been incorporated into Catholicism in such elements as baptism, the burning of incense, and confessions. People often worship local gods and spirits along with God, Jesus Christ, the Virgin Mary, and local patron saints. The Indians honor various gods, including the earth gods, and pray to them especially during planting and harvesting crops. These ancestor gods are honored through incense, food, and drink to help ensure fertility of the earth.

Holiday festivities, such as the celebration of Lent and Holy Week, are significant to Mayan Christians. Elaborate processions with decorated floats, thousands of people dressed in colorful costumes, displays of incense, flowers, fruit, and food, plus the ever-present loud fireworks, all make for a gala celebration. Reli-

gious feasts provide the major source of festivity for the parishioners with merriment and glee as the people dance to the carnival-like music. The altars of churches are decorated with "sagrarops," which contain fruits, handicrafts, and outstanding sculptures. Since most believe that the gods will help them in their daily lives, even those who are very poor will participate in these celebrations, especially during events such as marriage or baptism confirmation. It is often said that the "Indians are Christians in the churches and pagans in the fields," indicating the complicated mixtures of belief and practices.[26]

One Indian tribe, the Chichicastenango, participates in Indian rituals. Worshippers burn incense on the church steps, offer sacrifices such as flower petals, and burn candles to a Mayan god. The Kekchi pay homage to the Mayan god, *Tzultacaj*, who lives in the mountain caves and rests in a hammock suspended by snakes. It is believed that Tzultacaj sends these snakes to punish sinners. Minor sins are disciplined by snakebites, but the poisonous snakebite, which can be fatal, is used for discipline of a major sin. A curer of these snakebites, called Llonel, diagnoses and heals patients after the snakebite, if the person lives, by using various herbs and rituals.

One of the greatest fiestas of the year is held when a tribe celebrates the community's patron saint. One such deity is called Maximon, a cigar-smoking god. During a celebratory parade, masked followers will hold up an image of their patron saint at the beginning of the parade and follow it with the music of marimbas and dancing. There is always an abundance of feasting and drinking, usually of "chichi" (beer) and "pulque," a mild alcohol drink made from the juice of the century plant. Always evident are lots of firecrackers during a celebration of the spirits. (Even at night as I slept, I could hear the sound of fireworks popping from all directions.)

A festive Catholic celebration is held on Good Friday in La Antigua, where the procession may last as long as eight hours. The participants in the parade may walk over pine needles, flowers, and brightly colored sawdust that has been dyed and formed into unique designs.

Near the end of our stay, a retired Guatemalan Protestant minister in whose home we ate most of our meals, shared with us the story of his long ministry in Guatemala. He was born in 1918 into a very poor Guatemalan family, he said, and never had the opportunity to go to school. As a teenager he worked on a farm, making five cents for a day's work. Out of the five cents, he paid three cents to his mom to help feed the family, and the remaining two cents he paid to the farmer for the privilege of listening to his radio. He had become interested in Christianity and had a yearning to learn more. Since he could not read, his only means of gaining knowledge about the gospel was from the preachers on the radio. He memorized their sermons and returned to his church to preach those messages, and soon the members of the church suggested that he learn to read so he could gain a better understanding of the Bible. He seized the opportunity, and after he learned to read and write, he began to delve into the study of the scriptures. With great diligence, he became a full-fledged minister and said he had preached for more than sixty-five years. Now, in addition to his occasional preaching, he grows coffee on a nearby farm and continues to be a Christian witness in his community.

The son of this minister, now the Director of Wesleyan Ministries in Central America, shared a touching story with us regarding a man from the United States named Jonathan, who came to Guatemala to serve as a missionary. After two years in the country, Jonathan was unable to communicate with the Spanish-speaking people sufficiently to accomplish his goals, so he decided it would be best for him to return to the United States. The Guatemalan people with whom he worked had developed a strong respect for him and his efforts, and a local person asked him, "Will you help us build a well before you go?" He did so, and when he had finished, someone asked him, "Will you help us get electricity?" He helped them get electricity by directing the building of a dam, and the request for projects continued. Jonathan was successful in his ministry in Guatemala, even though he never learned to communicate fluently in Spanish. This story was an inspiration to us as we attempted to minister during a Vacation

Bible School with Spanish-speaking children, even though we did not speak their language. We learned that by helping the children with crafts, smiling and hugging them, and helping to provide funds for meals, even though our communication was through interpreters, we became ministers.

Vacation Bible School was held at the Iglesia Adonais, which means "God's Church," located at the edge of the deplorable, deprived, and almost inhuman Hurricane Village. This church was led by a pastor who refused a salary from his mostly-poor parishioners and worked at other jobs as a means to support his family. He and his wife, who was director of the Vacation Bible School, are two of the most notable and committed people I have known.

The sanctuary of the church where the Vacation Bible School was conducted was constructed of concrete blocks, a tin roof, handmade tin doors, openings where windows could have been, and a dirt floor where hundreds of little feet generated enough powdered dirt for a blinding dust storm. The church accommodated the 600-plus children who were jam-packed onto the handmade benches and a few folding chairs. Lighting for the sanctuary consisted of two wires pulled across the ceiling with several light

The Wesleyan Church, Iglesia Adonais, in Guatemala City.

Over six hundred children gathered inside of the church.

sockets and bulbs placed at intervals. The room had a small wooden stage decorated with colorful artwork depicting the theme of the week and lit by fluorescent bulbs attached to a plank in the ceiling.

Singing and instrumental music are a significant element of Spanish culture, and one will always find large amplification systems in their churches, even in the smallest churches. This church's loudspeaker system was so strong that the louder the music became, the further I walked away from the church, but still my ears could hear more than they wanted to absorb. I never doubted that God could hear these glorious, angelic little voices, even without the booming amplification system.

In addition to a sea of 600 adorable black-headed children in the sanctuary, there were sixty-five workers/teachers, mostly women but also some young men, and a few motley dogs that came in for a shady rest from the beaming sun. It was quite a conglomeration of bodies and flying dust. The dozen ladies who served lunches for the children worked in an older part of the church, performing such duties as washing bananas in bleach to

kill germs and packing sandwiches and cookies for children, which they placed in bags for distribution. Many of the children had come without food; thus, the lunches became a highly motivating factor in enlisting the children's attendance.

Children were divided into groups according to age for most of their instructions and crafts. It was an amazing experience to see how well behaved the forty or fifty children in a group were as they sat on the floor in very small rooms or used the benches in the sanctuary as their tables. Because of crowded conditions, the children's activities were rotated. Some would be involved in crafts in the sanctuary; others would be playing outside, while the rest would be involved in Bible study. Some churches from America had provided crafts for the children, and we spent much of our time assisting the children in assembling the crafts. There were usually fifteen to twenty children each day who made the decision to accept Christ, usually the older ones up to eighteen years of age. At the end of each day, we Americans distributed candy to the children as they left. I had taken twenty-five pounds of candy, and others had brought candy as well, and we saw some children go through the candy line, then circle back to go through a second time. It was hard to refuse these amazing children candy when they were so in need of special attention. For those of us handing out candy, a smiling face was all the reward that we needed.

Help Is on the Way

Many changes will need to be made in Guatemala if women are to obtain reasonable human rights anytime in the future. Several favorable legal changes have been passed during recent years to facilitate human rights such as the Penal Code, Article 232, which states that a married woman may no longer be punished for unfaithfulness. There has also been the passage of a Law to Prevent, Eradicate and Punish Intra Family Violence. Article Four of the 1995 Constitution states that "Men and women have equal opportunities and responsibilities and that all are free and equal in dignity and rights." Legally, women have gained, for the first

time, political backing for liberty and equality. Now, the real challenge will be to formulate a plan to see that these codes are followed.

Numerous organizations are seeking to help women with their tribulations; one organization is the National Council of Guatemalan Widows. This organization is composed of women working with women whose husbands were killed during the civil war. These widows live in dire poverty and some do not survive. They have endured extreme hardships, harassment, and exploitation by Ladinos, and even those individuals who are advocates for the widows' cause are constantly threatened and even beaten for their efforts in ministering to these women.

This organization, the National Council of Guatemalan Widows, has become one of the most effective grass roots groups in the country and seeks to inform these widows of their rights and denounce violations directed toward them. Their desire is that the government investigate, identify, and punish those who commit violations of these widows' rights.[27] The Wesleyan Church began building homes and wells several years ago for some of these widows, and other groups outside of Guatemala have joined in an effort to provide humanitarian aid for these destitute individuals.

An organization that is building bridges of opportunity and seeking employment for women of Guatemala is called "Friendship Bridge." This group specializes in aiding women through micro loans to assist in developing a small business. Friendship Bridge tells a success story about how the micro loan works. Shy and reserved Rosario is now living in a sturdy little house instead of a crumbling bamboo shack, her children are in school, and there is hope that their lives will be better than that of the past. Rosario, who was very poor, joined a group of four women to learn how to use her micro credit loan; then she began developing skills in business development, leadership training, and health. She began by weaving and selling cloth and selling items such as snacks to farm laborers and, with her husband, developed a business of buying and selling second-hand electronics. Life has improved considerably for Rosario and her family, thanks to the "Friendship Bridge" scholarship.

Rosario and her husband serve as a model for their children and demonstrate how a small amount of money can change their lives. An average loan in the Micro Credit Program is $100, and a scholarship for one child to attend school, such as one of Rosario's children, is $16. Friendship Bridge may be contacted at http:// www.friendshipbridge.org/borrower.[28] Church groups in the United States have also been involved in similar enterprises in helping women get started in small businesses such as bakeries and stores.

At least three women's rights organizations have as their primary goal the improvement of conditions for women who work in maquillas, and they have been instrumental in conducting human rights education workshops in Guatemala. Some of their goals in addition to human rights are seeking the rights of indigenous people, economic reform, and improving the status of women.

Two other groups that play a significant role in Guatemala are the non-government organization that promotes family planning and members of the Catholic and Protestant Churches. In addition to these groups who advocate for the civil rights of the women, there is still need for support from the legislature, judges, and police to provide necessary safeguards for women.

It appears that these organizations are directly or indirectly in quest of channels to address the quandary of women in Guatemala: whether by improving their literacy rate through access to education, humanizing health care, participating in the political arena, improving working conditions, or eliminating or reducing violence toward women. Women are making their mark on the culture, even though it is ever so slow. Groups are seeking to raise awareness and offer training workshops for leadership to allow for an exchange of ideas, and many people are becoming caught up in political reform. To change the culturally ingrained discriminations such as the patriarchal and discriminatory attitudes, it will take years and years of deliberate and forceful demands. It is, and will continue to be, an uphill struggle.

6

Ecuador—
A Country of Contrasts

The Winged Mary

THERE SHE WAS—a statue of Virgin Mary adorned with a pair of wings. She was standing rather majestically on a mountainous peak as if she was ready for a flight over the numerous volcanoes that perched themselves around the city of Quito, Ecuador. The fog and clouds hugged the hills, often obscuring the view of Mary as I stood in awe of this winged sculpture as sunrays penetrated the feathery clouds and bounced off the statue. I had never heard of Mary with wings, much less observed this effigy of her that is so honored by the people of Quito.

I learned that the people of Quito are the only people in the world that express reverence to a statue of Mary with wings. As I visited Catholic churches in Quito, such as the Metropolitan Cathedral and the La Compania de Jesus, I observed icons and statues of Mary with wings that were elaborately carved and sometimes encased in gold leaf. The concept of the insertion of wings on Mary is taken from Revelation 12:14. The scripture reveals that a dragon was hurled to earth and pursued a woman who had given birth to a male child: "She was given the two wings of a large eagle in order to fly to her place in the desert where she will be taken care of for three and a half years, safe from the dragon's attack." Vs 14.[1]

195

Even at night the winged version of Mary on the mountain peak gleams with illumination. With all the city lights aglow she appears to be surrounded by countless, glimmering stars. It is a striking scene.

A Country on the Equator

Even during February Ecuador was all dressed up with blooming flowers that seemed to embellish the country's landscape with splendor even on a moment's notice. Among the flowering shrubs and trees are such species as the hibiscus, retmana (a yellow flowering bush), the eucalyptus trees, flamboyants, magnolias, century plants, and the cinchona, the national tree, as well as many other trees sporting gorgeous multi-hued blossoms. Nesting in these shrubs and trees were some of the 15,000 species of birds of Ecuador, one of the largest varieties of birds in the world. Viewing Ecuador from the air revealed square and oblong tilled fields that resemble a patchwork quilt of artistic design.

In spite of all its natural beauty, Ecuador is considered the least developed county in South America. In a country about the size of the state of Colorado, a population of thirteen million people eke out a largely agricultural livelihood on mostly unfruitful soil. Ecuador is bordered on the north by Colombia, and Peru is to the South and East. The Pacific Ocean lies to the west and the Archipielago de Colon, better known as the Galapagos Islands, are located 600 miles to the west in the Pacific Ocean. The name "Ecuador" is derived from the word equator, which is the imaginary line that is an equal distance from the North and South poles. An equinox, which occurs twice a year, is believed by some to provide special energy from the sun as the sun crosses the equator. On those special days the length of day and night are essentially equal and there is no shadow. At this time indigenous spiritual healers make offerings to the sun in order to obtain extraordinary spirits.[2] As I visited the Ethnographic Museum and stood at the latitude of 0°0'0" at the equator, my guide said that due to the pull of gravity, I weighed four pounds less than I did earlier that same morning. I liked her calculations!

Since Ecuador is considered a tropical country there are no distinct seasons; however, there is a rainy period during February and March. Since the altitude in the Highlands, including Quito where we initially arrived in Ecuador, is 9,000 plus feet, the 600,000 tourists that come to Ecuador each year may feel light-headed upon arrival in the high altitude areas. I found I needed a little more rest on the first few days of the visit than usual.

One aspect that I always have to adjust to in South American cities are the noises, especially at night, and Ecuador is no exception; horns blow incessantly, large motors rev up, firecrackers pop to drive away spirits, the sirens of emergency vehicles scream, hawkers sell their wares such as bread on top of their heads in the early morning hours, and it seems that trucks and taxis are on the move most of the time. Traffic is so heavy that in some cities one sometimes finds it difficult to cross the street safely, especially since there are no traffic lights or stop signs on many streets.

The Spanish Conquerors

Before the Spanish invaded Quito in the 16th century, it is said that all the Virgin Women, gorgeous women who had been selected for the Inca ruler, were killed rather than allowing the Spaniards to possess them. Also the city was burned rather than surrendering it to the Spanish. The Indians (as they were named by the Spaniards who thought they had landed in India) also hid their gold, which is reported to have never been found. Another historical fact (or legend) during the 16th century pertains to a group of Amazon women called "Ganapuyaras," meaning water ladies. These women are depicted in a frieze that is perhaps fifty feet long and is carved over the entrance to a city building in Quito.

In 1534 the Spanish conquistadors, having learned of the wealth of the Inca natives, entered Ecuador with armor, guns, and horses to overtake the basically unarmed Indians. Spanish soldiers (about 200) captured thousands of proud Incas and ruled the country for 300 years. It was not until 1830 that Ecuador gained independence from Spain. However, the Spaniards had already made an imprint on the Ecuadorians, which remains even today.

The official language of the country is Spanish, the Spaniards forced Roman Catholicism upon the Indians, and the Spanish have influenced the architecture and most of Ecuador's culture. I learned that more Ecuadorians desire to immigrate to Spain and to the United States than to any other country.

There has been a tumultuous history of unrest between the well-to-do upper-class Ecuadorians, who generally have European ancestry, and the indigenous population or Indians. (The native people prefer to be called indigenous rather than Indians.) The upper class are the leaders in the government, the primary business owners, and the decision makers regarding laws and policies, even the laws pertaining to the indigenous people, which in most cases have not been favorable toward them.

The indigenous seek civil rights, more schools and health care, and advocate the maintaining of their heritage, including the preservation of the environment, which is significant to their culture. Ecuador has the highest rate of deforestation in the Americas and at the present rate the forest will be depleted in forty years.[3] A civil conflict raged for years between the upper class and the indigenous due to the lack of recognition and concern for the indigenous people, though some progress has been noted.

The Four Areas of Ecuador

There is a significant differentiation in the lifestyle of the people of Ecuador depending upon their location, their ethnicity, their economic status, and their cultural patterns. The country is divided into four specific areas: the jungle area near Peru is the Oriente, the area near the center of the country which includes the Andes Mountains is The Highlands, and the areas located between the mountains and the Pacific Ocean is referred to as the Costal. Far west into the Pacific Ocean are the Galapagos Islands.

The Oriente. Only three percent of the population of Ecuador live in the Oriente, but it is here in the steamy Amazon basin that Indians have been able to maintain many of their ancient customs. The people who populate the area are primarily the indigenous

people whose ancestors escaped the influences of the Incas as well as the Spanish conquistadors, thus they have been able to continue a lifestyle similar to their heritage.

With the discovery of oil in the Oriente in 1967 new roads are being constructed, and as people move into the area to operate the oil wells, the Indian way of life is threatened.[4] Oil has provided an economic boost to Ecuador with one third of the country's revenue being derived through the production of oil. However, for the indigenous people, it has been a blessing as well as a curse. The indigenous are being shoved farther and farther away from their native land into the jungle. This encroachment hampers the livelihood of hunting and fishing and destroys some of the fields used for agriculture. Many of the Oriente Indians have in past years been hostile to intruders, even to the point of beheading their enemies and shrinking their heads since heads are thought to have magical powers; however, the government has banned the sale of shrunken heads. Their lifestyles and culture have been and continue to be significantly altered due to their being shifted to these new areas.

The Indians of the Oriente hunt and fish in this jungle-rainforest that abounds with anteaters, rain forest monkeys, armadillos, lizards, poisonous snakes and other unique jungle dwellers. It was in the Amazon jungle that I held a somewhat tamed three-toed sloth that a family living in the jungle kept as a pet. Also, as we hiked, our guide told us to be on the lookout for jaguar pumas and poisonous frogs. I made sure I followed close behind the guide, for I thought he would know best what to do if an unsuspecting jungle friend or foe appeared. Neither the Indians nor animals are very hospitable to strangers in some of the most remote areas of the jungle.

The Sierra. Almost one-half of the population of Ecuador live in the Sierra or, as it is often called, The Highlands, which lies between two ranges of the Andes Mountains. In between these ranges are plateaus and valleys where cities and villages have found a home. Here live some of the upper class, Mestizos (Spanish and Indian ancestors), and native Indians who are descen-

dents of tribes conquered by the Incas. One of these cities in the Sierra is the capital of Ecuador, Quito, with a population of more than one million. The city of Quito appears to be surrounded by mountains of volcanic origin, which have an average height of 8,000 feet. There are at least six active volcanoes that spew ashes and smoke over the area, and earthquakes can often be severe. The Sierra has fertile arable land that is valuable for agriculture, especially since agriculture is the major industry in Ecuador and yet only seventeen percent of Ecuador's land is considered arable. The infertile soil poses serious consequences for a nation that depends so heavily on growing its own food.

The Costa. About half of Ecuadorians live in the Costa region that lies between the Andes Mountains and the Pacific Ocean. It is a very productive region and is the home of Guayaquil, a major seaport and the largest city in Ecuador. In 1982-83 heavy rains destroyed most of the crops and severely damaged the economy, devastating the area. It has taken years for the country to over-come this destruction. In the north portions of the Costa region are tropical rain forests where numerous trees abound, including the mahogany tree as well as the cinchona tree, a source of quinine used in treating malaria. Many unique flowers such as orchids and bromeliad grow in the Costa region as well. The coastal population consists of the upper class, matizos and the descen-dants of black Africans and Spanish settlers who have intermar-ried and created an atypical society.

The Galapagos Islands. The fourth geographical division of Ecua-dor is the Galapagos Islands located some 600 miles west of Ecuador in the Pacific Ocean. Three of the nineteen islands are inhabited with a population of approximately 10,000 residents but the remainder of the islands are uninhabited. Most of these residents live on the main island of Santa Cruz and have come from the mainland of Ecuador seeking employment, primarily in occupations related to the tourist industry. There is quite a con-glomeration of Ecuadorians who work as guides, rangers, in restaurants, at airports and souvenir shops. We had little contact

with the people on the islands; thus at the end of the chapter I will describe the land and exotic animals which we encountered.

Ecuador's Diverse People and Their Traditions

There is great diversity in ethnicity in Ecuador. I learned, however, that most of the people are of a conservative bent and live with a patriarchal mindset whether they are rich or poor. There is an extremely wide span in economic and societal aspects between the upper class and the preponderance of the people who are poor.

The Upper and Middle Class. The upper class of Ecuador consists of about ten percent of the people, and they usually have a European ancestry, primarily of Spanish heritage. They have been and continue to be the dominating power among the people of Ecuador. They reside primarily in cities, are educated, maintain political power and have a higher status in society than do other Ecuadorians. Although these wealthy families reside predominantly in the urban areas, they may have large haciendas in the rural areas operated by a manager that employs many of the poor at nominal fees.

As I traveled in the cities, I observed that the upper class live in "casas" or villas or mansions that are constructed out of materials such as concrete, stone, brick or wood and usually have windows decorated with ironwork, louvered shutters and well-manicured gardens. Wives of these powerful men, I learned, usually do not work outside the home but spend much of their time supervising their servants. They are known to expend a great deal of effort teaching their daughters to be lady-like and supervising them with a rather firm hand especially as regarding their association with the opposite sex. Children in these homes have few responsibilities, unlike the children in poor families who know work as a way of life.

The middle class, who also are white in appearance and boast a Hispanic heritage, primarily live in the large cities (more than half of the Ecuadorian people live in cities) and enjoy a rather

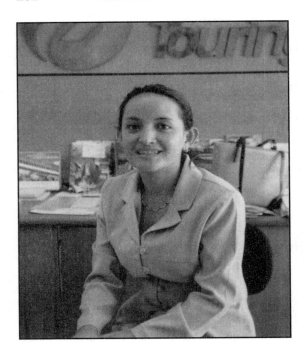

Ecuadorian business woman in Quito.

luxurious lifestyle similar to the upper class. The middle class seems to have appeared around 1950. They too are educated people and work as businessmen and in professional positions, as well as serve as governmental employees and army officers. They dress in an appropriate upscale manner and do not perform manual labor.[5]

The affluent dine elegantly on Ecuadorian cuisine. Breakfast, however, even for the upper and middle class, is by tradition small, perhaps only with breads, coffee and tea. Lunch is usually the main meal of the day since shops and offices are closed for two hours each day. Dinner is as late as 8:00 P.M. and one may partake of such fine foods as platanos, similar to bananas, which are cooked in every way imaginable even as a cake, fish soup with green peas, toasted peanuts, cheese and lots of potatoes, and every imaginable kind of meat and fruit.[6]

The Lower Class Metizos and Blacks. Nearly half of the population of Ecuador are Mestizos and about ten percent are Negroes

who live primarily in the coastal region. The Mestizos are dark skinned while the Negroes are black. The Negroes arrived during the 16th century to work as slaves on the coastal sugar plantations and have remained in the area. Though slavery was abolished in 1852, there is still a contingency of black people and some mulattoes who work and live not much better than did their ancestors, but they are free. The Negroes as well as the lower class Mestizos are mostly day laborers working in the fishing industry, loading stems of bananas on boats, or working in other areas of agriculture such as the cacao (used to make cocoa) farms. Few own land but most families keep pigs and goats. The Negroes' and the Mestizos' status are higher than that of the indigenous Indians but they, nevertheless, confront enormous racial barriers.

Most of the homes of the poorer Mestizos and blacks are constructed of adobe, reed or cane, or scrap materials. They usually have dirt floors and are often built on stilts to prevent flooding during the rainy seasons. Families, who live in the outlying areas of the cities and who have migrated from other areas, also build their houses of scrap material. Sometimes the only available space may be in the swampy areas near a city. From the air, one can observe the high-rise apartments in the cities that are being built to help with the population explosion. Since there are no laws regulating immigration, people from Peru and Columbia frequently move to the cities in search of a more productive life but often to no avail.

Women often work long days in the fields, and their weariness prevents them from accomplishing many household duties, such as keeping their homes clean. This lack of cleanliness and poorly constructed house, plus overcrowding, contributes to disease-causing organisms and invasion by insects. When a mother and her family cook, eat, and sleep in one room, proper hygiene is highly improbable. Many do not boil their water or milk because they do not understand the necessity for doing so, and some women say they do not like the taste of boiled water.

Some young Mestizo women, as well as other classes of people, have been appreciably influenced by Western culture, to the degree that one can observe in the cities a few young women

wearing short tight skirts with high heels and their hair dyed red; however, most exhibit a more conservative appearance in their attire. I suspect that these few observations are a significant deviation from the traditional culture.

The Indigenous

There are thirteen indigenous groups who are usually referred to as Indians that make up about 25% of the Ecuadorian population. Among the 71% of Ecuadorians who live in poverty are these indigenous groups as well as some of the Mestizos. Of these poor, 91% lack some of the basic staple foods and half do not have medical care.[7] Some are deprived of an education and have very little status among most Ecuadorian people. They live mostly in the Sierra but also throughout Ecuador and have little contact with the white people of the city, since they usually speak the Quechua language, wear Indian clothes and follow Indian customs. Many work for landowners and receive little or no pay. Instead of receiving payment some landowners allow them to cultivate small plots of land on the hacienda and grow food for their family.

One of the prominent tribes in Ecuador is the Otavalenos. They speak the Quechua language, which is the language most tribes have adopted, and are known for their beautiful weavings of soft ponchos, rugs, sweaters and other clothing items. I was so impressed with their weaving and designs that I purchased several items to bring home, such as a rug and wall hangings. Otavalenos walk many miles to cities and villages to sell their crafts. Near our hotel in Quito was a permanent market where the Otavaleno Indian women sold their wares. These women wear dozens of strands of painted gold beads high up on their necks, embroidered ruffled blouses and usually some type of shawl, or a wool poncho with ankle length gathered skirts. They have beautiful thick coal-black hair, light brown skin, and are most beautiful. They also like to wear black felt hats that resemble a man's hat.

I had more contact with Otavaleno Indian women than with women from any of the other indigenous tribes. I learned that

Otavaleno woman sells crafts to Winnie.

most of these Otavaleno women live on farms and that many of
their families own the land. They are a hard working, industrious
group of people who prefer to live on their own land rather than
in villages as many of the other Indians do. They make their house
of mud and wattle (poles intertwined with twigs or reeds) with
thatched roofs of grass. The house will consist of one room and
perhaps a porch where the wife and husband will weave on their
looms. On the porch will also be a millstone where the wife grinds
corn to make porridge for her family. She not only takes care of
household chores but also the guinea pig that is kept in her yard.
For recreation the family will play traditional Native American
songs on ancient-type flutes and panpipes.

Otavalenos usually have close family ties with not only their
immediate family but with extended family and relatives who live
nearby.[8] When I asked to make a photo of an Otavaleno woman

Women labor long hours to supplement family income.

who sold me some of her crafts, she would not do so unless her husband could be in the photo. She smoothed her clothes and had her husband remove his hat before posing for the photo. They both seemed pleased that I wanted their photo but seemed rather anxious about the ordeal. They are rather suspicious of strangers, especially white Americans.

Though husbands weave and share in some household chores, there is no doubt that the male is head of the household and women have learned their "role of submission" to the male in all endeavors. The woman works alongside her husband as they continue farming in much the same manner as did their ancestors, with oxen and wooden plows. Life does not change much for these women.

In the Oriente are two tribes of Indians that are indigenous to the area who are mostly farmers, hunters, and fishermen. The Indian women of these tribes mostly wear their hair long and often use red dye on their faces. Their dress usually consists of

wraparound skirts that are knee-length compared to most Indian women who wear longer skirts. Some of their income is derived from tourists who pay to take photos of the women in their village settings. These Indians have had more contact with the Mestizos (Spanish and Indian ancestors) and white people and appear to have less suspicion regarding strangers than do Indians in some areas like those of the Oriente.

Most Indians are poor and live in meager shelters. Some villages and homes can only be reached by boat, and I recall seeing some of these houses built on eight- or ten-foot stilts due to the floodwaters of the rivers. Women spend much of their time trying to survive by preparing food they have grown on infertile soil or fish caught from the tributaries that flow into the Amazon River. Even though men hunt for animals and fish, their families' staple diet consists basically of corn, beans and potatoes. Numerous women make ceramic items such as jugs and pots, and spin and weave cloth to make warm garments for their families. Women have learned to cope with existing circumstances in the jungle, though it is harsh and ever demanding to eke out an existence for her family. Women grow old quickly in the jungle. Sweat follows the line of her wrinkles as she demonstrates a naked determination for survival. However, a spike of truth came to me that was prickly—perhaps the remuneration of jungle life, in all its grandeur and wonder, may surpass some of the quagmires of our civilized world.

On numerous occasions I encountered indigenous and Mestizo women and small children begging for money. (We never encountered a man begging.) Most of these destitute women, as well as the children, wore shabby, grimy, and smelly clothes and had piercing haunting eyes that sought out empathetic people. They were gaunt individuals, who gave the appearance of being shattered and "washed out" but sought benevolence for their families. The children would lift a cup or their hands up toward our faces soliciting money. As the children pleaded for money they would sometimes stroke their stomach as if to say, "we are hungry"; they symbolically stroked our heart as well. We just could not bypass these children without sharing coins with them

even though we were aware of possibly perpetuating their begging. Occasionally we saw children who were just a few years old asleep on the sidewalk without a visible adult present. Because so many of the people of Ecuador are so poor and malnourished, it causes one to question the lack of justice metered out to these people.

On the other hand, I visited with indigenous women who were neat, clean and wore attractive Indian costumes. They were rather congenial and somewhat aggressive in their effort to sell their products. It is customary for a buyer to bargain with the seller for a lower price, but their prices were already so meager that I really didn't have the heart to seek a lower price. Women at the market took every opportunity, however, to make a dollar. If I asked a woman if I could take her photo, some would say "no" but most of the time a woman would say "one dollar." I usually would

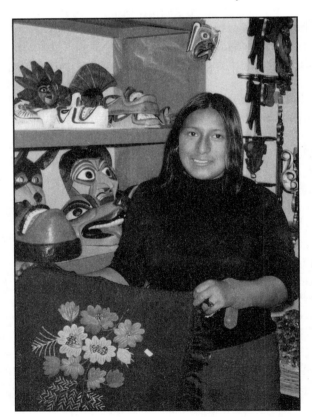

A woman sells her art, which is often painted with brushes made from her hair.

A mother cares for her child as she works.

oblige them if I really wanted a photo but otherwise I would just move on.

Creating handcrafts has been and continues to be an integral part of Ecuadorian Indian culture. Their ability to design and create meticulously such crafts as basketry, weaving cloth, stone-work, metallurgy, statues from wood and stone, beaded jewelry, and paintings with various mediums of art are ingenious. I found it fascinating that some of the women will use their own hair as a brush to paint or even to decorate an item such as a ceramic pot. On a weekend in Quito I observed Indians as they prepared for a display of their crafts in a local city park. They positioned tables under small tents, and tourists and residents came by the hundreds to see their interesting displays. Most of the sellers were women who were dressed in their multihued traditional costumes, encouraging buyers to just "look at this" as they held up the items they had crafted, such as a piece of art, jewelry made by twisting small strands of silver wire and inserting small stones on

wire, clothing, rugs and scarves made from alpaca and woven on a loom, and dozens of other items. Not only were these women putting a little money in their coffers but also they appeared to be deriving pleasure from fellowshipping with each other. They probably thought their long walk to market to sell their crafts was well worth the effort.

An indigenous or Matizos woman prepares her family's meal according to what food is available in her region. Usually the food is rather bland and most of the time she does not even use salt to enhance the flavor. She fries much of the food because her family especially likes fried food, and she will also cook rice, stews, thick soups and a favorite food called "llapingacho," a fried potato cake containing cheese. Other common dishes are "humita," a sweet corn cooked in husks like tamales and a dish called "empanadas" which is wheat pastries filled with meat. Also there is "aji," a popular hot sauce made with red peppers, tomatoes, onions and spices and used over chicken and rice or other meats. However, meat in the indigenous homes is rare; some say they do not like the taste of meat. Thus most of their protein is gained from beans or chickpeas. Although some peasant women have a few chickens and utilize the eggs, they sell the chickens at the market, which provides extra income to buy such items as grains and noodles that last longer but may not be as nutritious as the food they sell. The people suffer more from malnutrition than they do from hunger. It is the quality of the diet that is questionable.

Maltreatment of Ecuadoran Women

We had an occasion to have dinner with an upper-class Ecuadorian businessman and I listened intently to his comments regarding the role of women in Ecuador. I asked many questions regarding the plight of Ecuadorian women such as the extent of spousal abuse. He responded, "abuse is common—if a husband is beating his wife and someone tries to stop him, the woman may even say 'no'." He said women in general appear to accept the subservient role to their husbands. However, he stated that women are making slight progress in the business world in Ecua-

An Indian woman grabs a break on her bundle of merchandise.

dor. For example, he said a woman has been head of the Ecuadorian Internal Revenue Service for the past four years and has made significant strides in revamping the agency. I asked, "Do you think women are more honest and reliable in the business world than men?" His response was, "No, there are a couple of women mayors who are corrupt." I appreciated his candid responses and was pleased, however, to learn that some women have been elected to the position of mayor.

A female guide in Quito was most candid regarding the quandary of women in Ecuador. She related that the "macho attitude" poses serious detriments to stable marriages plus the male's infidelity, which is rather common, and spousal abuse, as major factors in women filing for a divorce. Other factors include the male's use of alcohol and drugs, which contributes to his demeaning behavior toward women.

A Report on Human Rights Practices written in 2001 gives the following information confirming the abuse of women in Ecuador. "Between June 2000 and 2001 there were 6,868 cases of sexual, psychological or physical mistreatment of women. In 1999 a Guayaquil NGO reported that one out of three women suffered from some form of domestic violence. Women may file complaints against a rapist or an abusive spouse or companion only if they produce a witness. Some communities have established their own centers for counseling and legal support of abused women. There is a government appointed Women's Bureau that can identify such violent incidents but has no authority to act."[9]

This report also states "that rape victims are reluctant to confront their rapist. Within a six-month period, however, there were 810 cases of rape. If the rapist marries the victim, the charges against him or anyone else who took part in the rape are not pursued unless the marriage is annulled. The government, in order to help decrease the crime rate, has raised the consequence (years in prison) for rape. For example the penalty for rape where death occurred has been increased from 16 to 35 years."

Additionally the report states, "Sexual harassment in the workplace is common. Typical cases of sexual harassment reported involves instances where a supervisor solicits sexual favors from an employee. Discrimination against women is common. Culture and tradition inhibit achievement of full equality for women. There are fewer women than men employed in professional work and skilled trades, and pay discrimination against women is common."[10]

An amendment called The Ecuadorian Law No. 11 of January 1997 to the Ecuadorian Constitution states, "The constitution, as amended, provides that the sexes are equal under the law, that the State will adopt measures necessary to achieve this goal and eliminate all discrimination, and that the state will improve the working conditions of women."[11] The amendment may be well intentioned but so far its implication has not been enforced to any significant degree. There is a strong tendency for governments to place equality for all people in their constitution but provide no visible means or assurance of enforcement of the law; however, it is a beginning.

Health Care in Short Supply

Although the Ecuadorian Government is working toward improving the standard of health care for the Ecuadorian people, there remain severe health deficiencies, especially as regards the poor. The lack of consumption of meat, milk, eggs, fresh vegetables and fruit has contributed significantly to diseases and tooth decay, not only in children but for their parents as well. Some international and local agencies provide milk for lunches in the primary grades; however, many of the children from poor families do not attend school. Health education and programs to prevent some of the more common diseases could help alleviate many health concerns.

Less than one-half of the homes of Ecuador are equipped with running water and even fewer have sewage systems. For the indigenous families piped water and sewers are almost nonexistent. Although water tank trucks do deliver drinking water to some areas, it is not sufficient to meet family needs. Rural women spend much of their time transporting water to their homes and many remain uninformed regarding the necessity of boiling the water to prevent their families from drinking contaminated water.

Because some homes have infestations of disease-carrying rodents and insects, occasionally officials will fumigate houses and a family's clothes to eradicate the unwanted pests. This was the method used to combat many cases of the bubonic plague, which was eradicated in the Sierra.[12] There have been vaccination programs to help with the eradication of yellow fever, smallpox, malaria, and polio; however, numerous other diseases still are present such as cholera which in 1991 affected more than 35,000 people, causing 600 deaths.

Rural people depend primarily on home cures since there are almost no rural doctors or hospitals. Indian folklore assumes that most illnesses are the result of supernatural forces, thus families provide their own home remedies with herbs and special remedies and seek cures through the invoking of the spirits. Many health authorities, however, are now accepting some of these herbal remedies as having curative powers and are using them on

occasion. Though mobile units are utilized in some rural and suburban localities, they are not as effective as having local medical facilities readily available to provide medical care.[13]

Another health concern, especially for expectant mothers living in rural and marginal urban areas, is the lack of family planning and health information regarding pregnancy. The high infant mortality rate, as well as the rate of babies born at risk, are considered the result of such factors as substandard housing, lack of cleanliness, low-quality food, lack of prenatal education, and the unavailability of medical facilities. Many mothers indicate their lack of energy or insufficient time after working in the fields, caring for their children, and caring for the home as reasons why they do not attend health education classes or seek medical attention during pregnancy. An expectant mother will often follow the pattern of her mother or other family members whom she has observed during their pregnancy, i.e., no prior medical care and a birth attended by family or friends. One mother tells of delivering her own baby, using a sigxi leaf which has sharp edges to cut the umbilical cord.[14] However, most mothers are more comfortable with someone in attendance at this significant time in her life. A new baby is probably one of the most significant events in her life, especially when it is the first child. It indicates that she is now a woman and has produced a precious baby that brings her untold joy.

However, having large families with limited resources delves some families deeper into the abyss of poverty. Large families may not have adequate resources for clothing, food, or houses, or the ability to educate additional children. When health professionals attempt to encourage families to limit the size of their families, the health workers are often met with suspicion and the assumption that the government is attempting to limit their families in order to decrease their numbers.[15] However, more families in recent years are seeking birth control methods such as intrauterine devices or birth control pills. The latter is often ineffective in that many uneducated women do not keep up with the current date or even own a calendar.[16] Apparently, males do not take noteworthy responsibility in the area of birth control due to numerous factors, one being cultural traditions.

Education Could Solve Many of Women's Problems

Although the Ecuadorian governmental statistics indicate 85% of the people are literate, it is apparent that many people have little or no opportunity for education. The Catholic Church, which catered to the children of the Spanish elite initially, started schools. Even in 1960 most of the schools were located in the cities and few of the Quechua-speaking Indians or Mestizos attended school. However, when schools were open to them, they were taught arts and handicrafts as well as some reading and writing. It was only in 1970 that classes were begun in Quechua, which is the primary language of the indigenous.

Even though education is free and the law states that all children are required to attend school between the ages of six and fourteen years of age, all children do not attend school due to numerous factors, such as children residing too far from the school or parents being unable to afford the required uniforms. Because schools in general are overcrowded, they usually have two sessions a day, one session in the morning and a second session for additional students in the afternoon. There are some schools that accommodate even a third session in the evenings for secondary students.[17]

I was curious about the many children I observed on the streets working and not attending school. One example was the three little boys who approached us requesting to shine

Education and training provide women work as police.

our shoes. We did not want a shoeshine but gave each of the boys money instead. They were not content. Even after we gave them money they begged for more. Numerous other shoeshine boys or children, selling such items as lottery tickets or crafts, were observed. It was heart-rending to observe these six- or seven-year-old children unattended by adults and roaming the streets begging for money to provide for their daily needs.

As additional women receive education, opportunities begin to unlock for them in positions such as office worker and sales, and in the traditional female jobs of schoolteachers, social service and medical service positions. Also, education enables women to become informed regarding their civil rights and to develop leadership skills. Education is perhaps the utmost medium for assisting women in moving from their subordinate culture to one of parity. It is also necessary that the worth and dignity of women be taught in schools as well as encouraged in the home. This philosophy must really begin in the cradle. Until the "old think" of the "hierarchical standard of justice" is replaced with one of a sense of worth and respect for women, there will be no dawn for justice for half of the people of Ecuador.

The Church Dominated by Roman Catholics

Though the Roman Catholic Church dominates the religious effort in Ecuador, there is perhaps no missionary story that is more imprinted in the minds of Americans than the tragic death of five evangelical missionaries who attempted to evangelize the Auca (Indians) in 1956. Nate Saint, who was a pilot with the Missionary Aviation Fellowship in the United States, felt a burning desire to evangelize the Aucas Indians who were a primitive and violent Indian tribe in the jungles of Ecuador. Nate, who was aware of the aggressive nature of the Aucas, attempted to enter the jungle with four other male missionaries, to witness to the Aucas. All people who had previously encountered the Aucas had met with death, which included the Inca (Indians), the Spanish conquistadors, the early Jesuit missionaries, and even gold and oil prospectors of the 19th century. The Aucas, desiring to be isolated from outside

contact, retreated deeper into the jungles and gained the reputation of cutting off the heads of people who invaded their territory. After killing a person and removing their head, they proceeded to boil the human head until the skulls shrank significantly.

Nate and his four friends, in spite of information regarding the sadistic reputation of the Aucas, planned operation "Auca." Their first step was to fly over the camp of the Aucas and drop gifts from their plane to indicate their friendliness toward the Aucas and indicate that they came in peace. The Aucas appeared to be accepting of the gifts and even seemed to watch for the plane each time it approached their area. After a period of time some of the missionaries decided to land their aircraft on a sand bar near the Aucas and attempt to greet them. Apparently all went well and during the next five days the other missionaries arrived to set up camp. Nate made radio contact with his wife indicating all was well, but in the following days there was no additional radio message from the men. Search parties immediately went into the area and found that the plane had been completely destroyed and the bodies of the five men had been speared to death and some decapitated. Their bodies were found either in the river or scattered in the area. This story shocked people around the world and received extensive press coverage, especially in the United States.

The story does not end with the death of these five men. Nate's sister, Rachel Saint, and Elizabeth Elliot, wife of Jim Elliot, one of the slaughtered missionaries, accompanied by Elizabeth's three-year-old daughter, decided to continue the missionary journey. It was three years later that these two women entered the Aucas' territory. They were the first people to connect with the Aucas and live to tell their story. Today the Auca people, mostly Christians, live in peace. This state of peace is largely credited to the work of these two fearless women who were determined, against all odds, to meet the challenge of ministering to the Aucas. Today Elizabeth Elliott, who has written several books regarding her experiences, speaks often proclaiming her mission endeavors to the Aucas. This happening of two courageous and valiant women, entering into the jungles of Ecuador to share their love

and the Good News story with the Aucas, has inspired many people to become engaged in Christian service.

When the Spanish arrived in Ecuador, they brought their Roman Catholic faith with them, which became the state religion in 1863. In 1904 a decree placed the Church under state control. Not only is the church political, but it is also the largest single landowner in the country. The Roman Catholic Church continues to be the dominant church in Ecuador with 90 percent of the population proclaiming their preference for the Roman Catholic Church even though it is said that most citizens do not practice or regularly attend any church. Middle-class Mestizo families, I was told, do not attend church as often as do the indigenous and upper-class families, who appear to be more dedicated to their religious faith. The Catholic Church has made significant contributions through opening of schools and ministries plus being a protector of the Indians. The government does not permit religious instruction in public schools though it is allowed in private schools.

Though the Protestant denominations have been permitted to be active in Ecuador, they compose less than one percent of the religious following. They have, however, provided schools and various services that have been immensely beneficial to the people, especially the poor.

Though most of the indigenous people are members of the Roman Catholic church, they have interwoven a significant amount of their earlier values and ways of life into their worship, as, for example, believing that spirits govern the weather, crops, and health. They usually participate in six to twelve fiestas each year with special celebrations evolving around baptism, marriage and funerals.

Some of the Roman Catholic Churches that were built as early as 1535 are still open for worship services. Such is the beautiful San Francisco Church in Quito. With its intricate icons and elaborate statues, I marveled at the highly skilled artisans that designed and constructed this church almost 500 years ago. Mass was in progress as I entered the church so I was able to sit with worshipers who were mostly women. But the priests, of course, were

male. Also, another intricate structure was La Companio de Jesus Church in Quito which was under construction for 160 years and was finally completed in 1765. It appeared that every icon, statue, and visible speck of the walls had been incased in gold leaf, including the statue of Mary with wings. One could question the efficacy of the elaborateness and the continual upkeep of these edifices while millions of people live in abject poverty within a stone's throw of these churches.

The Galapagos Islands

The islands, managed as the National Park Services of Ecuador, are the tops of volcanoes that emerged from the ocean millions of years ago and provide a home to atypical wildlife; many of the species are found only on these islands. For almost a week Woodie and I lived on a small cruise ship and were captivated by the fascinating wildlife as we hiked over the lava terrain. I will share some of the sights and sounds that I recorded in my journal.

Sunday, February 29, 2004
As our plane landed on the tip of San Christobal Island, we discovered that the length of the runway was so short that we almost splashed in the water of the Pacific Ocean as we touched down and came to an abrupt stop just a few feet from the ocean on the opposite side of the island. We passed the open-air terminal as we landed so the plane had to turn around and taxi up a hilly airstrip to the terminal. Buses soon arrived to take us to a small tanga (resembles a life boat), which ferried us to our waiting ship, the Flamingo. The ship accommodates only twenty tourists plus a crew of twenty Ecuadorians, all men except two females, one a maid who would at times steer the ship at night, and the other female was one of two guides.

As we entered our room located on the top deck, Woodie looked at the eight-by-nine-foot room and said, "Well, we have made it through forty-seven years of marriage, I hope that after we live together in this tiny room for a week we can still stay

married." It is a lot of togetherness. Most of the twenty passengers are senior adults except for two younger fathers with their teen-agers.

Soon after boarding we gathered in the lounge area to receive instruction from our guides regarding safety and our schedule of activities. Each guide is responsible for ten people. We were informed that we would dock within an hour for a "wet landing" at Cerro Bruja, located on the opposite side of San Christobal. We boarded a panga for a ten-minute ride before we were told to jump into shallow water from the panga and walk ashore. I now know what a "wet landing" means—jumping into the water and walking ashore. We eagerly jumped into the rolling waves—the coldest water I have ever put my feet in even though the sun was burning hot. (The cold Humboldt Current flows up from the Antarctic causing the low temperature.) We walked onto a pow-dery beach of white sand and soon I felt the full anger of the sun—so hot that I looked for a shade tree, but only leafless trees and shrubs were immediately visible. Woodie did not think it was so terribly hot but blood rushed to my face and I was burning within minutes after we arrived on the island. We sat under an almost

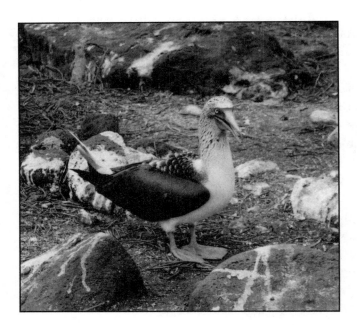

Blue-footed boobies of the Galapagos Islands.

leafless tree while most of the others snorkeled and swam to our amazement. A small finch walked up to us, pecked around our feet and finally walked away. We were careful not to intimidate birds in the area. We were so close to blue-footed boobies (birds) that we could have touched them, but we were instructed to stay on the paths and never, never touch the "fauna or flora."

As we returned to our ship, our guide mistakenly put us on the wrong panga, which was taking passengers to another ship docked near the island. We were so embarrassed when we discovered, on this our first venture from our ship, to be on the wrong panga headed out to sea to another ship. After letting off the other passengers, the panga driver turned back and took us to our ship.

Monday, March 1

We sailed almost all night and crossed the equator. Our guide instructed us that we would experience unusual turbulence as we crossed the equator since the water currents cross at this point creating rough seas. The guide was right. During the night I felt the tossing and bouncing as if we were in a rough storm, but it only lasted an hour or so.

Today we went to Darwin Bay (named after Charles Darwin, the naturalist). The golden beaming sun in the dome of the sky was partially covered by rolling clouds but there was a hot dampness. I dreaded the two-hour hike in the heat. We rode in a panga alongside the thirty-to-forty-foot high cliffs of volcanic rocks to see seals and birds. The waves were high and rocked our panga making it difficult to snap photos. To my utter amazement we docked beside a rock and were informed that we would climb to the top of the cliff to observe wildlife. It was solid lava rock and looked impossible to climb, but we did—it was almost like rock climbing straight up. I used both hands and my feet as I clawed my way up from one rock to the next, an exciting beginning to the day. After the long hike up, I discovered that coming down the cliff was even more treacherous than going up. I slid down more than I walked—my bottom served as an extra cushion.

Near the water's edge, where our panga was anchored, was a large seal sunning on a slick volcanic rock directly in our pathway—for sure he weighed 200 pounds or more. Since I was the

first person down the cliff, I stopped to get a closer look at his flippers and discovered that one of his flipper nails was missing. I bent over coming just inches from his flippers. The seal didn't like my invading its space so it immediately flipped over and upward with its face within inches of my face. The seal was flapping its flippers rapidly, growling and barking ferociously through a wide-open mouth showing its displeasure with me. I fell backward. Woodie and our guide, who were just behind me, helped me to gain an upright position. The seal would not budge from his sunning spot so we could board our panga. The guide waved her jacket in the seal's face continually until the seal finally, rather reluctantly, flipped over and rolled into the water. Even the guides do not touch the animals to encourage them to move. Later someone said to me, "Oh, you are the one that upset the seal"?

Well, I guess it was worth all the climbing effort to see such exotic and striking birds on the island. Volcanic rocks covered the island and we walked most of the time on small and medium size

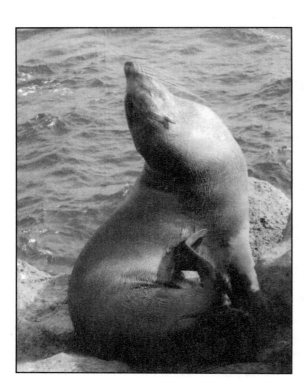

A sea lion that was displeased with a visitor's attention.

Rocky volcanic terrain on the Galapagos Islands.

rocks and huge boulders. We were so enmeshed in staying up-
right that we tended to forget the violent forces that initially
created these volcanoes. Where a little dirt accumulated between
rocks, there were a few scrawny plants and a few straggly trees but
no leaves. There was an earthy pungency in the air as we watched
the birds, hundreds of them just in one place, white boobies with
red or blue feet, masked boobies, and great frigate birds with red
pouches which they could inflate as large as a basketball to attract
females. The frigate birds also flapped their wings and made love-
calling noises to attract the females.

There are so many bird droppings that the lava rocks ap-
peared discolored, and adding to these droppings is the white
residual of the Polo Santo tree trunks. Together this coloration is
referred to as "ocher." The odor was rather stringent as we walked
on the rock-strewn, unleveled terrain. We were restricted to the
path since the area is considered fragile and needs unusual pro-
tection so the birds and other wildlife will not become extinct.
Tourists can visit the islands only in small groups and must be
accompanied by a guide in an effort to maintain the natural
habitat.

Frigate birds expand red pouches to attract female birds.

This afternoon we boarded a panga for another wet landing on GenoVesa. Inevitably when some of our group jumped from the panga (usually a woman), they would fail to land on their feet thus ending up splashing around in the cold water. So as a consequence, I was pretty careful to place my feet firmly on the bottom of the ocean floor. Here we saw mostly sea lions (type of seals). I was amused to see a newborn sea lion as well as a sea lion that looked about a year old nursing the same mother at the same time. Some baby lions would follow the mother sea lion around bellowing at the mother to lie down so they could nurse. Some of our tourists took sunbaths lying next to the sea lions.

Tuesday, March 2
We traveled across the equator again last night and it seemed that this time was worse than when we crossed it Monday night. Things fell in the room, doors slammed and I thought I might tumble out of bed. I said, "Woodie, do you know where the life jackets are?" He responded, "Oh, go back to sleep, we will soon be out of the rough waters." I stayed awake until the waves settled down and finally did go back to sleep.

We boarded the panga at 6:15 this morning in pitch darkness to go to Cerro Dragon Hill, North Santa Cruz Island. The sea lions again blocked our entry to the island so the guide had to clap her hands, wave her jacket and do all kinds of antics to drive the sea lions from the only spot for landing. Soon after arriving we viewed a heavenly blazing sun rising over the ocean and peeping through the tropical cacti. The island was formed, as were the other islands, by a volcano pushing up out of the ocean. There are no rivers on the islands that pollute the sea, thus the dark lava beaches just flow into the clear emerald seas. The flora here is different in that it has been isolated for millions of years from the mainland of Ecuador. The shore level on the side where we docked was only a few feet from sea level but, as we treaded up a hill and crossed the four- or five-acre island, we found perilous cliffs, fifty or sixty feet above the ocean floor.

At dawn, as the volcanic peaks rose up tall and mysterious, there was an explosion of birds searching for food and mates. We saw rare birds, and hundreds of slick, beautiful sea lions, as well as the ugliest creature God probably ever created, the iguana. The iguanas are typically two or three feet long and remind me of a dragon. They were quite a contrast to the beautiful sunrise that beckoned our attention as the morning dawned; however, I could hardly keep my eyes off these fascinating creatures, mostly languoring in the sun. I learned from our guide that there are two basic types of iguanas, land and marine iguanas, and they come in all colors, depending on whether they are shedding their skins or growing leather-like new skins. Some are black and others have irregular coloration that seems to adapt to the color of their environment. For example the black iguanas seem to stay on black lava and are often called black dragons. However, most of the iguanas that we saw were of yellow-orange and brown colors. The marine iguanas have a salt secreting mechanism in their fore-heads like a second set of kidneys so they can eliminate salt from their blood stream, thus making it possible for them to drink sea water. The marine iguanas have a more brilliant color pattern with gaudy patches of bright red and copper green. The iguanas, more than 200,000 to 300,000 on the islands, appeared lazy and uninhib-

Iguanas sunning on lava rocks.

ited by people as they rested near the succulent cacti and lava rocks. I kept stepping over them since they chose to sunbathe in the pathway. Equally fascinating were the many seals waiting for the warmth of the sun, while others swam searching for food in the shallow water.

We always returned to the ship for lunch. Upon boarding, the ship steward would stand at the stern of the ship with a tray of snacks. The food on our ship was Ecuadorian—cooked by an Ecuadorian crew. I told Woodie that we have a cook, not a chef, or perhaps I just needed to become more adapted to the Ecuadorian food. We ate lots of fried plantains, roasted dried corn, unusual fish soups, corn soup with shrimp, thick potato soup topped with avocado, lots of excellent bread, fresh fruit and juices. I really liked the snack mixture of popcorn and dried bananas.

In the hot slow time of the day, when the sun slowed to a crawl overhead, we traveled around the tip of Santa Cruz to North Seymour for a "dry" landing into the middle of perhaps 100 sea

lions. They all lay relaxing in the sun, spread out over the rocks. The female sea lions generally are very docile but the male at times reacts aggressively when he thinks someone is bothering his harem. One male may have a harem of as many as fifty females and reigns as the monarch of his harem until a younger, stronger stud challenges him and coerces him to leave. The monarch of this harem was estimated to weigh at least 600 pounds and bore signs of many scars from fighting with young studs. Our guide said he was about twenty-five years old and constantly patrols his domain to protect his harem from other males. (Rejected males leave to go and live with other rejected males on other islands). We were fascinated to watch some of the sea lions surfing on the waves that were perhaps ten or fifteen feet high. We halted to savor the moment, sheltering our eyes from the tiny grains of sand that the wind whipped into our faces.

The most danger we ever felt was on our departure from the island as we stood near some female sea lions while waiting for the panga to arrive. The male sea lion apparently felt that our nearness to his harem threatened the females so he bounded up the 40-foot cliff so fast that his flippers barely touched the lava rocks. There was no problem for us to remove ourselves from his beloved females. We scattered as if we were swatted flies, stumbling over rocks and each other, as we removed ourselves from his territory. We readily bowed to his demands.

I thought Monday was the roughest terrain I had ever walked on—well today was worse. Sometimes we walked on uneven black lava for one-half mile before we touched soil. The lava rocks were anywhere from about a foot thick to large boulders which were covered with bird excreta. Some of the rocks and cliffs looked like "the white cliffs of Dover." We walked on the excreta or, when we tired, we just sat on the "white" rocks because there was nowhere else to rest that was not covered with dry droppings.

Upon returning to the ship about 5:00 P.M. we discovered that our ship was experiencing mechanical problems and that the ship had been inoperable for the past two hours. We were far from an inhabited island (some islands are 100 miles apart) and with no generator we had no lights, air conditioning, or food. I imagined all sorts of things, like spending the night on one of these unin-

habited islands with the iguanas, but after transporting a me-
chanic from a ship that was anchored nearby, the problems were
corrected in a few hours and we were on our way. We learned that
the problem related to polluted fuel that the ship had taken on
earlier. I was thankful that we were able to resume our course.

I'm still having discomfort with the heat ... my face burns
even in the shade. Woodie thinks I may have sun poison. I am
determined that I will not miss one thing because of this problem
for "I am sure I will never come this way again."

Wednesday, March 3

We traveled twelve hours last night sailing around the tip of
Isabella (the largest of the Galapagos Islands) and crossed the
equator twice in one night. By now I am getting use to the
turbulence and too, I am so tired at night that nothing could wake
me. Because of the ship's mechanical problems and getting a late
start last night, we arrived at Tagus on Isabella Island later than
our schedule indicated. Six volcanoes flowed together to make
Isabella and I can't see a single tree or any vegetation from the
ship. The hike today was about four miles up to the top of an
inactive volcano to observe a lava field, scenic views, and graffiti
dating back to the 1800s. I changed my mind about not missing a
thing. I was certain that I could not manage the climb or the heat,
but Woodie did and he was one "done-in" man when he returned.
Some six or eight other passengers joined me in relaxing on the
deck while the hardy ones hiked up the volcano.

The experience of riding in a panga this afternoon around the
island to see water turtles, penguins, pelicans, flightless cormo-
rants and blue herons was more appealing than the hike in spite
of the high waves that were a little worrisome. The sea turtles
were about the size of a large tin tub but the penguins were maybe
a foot or so tall. The cormorants have lost their ability to fly but
have superior diving and swimming capabilities as they feed on
fish at the bottom of the ocean. We saw some of our first fur seals
that have short hair like a dog. Most sea lions have smooth skin
and are thought to have migrated from the coast of California
many years ago.

On most of the Islands we encountered small finches. These little birds provided Charles Darwin the incentive to write *The Origin of the Species* and to develop the theory of evolution. He observed that these little finches that now live on most of the islands, adapted to a specific island and assumed attributes that enabled them to survive. For example, if finches needed a bill like a woodpecker's bill to secure food from pecking a tree, then that was the type of bill the birds developed, or if there was a need for a top bill to lap over the bottom bill in a twisted manner in order to better secure food from the ground, that was the trait the birds developed. Though the finches could fly from one island to another, they still maintained their specific traits and would reproduce offspring with such traits.

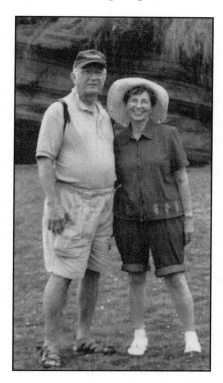

Woodie and Winnie fascinated with the black sand interspersed with pink and white oyster shells.

Thursday, March 4

Last night we crossed the equator twice to arrive at our next island. By 8:15 A.M. we were in the panga on the way for another "wet landing" and a three-hour hike. We waded to the beach, which was covered with black lava sand interspersed with pink and white crushed oyster shell. We soon left the sandy beach to begin another climb of heaps and bumps to see some new birds such as oyster catchers and lava birds; also there were lava lizards, more sea lions, red and yellow crabs, small black crabs, and sea gulls with their babies. There were so many marine iguanas that they literally covered the tops of the lava rocks.

I took a photo that had at least fifty marine iguanas lying in the sun together.

This afternoon we traveled to Bartolome Island where another climb was scheduled to the top of Mount Summit, another volcano. I really thought it would be too hot and too difficult for me but not Woodie—he took the challenge again. I really thought it was too much for him and hoped he would not go, but he did and returned with tales of breathtaking views of a unique volcanic crater. Tonight he has a sore throat, which could be due to exhaustion of the last two days.

Tonight was our night to sit at the captain's table. Although this handsome Ecuadorian captain does not speak English fluently, we had a reasonably interesting conversation. He is about 30 years old and his wife and two small children reside in Quito while he is at sea. He has been captain of the Flamingo for about three years.

Friday, March 5

Last night our ship traveled to Santa Cruz where we began our last day before traveling home. This was the day we got to see the tortoises (type of turtles), which are considered king of the Archipelago. Woodie and I and one of the guides left the ship at 7 A.M. with our rain jackets as raindrops slapped the ground and our bodies. Because of our plane schedule we had to leave the ship before the other tourists were up. We visited the Darwin Research Center where we saw incubators that hatch baby turtles and provide a protective environment until the turtles are able to survive on their respective islands. Because some turtles are almost extinct, research and protective care were established to reproduce rare turtles and protect them until they are about three years old and able to survive on the indigenous islands. Their shells need to be hard before they are released to prevent their being eaten by predators.

The most famous of the turtles in the Galapagos Islands is Lonesome George. George is the last of his species and rangers have frantically sought to find a female to mate with George. He weighs about 600 lbs. and is between 80 and 200 years old—no one

Turtles may weigh 600 pounds and live 150 years.

really knows just how old he is, but he is old for sure. He refuses to mate with females from another species, so when he dies, this specific species of turtles will be extinct.

We were fascinated at seeing other turtles weighing up to 500 pounds each. There were five of them having stalks and green leaves for breakfast, and who seemed to be posing for us to make photos of them.

When earlier ships and settlers landed on the Galapagos Islands, more than a century ago, they brought such animals as goats, rats, dogs, and donkeys, which are now wild and not only eat the grass where turtles graze but are predators of turtles and their eggs. Without assistance from the local rangers these turtles would probably in time become extinct.

Tui de Roy, a former native of the Galapagos Islands, says in her book *Galapagos Islands: Lost in Time*, "The earth is at peace with self in Galapagos."[18] I think the most astounding lesson I learned during these six days on the Islands was that people and animals could be at a peace with each other, even those animals in the wild. When animals have not been harmed or threatened by people, there is no fear. People and these animals appear to live in

perfect harmony. Henry David Thoreau said, "We can never have enough of nature. We must be refreshed by the sight of vast and titanic features." I have certainly been refreshed.

The Struggle with No Visible End

Though we did not encounter many women on the Gala-pagos Islands, my thoughts returned to the women on the main-land and their quandary. I learned that numerous agencies, coun-cils, and organizations seek to aid the women of Ecuador in rising above the demeaning status that holds them captive in their own society. Some organizations have been able to effect significant changes, but the process of making noteworthy changes in the inherent culture is complex. Throughout their lives women have been instilled with the dogma of subservience to males. Thus, it is most difficult to advocate, even to women, that they deserve civil rights, deserve to be treated with dignity and should have parity with males. Until women are enlightened through education and are motivated to seek a more just society for themselves and other women, progress will move slowly. Educating males to recognize the worth of women is an even more difficult task.

One of the organizations seeking to assist women is The Ecuadorian Women's Permanent National Forum that includes more than 320 women's organizations, which promotes social, economic and cultural changes for women. The National Wo-men's Council, another organization, provides support for ap-proximately 500 women's groups, many of which promote social consciousness and greater participation by women in the political process.[19] There is also an organization called the Women's Politi-cal Coordinator that operates in twenty-two provinces promoting women's rights and political involvement. One would think that with this many agencies seeking parity for women that justice would be just around the corner, but it isn't.

Affecting women as well as their families is the raping of forests by those seeking oil. The heritage of the Indian has been built on the sweetness of the forest and a mysterious affinity with nature that governs their lives. This traditional heritage is threat-

ened through the destruction of the forest in exploration for oil. The Confederation of Indigenous Nationalities of Ecuador is an advocacy group for the indigenous who claim unregulated logging, mining, and pesticide use seriously hamper the environment, which is the livelihood for many of the indigenous tribes. This organization is independent of political parties or religious groups and challenges government policies that threaten indigenous people. "A people without land is a people without life."[20]

Women's problems are affected by the over-all economy and well being of a country. Ecuador is confronted with foremost concerns as tremendous national debt, low per capita income, poor social conditions, an unstable government, and lack of good farming methods, as well as environmental issues, a major gap between the rich and poor, and the instability of the government over the past years, which prevents significant foreign investment that could help the economy. All of these issues have serious affects upon the well being of women. Women are confronted daily with the smell of poverty, in their needs for clean water, good quality food, health services that provide solutions such as the controlling of worms and amoebas, and there is a need for more local schools with better trained teachers. The immediate needs of survival for many of the women appear more noteworthy than women being concerned with more humane treatment, civil rights, and parity in the workplace. For many, life becomes a matter of continued existence. Until some of the necessities for livelihood are addressed, parity for women will probably lie dormant while women's lives continue to be determined by the prevailing culture.

7

Alaska's Women—
Rough and Tough

IN ALASKA, THERE IS A POPULAR SLOGAN ON T-SHIRTS that says, "Alaska—
where men are men and women win the Iditarod." The Iditarod is
a long distance dog-sled race, known as mushing, held in the
Northern Sound of Alaska. The race has challenged men for years,
but not until the 1985 Iditarod, when Libby Riddles drove across
1,049 miles of Alaska's rugged territory, had a woman won the
race. Libby drove her dogs during a deadly blizzard over hazard-
ous terrain and icy lakes from Anchorage to Nome and was almost
immovable in a tremendous blizzard during the last few days.
Nevertheless, she continued the journey while the male mushers
stayed behind because of the inclement weather. Unrelenting in
the pursuit of her goal, she pressed forward and was declared the
winner. The *Anchorage Times* headline read, "LIBBY DID IT." She
captured the attention of the nation and was featured in maga-
zines such as *Sports Illustrated* and *Vogue* and in newspapers
around the world.

At age sixteen Libby left the familiar and comfortable sur-
roundings of Minnesota and Washington state to homestead in
remote western Alaska. Her love for animals and her adventurous
nature eventually led to her winning the race, which is often
referred to as the "Last Great Race on Earth." While I was in
Alaska, I heard her describe the years of preparation for the
journey, as well as her present vocation of training dogs for
mushing. Following her presentation, I asked her if winning the

Iditarod had changed her life. Her answer was, "I have tried to not let it change my life, but many doors have been opened for me as a result of winning the race." Libby now not only trains her sled dogs but works as a glacier-mushing tour guide as well. She is one of the truly great women of Alaska. Today, her name and those of Susan Butcher and Dee Dee Jonrowe have become tantamount with mushing in Alaska.

Exploring one of the "last frontiers" in the United States and discovering the role of women in Alaska was an adventurous quest for my husband, Woodie, and me, an adventure that would reveal to us the exotic beauty of glaciers, mountains, forests, and warm friendly people. Soon after our arrival in Alaska, we ventured out to sea in exploration of the coastline of Alaska and encountered a gale that lasted almost half a day. Since the waves were appreciably high, causing the ship to pitch to and fro, we retired to our beds until the storm eased. Following the gale, we scrutinized from our small window the picturesque scenes of

One of the 300 rivers and streams in Alaska.

distant mountains that edged the ocean. On deck the views were even more beguiling while the chilling winds swept past us, constantly slapping our jackets and our faces. However, in spite of the unfriendly arctic cold sweeping down upon us, we stored these aesthetic treasures in our minds in order to revisit their beauty and crispness for days to come.

This glorious and exotic state of Alaska is thought to have been formed more than 25,000 years ago. Because of the extreme cold periods during the Ice Age, hefty frozen glaciers formed and deprived the northern oceans of water. Thus, land appeared and permitted nomadic tribes, along with their cattle, to travel across a land bridge from Asia, and those who made the crossing contributed significantly to the present culture of Alaska.

Following the exploration of this territory by Vitus Bering, an explorer seeking luxurious sea otter furs, the Russians claimed the area in 1728. After taking possession of the region, the Russians forced many of the native Aleut hunters to supply furs for the Russian ships. During this period, not only were the Russian men sexually abusive to the Aleutian women, but also scores of their husbands were captured and transported to distant areas for hunting, leaving the women without food or resources. Many of the women and men perished. Later the Russians transported the remaining Aleuts to the desolate Pribilof Islands, where the men were again forced to hunt fur seals. With minimum provisions of food and shelter, most of the Aleuts in that location perished. Their tribal numbers diminished from about 20,000 in 1741 to about 2,000 by 1899.

Eventually, as Russia was plunged into economic depression due to the Crimean War, and as the fur trade became less profitable, the Russians in 1867 agreed to sell Alaska to the United States for $7.2 million. Because of the massive size of the territory, the cost of the territory to the U.S. was about two cents per acre. Consequently, Alaska came under the protection of the United States, specifically the United States Army.

Subsequently, the United States became the owner of land stretching from the Atlantic to the Pacific oceans. Alaska is edged by the Arctic Ocean on the North, the Bering Sea on the west, and the Gulf of Alaska on the South, with Canada on its eastern

border. It is the widest and longest state in the U.S. and boasts the highest mountains in the country. Alaska is larger than 200 of the world's countries and has some 300 rivers, 100,000 glaciers, and 3,000,000 lakes, with much of the land sheltered by ice.

The Aleuts, who were the earliest settlers in Alaska, called this dazzling terra firma "Akeska," meaning "the great land." As they moved northward in search of a home, they experienced the region's unsympathetic sub-zero climate and ruthless winds, but encountered a terrain abundant with sea mammals and fish, and snarled forests overflowing with wild animals and fowl.

Perhaps the most astonishing phenomenon in the history of Alaska occurred when George Carmack, along with his Indian partner, discovered gold on the Klondike River in 1896. The event, which created an assemblage of miners from distance lands, especially from the United States, was unparalleled. More than 100,000 miners, confident of finding their fortune on the Klondike River, poured into the frontier region. When gold was subsequently discovered in Nome and Fairbanks, Alaska gained even more prominence in the eyes of the world, enticing adventurers, including women, to come to Alaska to find their destiny.

A number of colorful women came to Alaska. Among them was "Diamond Lil," a popular entertainer who flaunted a diamond between her front teeth. There was also Klondike Kate, a frontier woman who entertained the miners with her vaudeville act and was able to accrue $150,000 from the gold nuggets tossed to her during her performances. Belinga Mulroney, another Alaskan pioneer woman, astounded her fellow workers by throwing her last half dollar into the Yukon River and vowing never to use small change again. Later she became the proprietor of a hotel in the North of Alaska. Mattie Crosby, an African-American reporter for a San Diego newspaper, hiked the Chilkoot Trail as a teenager to report on the gold rush, and Woodie and I rode a train for more than two hours to see the craggy and treacherous trail that Mattie hiked. Later Mattie was celebrated as the proprietor of a bathhouse.

Many of these women were in the business of entertaining the gold miners. Reminiscent of the gold rush days in the little Alaskan town of Ketchikan is a relatively small mint-green house on

Creek Street known as "Dolly's House." Its preservation as a museum is a tribute to its legendary resident, Madam Dolly, who boarded thirty women who were often called "sporting girls." It has been said that Ketchikan was the "last place where men and salmon came to spawn." As a gateway to the north during the gold rush, it was considered a last chance place for men on their way into the wilderness or on their way back to their homes. Prostitution was a profitable business and remained legal in Alaska until 1950.

Following World War II, the bordellos were closed. I had no desire to visit museums where wolf-like packs of men devoured women. Even men's precious gold could not compensate adequately for the high cost of prostitution for these women. It is inconceivable to me that this shadowy side of the city's history is the element of choice to memorialize the legacy of the gold rush.

After the Japanese attack and occupation of Alaska's Aleutian Islands during World War II, the American government, under the leadership of President Franklin Roosevelt, decreed that an Alaskan Highway would be built, reaching from Dawson Creek in British Columbia to Fairbanks, some 1500 miles. This road was constructed in just eight months with construction crews plowing through swamps, fording rivers, and tunneling through precipitous mountain regions and virgin forest. With the completion of this highway, thousands of troops arrived in Alaska to wage war against the Japanese, who had held the islands for more than a year. This was the only area of the United States occupied during the war, and after the United States bombed the area for more than two months, the Japanese withdrew.

Following the repossession of the Aleutian Islands, the Aleuts (tribe) were evacuated to southeastern Alaska. Here they were provided with food and limited medical care and placed in deplorable abandoned cannery buildings. Consequently, due to crowded conditions, disease, and lack of decent care, many of the Aleuts died. The treatment of the Aleuts during the war was one of the worst violations of constitutional and human rights in modern history. In 1988 the Aleuts received an apology and some monetary compensation for damages from the United States Government.

In the early fifties a long, tough battle against proposed statehood for Alaska was piloted by the fishing industry of Seattle and other costal areas. Fishermen in the Seattle area and along the Pacific Coast had enjoyed harvesting the plentiful fish in Alaskan territory for many years. The industry was aware that with statehood Alaska would manage its own fishing industry and restrict some harvesting of the lucrative ocean resources along the Alaskan Coast. However, despite protests, in 1958 President Eisenhower signed a bill that officially made Alaska the 49th state.

In 1964 Alaska experienced an enormous earthquake so violent that people thought the world was ending, as the terrain ripped open and buildings sank into the earth. Trees were submerged in the marshes, and gigantic waves tore gashes in buildings and everything else in its path. There are watermarks on the coastlines indicative of the 100-foot raging wave that walloped Seward, a harsh reminder of the gigantic earthquake. Earthquake stories were told to us almost every day that we were in Alaska, and though much of the devastated area has been reconstructed, the emotional impact on the people is still apparent. Even in Anchorage, several hours' ride from Seward, we heard stories of the wall of water rushing toward Prince William Sound's coastal communities and people scrambling for high ground as their boats were tossed on to the beaches. Even when a minuscule earthquake strikes today, people shudder, for they still recall the "big one" of 1964.

Much of the terrain and life of the early settlers still exists today—cold desert tundra in the Arctic, musket marshes, hot springs, volcanoes on the Aleutian Islands, boreal forest, alpine meadows, shimmering glaciers, limestone caves, rain forest in the southeast and the permanently frozen ground called permafrost. As we viewed this unspoiled environment and breathed in the breezy, pristine autumn air, we were dazzled by the glittering, snowy mountain peaks on the horizon, reflecting the incandescent rays of sun. In the awakening of dawn, we experienced the slow blur of sunlight along with the deafening silence of the white lakes, while the forest appeared dense and forbidding as each plant fought for its own right to exist. We saw the dales turn a vibrant red against the green spruce and hemlock, and the wood-

lands splashed by the golden, grassy slopes and dazzling purple wildflowers. It is here that the early Eskimos survived, hunting bear, moose, and caribou, as well as searching the coastal areas and waterways for whales, walrus, seals and waterfowl such as geese and ducks. For thousands of years Alaska has been untouched with the exception of the addition of a few cities and highways and the construction of oil wells with all of their entanglement with the environment.

Alaska consists of six regions—the Arctic, usually referred to as the North Slope; Western A, bordering the Bering Sea coast; the Interior; the South Central; the Southeast, often referred to as the Panhandle, and the Aleutian Islands, dubbed "The Chain." Within these six geographic areas live three groups of native people: the Aleuts, who live on the Aleutian Islands; the Eskimos, called Inupiat and Yupiit; and the Indians consisting of the Tlingit, Haida, Athabasca, Eyak and Tsimshian tribes. Only 20% of the Alaskan population consists of the natives, and about 80% are white non-natives who immigrated from "the lower 48" of the United States and from other countries. A small number of African-Americans, Hispanics, Asians, and Pacific Islanders are interspersed within the population. Most of the natives live in rural villages where more than 100 languages are spoken. Those villages are usually located in the rural areas off the road system and the residents are referred to as "living in the bush" or rural Alaska. It is the native Alaskan women, both from the bush country and the cities, that are the primary topic of discussion in this chapter.

Today, Alaska has a population of only 800,000 or one person for each square mile versus the lower United States with seventy-three people per square mile. The population is equally divided between men and women. However, a native Alaskan told me that he came to Anchorage because his village had too few women, ten men to every woman, and few employment opportunities. The reality is probably that he was related to most of the women in his village and they were not available women for him.

The winters in Alaska produce some of the harshest weather of any place in the world, with ranges of temperature varying from a rare subzero temperature in the Aleutians Islands to as

much as -80 degrees in the Arctic areas. Snowfall ranges from approximately three inches a winter in the southern coastal regions and up to 1,000 inches in the northern arctic areas. This ruthless artic air produces permafrost, with its layers of shifting, ice-covered soil about a foot deep. Upon this permafrost a thick layer of short, little plants like blueberry bushes grow on the tundra and keep heat from penetrating the earth, and so the permafrost often remains throughout the summer.

Fall is typically rain and chilly winds with an occasional splash of sun. The continual glacial soggy rains kept us waterlogged far more than we wanted; however, the air was clean, crisp, and invigorating, especially when the sun's rays clamored through rare holes in the churning clouds. A man in Juneau, the capital of Alaska, conveyed to me that he would like a profession as a weather forecaster because he would predict rain every day and would be correct 80% of the time since rains fall 240 days of the year.

A major contrast exists between the large Alaskan cities, such as Anchorage with its population of about 300,000, and the small villages and towns like Ketchikan, located on the Alaskan Inside Passage. Anchorage, with one third of the state's population, is a fairly modern city with contemporary hotels, upscale restaurants, an impressive airport, and sophisticated art centers. On the other hand, Skagway, located on the shore of the Revillagigedo Island, maintains the appearance of its early period of history with its sturdy, unadorned houses built on stilts near the water's edge. Its bay, however, is dotted with modern seaplanes and small boats that are crucial for survival in Skagway, since there are no roads through the precipitous mountains surrounding the village. In most cases, the old has not been replaced with the new, as is true for much of Anchorage.

In some of the more remote villages, people live much like the natives who existed some 100 years ago. However, even though they live off the land with their hunting, fishing and making some of their clothes from animal skins, many also have modern conveniences such as cell phones, televisions, and electricity. For those villages without inland roads or railways, but located adjacent to

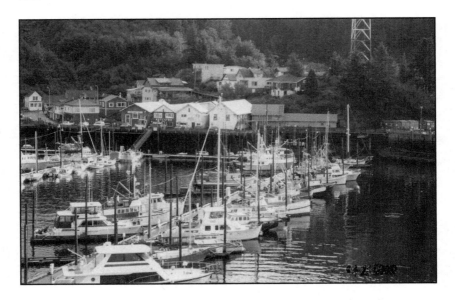

Ketchikan, a village located on the Alaskan Inside Passage.

water, seaplanes are necessary for survival and communication with the outside world. Bush pilots, who make regular visits to these villages, have shown the residents much about life outside. Thus, it is no wonder that one out of three residents of Alaska has a pilot's license. In some areas I saw more seaplanes on the water than cars on roads. Ferries and boats also service some of these remote villages, especially those on the coastal waters.

Some of the native Alaskans who live in the bush country depend upon their share of the Alaskan oil fund for survival supplies. In Juneau, I talked at length with a female bus driver regarding how this annual fund was developed, and she told me of the distribution of oil shares, which occurred in 1968 when oil was discovered at Prudhoe Bay. The oil companies built pipelines from Prudhoe Bay in the north across Alaska to the ice-free port of Valdez, some 800 miles south, where ships would transfer oil to refineries in the lower U.S. The oil companies agreed that eligible Alaskan natives would become shareholders and be paid a certain sum per year. Many Alaskans, I was told, have financed business ventures with their funds, others have saved for college education

for their young people, and others have used their funds for meeting survival needs. This oil fund has been a source of great assistance and enhancement for the native Alaskans.

Alaska, with its rich natural resources, still entices fishermen and hunters, prospectors and adventurers from all over the world in search of furs, fish, oil, coal, timber, and zinc. However, it is the one state that has not been significantly altered by masses of people and developments. Though earthquakes and volcanoes have created immeasurable damage, there is still an unbelievably great expanse of natural land that has never been explored. It was John Muir, the naturalist, in 1879 who came to Alaska and discovered the massive glaciers and the magnificence and splendor of the land. Because of his fascinating writings, especially his book *Traveling in Alaska,* many people were influenced to migrate to Alaska. Today, people are still fascinated with Alaska's mammoth glaciers, native villages, and unmarred terrain.

Early Alaskan Women—Steady and Sturdy

Women in the early Eskimo settlements were indispensable to the men. Their role consisted not only of caring for the children and preparing the food, but included also chewing animal skins to make them pliable and clean in order to make clothes for the family. Usually prior to marriage, a husband would take his bride-to-be to live with his parents, so she could learn the intricate skills she would need for their marriage, including sewing and cooking, as well as cleaning and preserving animals and fish for food. Another necessary task for the wife was to learn the trick of keeping her husband's clothes and boots dry. She also learned to make boots, called "kamiks," for her family. Men's boots came up to the knees and were covered with loose trousers, while women's boots were made of a male bear's skin and were more sophisticated, extending up to her hip. The Eskimo woman often utilized fox fur for making her coat and decorating her boots. The fur was not only warm, but she also wanted to appear "nice-looking" in her luxurious fox. She made summer clothes for the family from sealskins and bird skins with the feathers turned inward. Though

the summers were not nearly as severe as the winters, they were still cold; thus, it was necessary to provide warm clothing for her family even in the summers. For her babies, she constructed an "amaunt," a type of clothing with an attached hood to keep the baby warm as she carried him or her on her back.[1]

Contrary to popular belief, the residence of the early Eskimos was not an igloo. Repeatedly, I asked, "What about the igloos? Didn't the Eskimos live in igloos?" I was informed each time that igloos were never used as permanent homes by the Eskimos. Occasionally, a hunter would build an igloo from ice for a short-term shelter while on a hunting excursion, but it would not be used for a long-term residence. Their homes usually consisted of circular constructions measuring about nine feet in diameter, built from stone and peat; however, some of the earlier Eskimos used twigs and straw for constructing their habitat. Inside were stone benches that were used both for seating and storage underneath. Grass, straw, and animal skins were placed on the floor for sleeping. We were able to visit six or eight reproductions of these original habitats of Eskimos, Aleuts, and Indian tribes. These

A replica of an Eskimo home with a chache to store food.

replicas of their habitats were constructed according to the historical information provided by the tribe's ancestors.

The Aleuts from the Aleutian Islands, distant cousins of the Eskimos, built their habitat underground. They dug a rectangle in the ground approximately fifty feet long and twenty-five feet wide and constructed a roof over the dugout area out of driftwood and whalebone, topping off the roof with sod and moss. Because of their extended-family custom, with the bride bringing some of her relatives with her when she married, it was necessary to share a house and divide it into rooms. Often on the inside of the house, trenches were dug for a common toilet and lined with animal skins to absorb some of the odor.[2] In the center of the house was a place for a fire where the families gathered for warmth, cooked their meals, and had family gatherings, also where the children played and the women sat to sew clothing from sea lion skins, bird skins, and furs of otters and seals. Here they sewed parkas, called "kamleikas," for both themselves and the men. The women made their parkas out of seal's fur and the men's parkas from bird skin.

Woodie stands in front of a replica of an Aleut underground home.

Women also used the seal fur and the flippers of sea lions to make waterproof boots.

The Indian tribes, on the other hand, lived a somewhat more diverse existence due to their nomadic lifestyle. The Athabascans built teepee-style tents, using birch trees for supports and covering them with the skins of caribou. For windows, they stretched seal intestines over holes, which they had cut in the tent covering of caribou skin. The Athabascans hunted animals such as moose, bears and caribou, and small game such as rabbits and squirrels, and they utilized all parts of animals. They not only used the food, but they also made clothes, sleeping mats, boats, and dogsleds from the hides, needles from the small bones of birds, thread and fishing line from the animals' muscle sinew, and frames for boats, cutting tools, and dogsleds from the bones.

On the other hand, the Tingit Indians lived in more permanent houses, which contained cubicles for many families. Their two-level houses were constructed from large planks with split cedar logs for the roofs. Since they lived in clans, the houses were built large enough to accommodate fifty to sixty people in one house. The fire for cooking was built on the dirt floor.

Since the Tingit lived in southeastern Alaska, they did not experience the severe cold that most of the other tribes did, so the

An Athabascan (Indian) teepee-style home.

women sewed clothes made not only from the skins of animals but also from woven vegetable fiber, roots, bark, mountain goat's wool and dog hair. The women adorned themselves with nose rings, anklet bracelets and even tattoos. The role of the Tingit woman was significant. Though her husband paid a dowry for his wife, her family, to determine if she enjoyed a good quality of life, continually monitored her in her home. The children belonged to the mother's clan and she was responsible for the teaching of her daughters.[3]

Most of the early tribes ate sea lions, sea otter, whale, fur seals, and all kinds of smaller fish, such as salmon, cod, halibut, and clams. On land, most any animal found could be eaten, including bears, deer, rabbits, sheep and goats. For diversity there were bird eggs, roots, and berries, which were harvested especially in the permafrost areas. Some of the tribes often ate their food raw, even the meat. Because the safeguarding of food was a necessity, these people were unique in their means of drying, freezing or storing surplus food. We observed the Aleuts' racks for drying fish, which resembled clotheslines, strung on wooden poles like our grand-mothers used for drying clothes on washday. Some tribes learned to bury their food for preservation, while others stored food high on platforms for safety. When food was very scarce, some, like the Aleuts would live on seaweed and fish.[4]

The whale was perhaps the paramount catch of the day for the indigenous men, but after spearing the whale, an immense challenge ensued to hoist the weighty creature from frigid waters to the village, where the women would cut the whale into portions for distribution to all the village families. Everything from the whale, including blubber, the meat, skin and viscera, were and are still utilized. When an abundance of food was available, such as capturing a whale, there was gleeful celebration.

Today's Native Alaskan Women

When, in 1935, the United States government offered forty acres of farm land to families, more than 200 of the people took advantage of the offer to become owners in the wilderness areas north of Anchorage at a mere cost of $200. This frontier, though

rich in natural resources, was undeveloped. These families de-
sired an opportunity for new beginnings, but the frigid weather,
lack of medical care, insufficient diets, poor housing accommoda-
tions, and lack of transportation took their toll on these early
settlers. Following World War II, however, pilots began to make
the dangerous inland journey, flying up rivers and transporting
people, as well as delivering supplies and mail to the natives living
in these isolated areas.

Living in these isolated areas, the natives continue to follow
countless traditions of their ancestors. Roads are almost non-
existent in most of the bush country (and even if there are roads,
at least half are not paved). People walk to their destinations or
utilize snow sleds, all-terrain vehicles, boats, and airplanes to
make contact with the outside world. In the rural areas that we
traveled, we observed that most families lived in small log huts or
plain wooden houses that appeared to have three or four rooms
built over the permafrost or ice lens. The heat from the house often
melts the icy permafrost, causing the ground to sink. When this
shifting occurs, doorways and windows often become less than
square and difficult to close. It may then be necessary to situate
jacks under the house to facilitate leveling. When doors are unable
to be closed, women will sometimes use curtains on rods to cover
the doors and windows.

Occasionally, I was surprised to see an airplane parked in the
yards of some of these out-of-the-way houses. Though the Alas-
kan people, generally speaking, are not wealthy, owning an
airplane is a means of survival, just as an automobile seems
essential to people in the lower forty-eight states. Thus we often
saw planes parked in residential housing areas, usually with
private runways, located adjacent to a cluster of unpretentious
homes.

As we drove past some rather isolated homes near Anchorage,
we could see in several front yards caribou skins stretched for
tanning, and smoked seal, fish and birds drying on racks as long as
fifteen feet. This does not mean, however, that the residents were
void of a number of modern conveniences, such as cell phones,
radios, televisions powered by batteries, and generators to pro-

Today's typical rural home in Alaska.

duce electricity. These people may live in villages, which provide schools and recreational activities, then make yearly trips either by air or boat to a store in order to purchase essential items, as well as items that make life more convenient and enjoyable. They continue to survive, though, primarily from the resources provided from the sea and land for food and clothing.

Some of the recent additions that lessen the work of women are sewing machines, ready-made clothing, transportation by automobiles and small airplanes, and the addition of conveniences such as canned salmon, peanut butter, milk, and macaroni for their meals. While still much of their food comes from hunting and fishing, a woman occasionally enjoys the convenience of opening a can of food for a meal. Though they have the availability of machine-made jackets, most native woman still delight in having their husbands bring in seals that have shiny thick fur for making boots and clothes for her family. Another mammal that is choice for the Eskimo woman is the walrus that not only provides food for her family but also the much-sought-after ivory for making jewelry and other items. Because of the fear

of extinction of the walrus, only the Eskimos are allowed to hunt it.

One of the foods that is essential for those living in remote areas is the blubber from sea mammals, as was noted earlier. Blubber is the fat layer just under the skin of a mammal designed to keep it warm, and it is this blubber, along with the meat of the mammal, that is essential to producing a layer of fat whereby the human may also keep warm. This is one of the reasons why whales are such a prize catch, for they are the largest of the mammal group and provide the most blubber. I observed the Beluga whales as they romped in the water off the Alaskan coast, rolling playfully in the sea, and thought ironically of how much easier it is today with modern boats and spears to capture a whale than in the earlier days of the natives.

One of the great challenges that native Alaskan women encounter today is survival in the frigid temperature of the winter. With temperatures plunging to and beyond -50 degrees in the northern areas of Alaska, it becomes essential for women to provide warm clothing and homes for their families. Because the wind is so obstinate and unyielding, a woman may encounter difficulty walking upright, thus finding herself walking at a slant with the wind as her breath forms little ice crystals. If there is an

Eskimo women from Buckland, Alaska.

automobile in the family and electricity is available, they will probably plug their car battery into an electrical outlet when not in use so their engines will be warm enough to start when they wish to drive.

One of the marvels of Alaska is the variability of daylight. I found it difficult to sleep when the sun was still peaking above the horizon at 11:00 P.M. in September. However, the reverse is true in the winter, when there are only a few hours of light during the day. On June 22 the sun never sets, and on December 22 daylight lasts only four to six hours with some darkness on either side of those hours. From March 21 to September 21, the sun circles the arctic North Pole and really never sets.

Women today have to make the same adaptations to long days of sunlight in the summer and short days of light in the winter as did their ancestors. Several women told me of the difficulties of adjusting from days of constant light to days that are mostly dark. Just getting the children settled in for the night when the sun is still bright is a challenge in the summer, and having the children attend school largely in darkness in the winter is a reality that they have to adjust to.

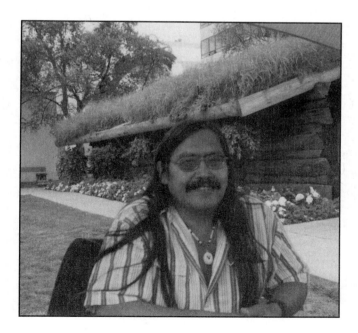

An Indian carver from southeast Alaska sits in front of a sod roof.

Although people must adapt to these extensive periods of light in the summer, they do delight in producing the incredible vegetables and dazzling flowers that thrive with the extra sunlight. I was astounded when I saw a head of green cabbage that weighed more than forty pounds and was still growing. I was even more amazed when I picked up a copy of an Anchorage newspaper and saw a photo of a cabbage that had grown to seventy pounds in size. Though the growing season is very short and the weather unpredictable, the vegetables and flowers benefit from the extensive light plus the abundance of moisture.

Splendid flowers are abundant in the city of Anchorage, where some of the native Alaskans have chosen to live rather than in the bush country. As the largest city in Alaska, Anchorage boasts a population of 300,000, almost half the population of Alaska. Here in this vibrant city are tall downtown buildings, hotels, museums, modern shopping malls and apartment buildings. The way of life for the women living in the city is quite different from that of women living in the bush. City life is often met with challenges of a different nature than the survival mode of women in the bush country.

Wildlife is abundant in Alaska, even in the cities and villages, where wild animals sometimes run free. We had occasion to see an example of this in the suburbs of Anchorage, as we observed a hefty, chestnut brown female moose and her calf as they leapt over a lofty fence into the yard of a residence. One can often see bald eagles perched on streetlights, geese nesting on the museum lawns, and grizzly bears following salmon streams into downtown areas. Along the highways to the cities, the observer can see wildlife such as mountain goats making their way through the untamed grasses and climbing rocky slopes. With so many wild animals in Alaska, it often seems that even the inhabited areas of Alaska take the appearance of a zoo. As we threaded our way through the grandeur of Alaska, we were constantly reminded of the splendor of the terrain, with its endless curving valleys and vaulted mountains and cliffs, and its magical charm of sheltering countless wild creatures.

One of the charms of Juneau for us was following a cascading stream into the higher elevations where salmon, returning to their birthplace to spawn, hurled themselves upstream. The tumbling stream, roofed by tall trees, dashed vigorously against the rocky slopes and debris of fallen trees. The forest bordering the stream was dense and forbidding, so we stayed close to the stream, where the air was heavy with moisture. This mysterious instinct of the salmon to travel hundreds of miles to return to their birthplace to spawn and then die is truly fascinating, and on several occasions, we observed so many salmon scrambling upstream that the water appeared a pinkish-red.

After observing this annual rite of the salmon life cycle, I was reluctant that evening to eat this delicacy; however, since the salmon steaks had been prepared for us, we ate and did enjoy the dinner. The salmon had been cooked over a log fire and drizzled with caramel sauce, then was served with slaw, potato salad, baked beans, and warm cornbread. For dessert, we sipped hot peppermint tea and ate blueberry cake and roasted marshmallows over a log fire near the salmon stream. It was a thoroughly charming and delightful meal.

Medically Speaking

Alaska has a system of free health care; however, because of limited funding, health care is limited, and not all Alaskans are healthy, so says an article in *The Journal of American Medical Women's Association*.[5] It is believed that many of the health problems of the native Alaskan women come from their poor social environment and the disintegration of the family, which often leaves the wife and children without adequate financial, or emotional, support.

Another suggested cause is that native Alaskan women have a slightly higher rate of smoking (seventeen cigarettes per day) than the Alaskan white woman (fifteen cigarettes per day). This level of smoking may be related to cultural practices concurrent with the use of alcohol. Other factors such as a lower education and income

*An Eskimo woman in
native costume.*

levels may be contributing factors to the health problems of native women.[6] The two leading causes of death for Alaskan women, both native and white, are cardiovascular disease and cancer.

Another major health concern for Alaskan women is unwanted pregnancy. According to Family Health Dateline,[7] half of the pregnancies of Alaskan women were unplanned in 1990-93, resulting in 23,312 unwanted babies. It has been reported, "women at-risk for unintended pregnancies are often simultaneously at risk for contacting a sexually transmitted disease. Reports indicate that in unwanted pregnancies women are four times more likely to experience physical violence during or immediately before pregnancy as women with intended pregnancies" (Pregnancy Planning and Wantedness Among Mothers of Alaskan Newborns).[8] Fifty-eight percent of native Alaskan women have unplanned pregnancies with teenagers least likely to use birth control.

However, a more positive statistic regarding Alaskan women is that Alaska ranks 45th among the states in incidence of cases of AIDS, making it one of the lowest prevalence states for AIDS in the

United States.[9] The majority of those with AIDS (74%) are those who inject drugs, or are homosexual, or both.

Native Alaskan children are at risk as their mothers are. It has been reported by the Family Health Dateline that one in five Alaskan children under five years of age experienced poverty in 1990, while 22% of Alaskan children under eighteen years of age lived in single-parent families. During the period of 1990-1994, Alaska experienced the second highest death rate in the U.S. among children less than ten years of age, and it is estimated that a third of these deaths were preventable.[10] In addition, the vaccination programs for the prevention of communicable diseases for Alaskan children falls behind the average vaccinations for children in the United States as a whole. The national average vaccination program for two-year-olds in the United States in 1996 was 78%, while in Alaska it was only 73%.

Abuse of Women and Children

The governor of Alaska, Tony Knowles, recently stated, "The statistics on domestic violence and sexual assault in Alaska are appalling."[11] Though accurate statistics are not available, it is believed that husbands or boyfriends abuse more than ten percent of Alaskan women each year. Another revealing statistic is that 26% of Alaskan women will be victims of domestic violence at some point in their life. Of those abused, 26% will require medical treatment for injuries. Though data is scant on the actual number of women abused, it is estimated that thirty-five percent of abused women have a child or children who have also been abused. The alarming rate of domestic violence is recognized as a serious medical and social issue, according to The Family Health Dateline.[12]

Also the Dateline stated that in 1996, data from the Pregnancy Risk Assessment Monitoring Systems (PRAMS) revealed that eight percent of women who had recently delivered a live born infant stated that they were abused during the twelve months before or during pregnancy. The rate of abuse during the same period for Alaskan teenagers was 19%, but for native Alaskan

teenagers, it was 22%. Seventy-five percent of these teenagers indicated their husband or partner was the abuser. Two percent of those reporting said they had been raped either during their most recent pregnancy or since their new baby was born. Fifty-three percent of the women screened indicated that abuse during pregnancy occurred less often than during the twelve months prior to pregnancy.

Alaskan women also face a much higher risk of homicide than women nationwide. Non-native Alaskan women are murdered at a rate of 1.5 times higher than the national average (6.2 per 1,000), while native women are murdered at a rate of 4.5 times higher than the national average. Eighty percent of the homicides are related to domestic violence, according to STOP (Service-Training-Officers-Prosecutors Project 1995).[13] The STOP project also indicates that in 1993 Alaska's forcible rape rate was 83 per 100,000.

The STOP program, implemented by the governor of Alaska, was designed to combat this high rate of domestic violence in Alaska. He stated, "The emotional and physical effects of domestic violence and sexual abuse are devastating the lives of far too many Alaskans. A primary goal of this administration is to provide the opportunity for all Alaskans to live in healthy, safe communities, free of violence and exploitation. The best method to achieve this is by supporting and strengthening Alaskan families, putting in place the mechanism to provide better service to victims, and prosecuting abusers to the full extent of the law."[14]

Children who observe abuse of their mothers suffer secondary psychological effects, including aggressive behavior and depression. Male children who observe abuse in their family are more likely to become abusers themselves as adults, creating a vicious intergenerational cycle of violent behavior.

A review of child abuse and neglect cases indicate that 58 out of 1,000 children in Alaska under the age of 18 in 1995 were abused; however, only 16 out of 1,000 cases were substantiated. The National Committee to Prevent Child Abuse advocates the use of Healthy Start, a program that identifies at-risk children and provides intensive home visitation from workers to provide family support. The program, Healthy Families America Alaska (HFAK)

is committed to working with families through the promotion of healthy childhood growth and development through nurturing relationships, teaching problem-solving, and improving the family support system.

In spite of commendable efforts to enlighten the public regarding the extent of violence directed toward Alaskan women and children, there still exist far too many instances of these intolerable crimes against humanity that still exist. However, by coordinating efforts in the political arenas with welfare agencies, health agencies and other concerned entities, assistance to victims of violence should be forthcoming. It will be a time-consuming and complex endeavor to stop or even reduce the painstaking cycle of abuse of women in Alaska.

Influence of the Russian Orthodox Church

Among the early religious influences on Alaska was that of the Russian Orthodox Church, and remnants of its heritage are found in Alaska today. The first Russian Orthodox Church was established in 1816 in Sitka, when the church launched efforts to establish a missionary base there. It seemed to me that there are still more Russian Orthodox churches in Alaska than any other, and I saw more evidence of the Russian influence in the fact that many of the Aleut families have Russian surnames.

During the 19th century, a number of other religious groups crossed into the frontier of Alaska to establish their presence, primarily members of the Lutheran, Presbyterian, Episcopal, United Methodist, Southern Baptist, and Catholic churches. It was through the efforts of these church groups that the early education for the Alaskan people began, and before 1912, there were few schools not aligned with one of these churches.

During World War II, a number of churches were damaged or destroyed. Not only did those Japanese soldiers who occupied a portion of Alaska participate in the destruction of many of the churches, but so did the American soldiers who arrived to drive out the Japanese. This devastation took place in the early 1940s, and it was not until 1988 that the United States government

compensated the Alaskan people with funds to restore their churches.

Women at Work

Women in Alaska do much to financially support their families. Many have professions similar to those of American women in the "lower 48," but some have vocations that are unique and challenging. Some of the more unusual occupations they hold include working at musk ox farms, carving totem poles, managing reindeer farms, harvesting salmon, operating helicopter stations for flying over glaciers, and being wives and mothers in the bush country. Alaskan women are strongly entrepreneurial, particularly in the cities, resulting in their being ranked 35th in business ownership in the U.S. in 1992.

Women's Work at the Musk Ox Farm. As I rubbed the smooth, spongy wool across my face, I discovered that it was the softest and most luxurious texture that I had ever felt. It was a piece of

A grazing musk ox.

delicate wool, more luxurious than cashmere, which had been removed from a musk ox, combed by Eskimo women into threads, and then knitted into expensive hats, scarves, and stoles. The soft under-hair of the musk oxen is called "qiviut." This wool, which is usually a chestnut brown, is woven into varying designs, which indicate the tribe of each Eskimo woman. Some of the musk ox live in the wild, where in the past years, they came close to extinction due to the demand for their wool and their meat. Because they were almost extinct 100 years ago, state laws were enacted to protect these buffalo-looking beasts with their long, shaggy coats of hair that sway like a skirt in the breeze. Some still live in the wild, while others have become domesticated on farms.

These musk ox farms provide employment for women, not only in the knitting of the musk ox wool but also in the daily upkeep of the musk ox as well. Part of the maintenance program for the domesticated musk ox is socialization, and on the farm we visited, I observed a woman employed to socialize two hours each day with the young musk ox. As we walked over the farm with rain pounding on our cold plastic ponchos, we saw the Eskimo woman caress, cuddle, and talk to the young musk oxen.

The musk ox gets its name from the sweet, sharp, musky smell given off by males during mating as they emit urine on their legs, which causes the odor. During the mating season, the males, weighing from 1,000 to 1,200 pounds, will butt heads until a survivor emerges. A unique characteristic of the musk oxen is that when they are threatened, after their young are born, they will stand shoulder to shoulder in a circle with their young in the center to protect them from wolves or other dangers. In the wild during the winters, they will scratch three or more feet deep into the snow to find green grass for winter food, but on the farms, of course, it is usually the women who provide food.

Women's Role on the Reindeer Farms. Traveling north from Anchorage through icy rain and bitter cold temperatures, we arrived at a reindeer farm. Though most reindeer live unre-strained in the enormous territory of Alaska and graze on the tundra with their larger cousins, the moose and caribou, some reindeer are domesticated for their hides, meat, and antlers.

A farm with more than 150 reindeer.

Domesticated reindeer farms provide a source of employment for women. I talked with a young woman who was an attendant at a reindeer farm. She courteously escorted me over the farm where I observed more than 150 graceful reindeer calmly huddled in herds, as if to provide protection from the cold elements. The deer would slightly turn their heads as we walked by, as if we were more of an annoyance than a threat. When a fence separated us from the deer, often the deer would walk to the fence and stick their noses through the fence as a pet would. Some of the deer sported hefty antlers so large that I wondered how they could hold their heads high, and others had only little stubs for antlers. Caring for reindeer is a tough job, but these Alaskan women absorb the bitter cold and managed, for it provides a means of survival for some of them.

Women as Sales Associates for Tourists. In that most Alaskan women speak not only their tribal language or Eskimo but English as well, they communicate effectively with the many tourists who travel to Alaska. These women sell an unbelievable array of souvenirs depicting the history or customs or products of their state. Among the items they offer include dolls with luxurious fur wraps

and headdresses, various kinds of skin boots, miniature fur animals, musk ox items, totem poles, and coats and other clothing items made from reindeer skin, sealskin, and various kinds of furs. An item often sought by tourists is the "ulus," a knife with either a stone or bone handle that was used by the natives to skin animals and fish. Another popular tourist item is the totem pole, and the town of Ketchikan claims to have more totem poles than any other city in the world. For the totem poles, native artists carve icons of their family or clan's history from cedar and paint the poles with totemic symbols to honor significant events or people. The totem poles are very popular with tourists, including the writer who displays one of these traditional Alaskan pieces in her home.

I learned from the Alaskan women I talked to that tourist trade from "the lower 48" is essential for the survival of many Alaskans. Some days, in a small town like Ketchikan, as many as 8,000 tourists arrive on five cruise ships. Without these customers, the employment of women in the tourist shops would be minimal. Tourism provides a means of livelihood not only for the merchants, but women working in restaurants and others who work as tourist guides.

Women Working in Salmon Factories. The salmon factories present another occupation for women in the town of Ketchikan, which is only six miles long and half a mile wide. This village, with its 14,000 residents, is locked by the ocean on the west, the mountains on the east, and is bound in by rugged terrain. One comes to the village by boat or by seaplane, for there are no roads or railroads entering the city. We arrived by boat and were entranced by the splendor of the village, with its small houses standing tall on pilings driven down into the ocean floor. The wooden bridge walkway, which meanders among the buildings of Ketchikan, was built over the water and in between houses and shops. Hundreds of boats lay nestled in the bay, while the mountainsides were specked with trees and a few houses in among the rocks. This town was once a gold boomtown, then a cannery town, a timber haven, and now the salmon capital of the world.

While it is usually the men who catch the salmon, it is the women who can them in the factories. We were in Ketchikan in late August and observed literally thousands of salmon leaving the ocean to enter fresh water streams to spawn at their birthplace. They crowded the streams, jumping over each other, to arrive at their spawning ground. There is a metamorphosis of the adult salmon at this point in their spawning, as they return to fresh water and their color becomes a reddish-pink. The females lay thousands of eggs under rocks, the males fertilize them, and then the life cycle of these salmon is complete.

We saw thousands of salmon already finished with spawning, now dead and floating downstream. These dead salmon, then, become a source of food for bears and other animals, as well as for large fowl such as cranes and crows. When we followed a stream to watch the salmon jumping, I encountered a man with a huge malamute dog. As I stopped to make a photo of the owner and his dogs, he said the dog smelled a bear and suggested that we not go further into the woods. I was happy to head back downstream and let the bear have his meal of salmon without interruption.

Women Driving Trolleys. Another occupation for Alaskan women is that of driving trolleys. In Juneau, the capital city of Alaska, I talked at length with a woman whose job it was to skillfully maneuver her trolley over the hilly roads of the city. I learned that she, like so many other Alaskans, was not a native but had come from the lower United States to Alaska some twenty-five years ago. Her training in education had prepared her to be a schoolteacher; however, jobs in education were scarce, with some 1000 applicants for every teaching position, so at age forty-five, she was still looking for work more suited to her training.

Women as Train Hostesses. A young Alaskan woman sold refreshments and souvenirs from her rolling cart, as she recounted historical events regarding the Chilkoot Pass during our four-hour train journey from Skagway up the mountains to the pass. Here I saw another vocation for Alaskan women that related principally to tourists, and her review of the history of the gold rush in the late 1800s fascinated us all.

Skagway, where the train trip originated, is located on the northernmost port on the Inside Passage, off the shore of Taiyua Inlet and at the head of Lynn Canal. We took this train journey over the White Pass and Yukon Route on a three-gauge railroad track to see the Chilkoot Pass, where gold prospectors arrived before entering Klondike in Canada in search of their fortunes. This narrow-gauge railroad was built because it required only a ten-foot bed, whereas the standard 4.8 gauge railroad required a fifteen-foot roadbed and also because it provided a smaller turning radius to negotiate sharp curves. The little train traveled almost straight up the sides of huge mountains and around peaks to the White Pass Summit (2,865 feet) and the edge of the Yukon in British Columbia. The flora along the mountainsides was magnificent as we observed the black cottonwood trees, deciduous sitka spruce, sub-alpine firs, and large pole pines and appreciated the panorama of red elderberries and purple nootka lupines.

In the little train, we chugged along the shoulders of sheer granite mountains and along the sides of deep gorges, which in the late 1800s provided trails and campsites for the first gold prospectors. The discovery of gold in the Klondike in 1896 brought one of the biggest stampedes for gold that the world has known, and the town of Skagway grew to a population of 10,000. Canada required that the prospectors take 2,000 pounds of food with them, enough to last one year, as they made their trip some 550 miles into the Yukon to the gold fields. Getting the designated supplies to the top of Chilkoot Pass meant ten dangerous trips from Skagway to the top of the pass before the men could enter Canada and the Klondike gold region. This represented forty-five miles of hazardous hiking, sometimes with horses, in intense arctic cold over treacherous mountain terrain. At one point we passed Dead Horse Gulch, an area where over 3,000 horses died, trying to haul supplies for the prospectors—"like mosquitoes in the frost" (Jack London).

Today the town of Skagway has fewer than 1,000 residents and plays to the tourist with displays of false-front façades of stores and red-light saloons, horse-drawn wagons, costumed ladies, and wooden sidewalks to evoke the atmosphere of the late 1890s. Many of the women of Skagway are dependent on the

cruise ships to bring tourists eager to learn of the early history of searching for gold in Alaska.

Women's Work at the Helicopter Pad. An unusual type of employment for Alaskan women is that of assisting individuals with gear needed for walking on glaciers. I was ecstatic to learn that a helicopter would fly me to glaciers, where I could explore the icy terrain on foot. However, before we could begin the journey, several women assisted me with getting my boots, life vest, and other gear and escorted me to the helicopter. I was in Juneau, which rests on the Gastineau Channel nestled against precipitous mountains and the only U.S. state capital inaccessible by road.

The glaciers near Juneau began forming millions of years ago as snow, which was piled high in the valleys, melted and refroze to become rivers of ice. When the glaciers are packed hard, the ice becomes a beautiful and captivating blue-green, but those times when the ice moves slowly down the mountain and mixes with dirt and rocks, it simply looks like dirty snow. As the glacier segments break off at the edge of the sea, called "calving" (an event which we were able to observe), the ice forms icebergs of various sizes. The 100,000 Alaskan glaciers, we were told, contain three times more fresh water than do the 3,000,000 lakes, rivers, and streams in Alaska combined.

For our excursion to the glacier fields, I sat next to the helicopter pilot, enjoying an exceedingly clear view of the weird and wonderful configuration of glaciers. Using a set of headphones, the pilot provided information regarding the formation of glaciers as we flew over the snow-capped mountains and a lake which lay between two mountains, then lifted up for a bird's-eye view of the glaciers.

Eventually, the pilot cautiously sat the helicopter down on a sizeable glacier, just a few feet from an icy 100-foot gorge. He shuffled the helicopter gradually over the glacier, probably to make sure we had solid footing, and then told us to step guardedly from the helicopter to avoid slipping on the ice and sliding into the gorge. He asked us to walk forward, never backward, not even to step backwards to take a photo, as that was how accidents

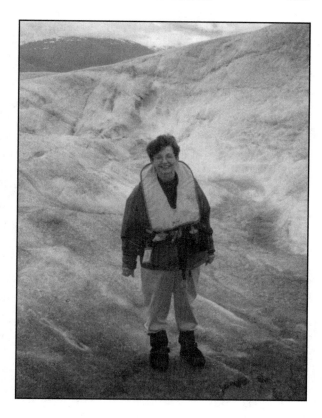

Winnie explores glaciers.

happen. When I asked if people ever fell, he told me more stories than I wanted to hear about the consequences of stepping in the wrong spot. With his words in mind, I used the utmost caution as we investigated aqua surface pools, "moraines" (deposits of stones and boulders), and "moulins" (shafts in glaciers kept opened by falling water). As we walked over the glacier, the pilot picked up "ice fish," ice particles from the small streams that flowed from opposite directions and merged in a low spot to enter a hole in the glacier.

The only wildlife we saw on the glaciers was mountain goats, but we knew, of course, that bears and a variety of other animals live on or near the glaciers. This Juneau Icefield was remarkable with its ice spires and the pinnacles of the cascading ice at the Hole-in the Wall, the Taku Glacier, and Dead Branch Glacier. We

also stopped on the Norris Glacier to see the crevasses and streams that emerged and then disappeared beneath the ice surface.

Women in Sales. The field of clerking is a major source of employment for women in the tourist towns, the cities, and in rural areas such as country stores. After our jaunt to the reindeer farm, we were famished but unable to locate a place to eat in this rather desolate rural area. However, eventually we spotted a small country store/gas station, and after some deliberation felt it was our best prospect to find food, even if only crackers and something to drink. Woodie remained in the car while I ventured into this country store and discovered a refrigerated container with a few chilled sandwiches. When I asked if the sandwiches were fresh, the woman responded, "Oh yes, they are only two or three days old." I selected two ham and cheese sandwiches for lunch but did not tell Woodie just how "old" they were. Though the sandwiches were lacking in freshness, we ate them ravenously and continued on our journey, searching for moose, bears, eagles or whatever wildlife or view presented itself.

An Aleut Indian woman sews beads on craft to sell.

There were many other occupations for women such as the large cadre of women from several Indian and Eskimos' tribes employed as dancers and singers wearing their traditional costumes that entertained tourists. There are also women in traditional occupations such as teachers, health care services, waitresses, and office workers, and a few in politics. It is the women in the "bush country" that find limited opportunities for employment and often remain in their traditional roles of mother and wife.

Living and Learning

Alaska's schools receive their primary support from the state, and most children go to public schools. Only four percent of the children attend private schools, and most of those are associated with religious groups. Education for most children is similar to that in the "lower 48" with compulsory attendance for children aged 7 to 16. Surprisingly, Alaska has the highest level of education of any state, with 87% of adults having a high school diploma.

However, for children living in the remote areas of Alaska, education is more complex. Students living in small villages may attend a local school or go to a boarding school provided by the state, necessitating their leaving their villages, or study by correspondence courses. Even though the villages may be remote, the families often have computers with Internet connections, and the students may take teleconference courses via satellite. In villages where there are one- or two-room schools, the school may also serve as a community center. It may be the only place in the village with electricity or running water.

In recent years there has been a revival to preserve native art and cultures, with schools providing specialized programs for this purpose. Some of the village schools offer language classes in the native tongue of the Yup'ik, Inupiat, or Tlingit and provide native craft classes in ivory-carving, skin-sewing and beadwork.

For students desiring to go on to higher education, there is the University of Alaska with satellites in Fairbanks, Anchorage and Juneau, university extensions in various centers, and community

colleges in almost all larger areas. Other colleges include Sheldon Jackson in Sitka (Presbyterian), Alaska Pacific University in Anchorage (Methodist), and an Orthodox Seminary in Kodiak.

Leisure Time

Much of the recreation of the Alaskan people is focused on the cold climate sports, such as sledding, ice-skating, skiing, snowmobiling, and dog sledding. These events, though experienced in extreme cold, are fun events for people who dress with appropriate warm clothing. In that most people in a community know each other or may even be related, their sense of community is strong, especially in remote areas where people live at a slower pace. Even small children enjoy playing outside in extreme cold weather such as –50 degrees. Children often compete in the dog races with their puppies, and the sport of racing dogs, mostly malamutes and Siberian huskies, is like that of racing horses in the "lower 48." Women are involved not only in the racing itself but also in such tasks as knitting booties for the dogs they race.

In some areas, such as Hooper Bay, the prehistoric tradition of creating art from nature still exists in such forms as basket-weaving. The Athabascans' beadwork and skin-sewing are artistic and beautiful, and these women also especially enjoy native dancing and the art of story-telling.

Some of the recreational activities enjoyed by families are the blanket toss, softball played on snowshoes, and 5-K Frostbite Footrace, and in the summer many families play baseball. A winter event is the Nenana Ice Classic, where a tripod connected to a trip wire is frozen in the river ice. With the arrival of spring, people bet on the exact minute the ice will break and begin to flow. This thawing causes the trip wire to set off an alarm clock and signals that spring has officially arrived.

In the winter many women enjoy decorating their yards and town with art sculptures. In Fairbanks there is the Ice Art Festival sculpturing competition, in which people come from around the world to see and compete in designing ice sculptures, such as life-size nativity scenes at Christmas. We appreciated the sculp-

turing skills as we observed a three-foot-high delicately carved ice swan.

The fact that music plays a significant role in the Alaskan culture can be observed as natives sing and play their unique instruments on the streets for shoppers and tourists. A popular Alaskan entertainer is Jewel Kilcher, who grew up near Homer and lived without the convenience of electricity or running water most of her years. Her lovely singing voice and her songs showed her love of the natural world and its significant contribution to her life. When, as a young woman, she left her home to attend college in California, word spread regarding her melodious singing, and she was offered a record contract, which resulted in a "mega hit" for her and her being honored with a "best new artist" award. Not only does she continue to sing, but she also writes poetry and thrills Alaskan audiences.

Other Champions Among Alaskan Women

Perhaps the most impressive Alaskan woman I encountered was Libby Riddles, introduced earlier, who is a musher, a racer of dogs. In 1985 she became the first woman to win the renowned Iditarod Race, traveling over wild and dangerous Alaskan territory. Libby tells that on the last day of the drive, she and her dogs encountered a brutal snowstorm, which rendered her almost powerless to find her way, but she continued the race while some of the male mushers stopped. Some of the men contemplated organizing a search party to find Libby in the storm, but all the while she was waiting for them at the finish line in Nome.

Another woman who has found a place in Alaskan history is musher Susan Butcher, who has won the Iditarod four times. Like Libby, she has dedicated much of her life to the training and racing of her dogs. Dee Jonrowe, another musher, holds the record for the fastest woman to win the Iditarod and the fourth fastest time ever. These women have shown the strength and determination of women in Alaska. They grabbed at the opportunity to demonstrate their skillfulness to compete in a world previously owned by men—and they won.

Another prominent Alaskan woman is Katie Hurley. On March 30, 2001, Governor Tony Knowles proclaimed "Katie Hurley Day" to honor this eighty-plus-year-old woman for her devoted service to Alaska. Katie, a native of Juneau, served as chief of staff to territorial governors for eight years and as special assistant to two senators. As a member of the Alaskan Democratic Party, she served many years in the House of Representatives and also ran for lieutenant governor. Her other achievements include serving as president of the state board of education, as a member of the State Commission for Human Rights, and as executive director of the Alaska Commission on the Status of Women. Katie's career has been a role model for other women, as she served her state with warmth and dignity and tirelessly promoted the cause of women throughout Alaska.

So many women have contributed to making Alaska what it is today. Another such woman is Mother Alice Lawrence, who was honored in 1997 by President and Mrs. Clinton for her work in feeding, clothing, and devoting money and time to help the people of Alaska, especially those in Anchorage. The city recently built a larger home to help her in accommodating all the "Cheechakos," newcomers who have not spent an entire winter in Alaska. Mother Alice's devotion to others has made a noteworthy difference in the lives of impoverished people in the region.

Rachel Craig is a woman who is seeking to preserve the traditions of her Inupiat (ee-nyoo-payt) people, but she realizes that the youth of her tribe need to acquire skills enabling them to succeed in a different world. She is director of the Material Development Center for the Northwest Arctic School District in Kotzebue, where she is seeking to incorporate Inupiat language and culture into the school for the Inupiat children. Reared in the culture of the Inupiat, Rachel now works to pass her knowledge to her people. She says that it is important for native women to know about their family heritage and traditions and to pass these to their children. The traditional emphasis on attaining high grades in school to secure good jobs with access to luxuries, she says, conflicts with the Inupiat cultural viewpoint that teaches people to share, not acquire. When Inupiat hunters are successful, for

example, they share not only the food but the skin of the animal as well. She teaches young women that there is room for both philosophies in their lives. She also attempts to record stories and information about the Inupiat people in order to maintain these for their families as well as integrate these stories into the school curriculum. Rachel states that it is important for the children to "know their identity so that they can have the inner strength to face life and its problems."

Jenny, an Inupiat Woman

Though this is a fictional story, I have written about Jenny based upon information that I have learned regarding Inupiat women as they live today. Inupiat means "the real people" who live north of the Arctic Circle.

Jenny thrashes at the harsh wind as she attempts to shield her eyes from the flurry of snow that pounds her body and turns her jacket into a white blanket of snow in her walk from her home to the small hole dug into the earth of ice. She has walked this seventy-five feet so many times that she knows it by heart, but the blizzard causes her to be somewhat disoriented. She must find the covered hole where she stores her food in order to secure fish and butter and the last pack of frozen berries that she picked last summer. With the ground frozen year round, the hole makes a wonderful storage place to preserve foods. Even though it was after midday on this day, it was still dark, and she stumbled as she walked to the hole dug in the ground. She could not help but worry about Jonathan, her husband, who had taken their eight-year-old son, Sam, to hunt for food in the wilderness yesterday and had not yet returned.

The winter had been extremely hard and food was scarce, since this was near the end of winter. Supplies were running low, and it would be another month before they could leave for their annual summer visit to the coast to fish, hunt, and pick berries. If Jonathan could only bring home a bear or deer to tide them over for a while, things would be so much better. However, his delay in returning causes her to fret because the snowstorm had been

exceptionally heavy and the winds had blown forcefully all night. Perhaps Jonathan had trapped or shot so many animals that he and Sam were unable to bring their catch home on the sleigh, or maybe a dangerous animal has harmed them. Jenny's imagination runs wild as she searches for the dugout. She strains her eyes as she looks down the path to look for the dugout and hopes to see a sight of Jonathan and Sam, but there is no sign of them.

Jenny reaches the dugout and finds only a few berries that they had picked last summer and three small fish left over from months before but there is no butter left. The fish are dry but she will boil them to make a stew and hope there is enough flour to thicken the broth. She will add a few potatoes to the fish stew that will give them much-needed nourishment. She is glad that Jonathan has sold the sled that he made so they have been able to purchase items at the local village store. She wishes they had enough money for pizza or hamburgers, which the children so enjoy, but that will have to come at a later time.

Jenny returns to her house and begins to cook the fish for their evening meal. Their house is small, but she is pleased that it has three bedrooms, a bath, and a kitchen with electricity and running water. It is just the right size for her and Jonathan and their two children and her mother-in-law, who lives with them. Jenny well remembers her childhood home, which was dug into a bank of earth and covered with sod and grass, just like the home her ancestors had built for centuries. The house she and her husband have is built out of lumber with two glass windows, not the dried stretched stomach of a walrus used for windows in her childhood home. How pleased she was to have windows to let in light, even though it did not keep out the cold as well as the skins. Her mother had cooked over an open fire on the ground in the center of the house with the smoke rising up through a hole in the ceiling. Today cooking on her electric stove is so much easier for Jenny, and she is thankful.

When Jenny returns from her walk, she finds little Adda, her five-year-old, and JoAnna, her mother-in-law, huddled in the corner of the kitchen close to the small wood stove. JoAnna is sewing reindeer skins to make warm fur-lined boots for Adda.

Grandmother is enticing Adda to come watch and learn how to sew the boots. "My child," she says, "you need learn to make mukluks [boots]."

"But, Nana," Adda responds, "it's too hard to push the needle through that skin."

"Life is hard, my child, but unless you watch and try you will not learn. Soon your fingers will be strong and you will be able to push the needles through the skin and make your own boots," her grandmother replies.

As Jenny prepares the potatoes for the fish stew, JoAnna asks whether Jenny has seen any sign of Jonathan and Sam. "No," says Jenny, "and the blinding storm continues and they have so little food with them. Jonathan thought they would be back last night. I hate to think of them out in this storm. Maybe they built an ice house to sleep in last night."

"Perhaps they have found shelter and Jonathan has killed a rabbit or some other animal for food," JoAnna replies. "I'm sure they'll be fine."

Jenny is not so sure as she continues stirring the fish stew, but JoAnna reminds Jenny of how strong Jonathan is and what an excellent hunter he is. Jenny knows that she must stay busy to help alleviate the worries of what might have happened to Jonathan and Sam.

Jenny thinks of some of the village people who have telephones or CB radios and many other conveniences in their homes and thinks how good it would be if Jonathan had a CB radio to let her know if they are all right. However, Jonathan has been in the same situation as about half the other men in the village, having no regular work in the winter. Money is difficult to come by, and many conveniences have to be sacrificed. In the winter months, Jonathan spends most of his time building sleds, hunting, and tending to his dogs, then when money is available, purchasing materials to make new snow sleds. They receive $1900 a year from stock in the oil industry, called the Alaska Permanent Fund, but their dividend check does not last long. It is needed to pay the electricity bill, to buy groceries and clothes, as well as fishing nets and hunting equipment. There is little money left for purchasing

materials for building sleds or getting such luxuries as a telephone.

"I knew Jonathan should not have taken Sam on a hunting trip in this stormy weather. He is just too young. He is not nearly so strong as Jonathan," Jenny remarks to JoAnna in a frightened voice.

"Jonathan was a good hunter when he was Sam's age," says JoAnna, "and Sam must learn to survive in storms and search for food for us as does his father. Our traditions of hunting and fishing ought to be taught the children."

Jenny remains silent, thinking only of the welfare of Jonathan and especially of her only son, Sam. He is the joy of their life and nothing, she feels, should prevent Jonathan from keeping Sam safe.

Time drags slowly until the end of the day when Jenny hears a sound in the distance. It is the howling of dogs, and she immediately recognizes the sounds as Jonathan's dogs. Rushing to the door, she flings it open to watch for the sled. Soon she sees Jonathan at the helm, with the dogs straining eagerly to come home, where they know food awaits them. Looking for Sam, Jenny sees what appears to be Sam lying on the sleigh, covered with skins to keep him warm. There is also a big buck lying next to Sam. Alarmed, Jenny rushes out shouting, "What is wrong with Sam?" Jonathan rather abruptly shouts back, "He's all right, just a slip on ice and he hurt his ankle. He'll be fine."

Jenny quickly pulls back the skins covering Sam and sees the ache on his face that only a mother can know. "Oh, Sam, what happened?" Turning to Jonathan, who is trying to calm the dogs enough to unhitch them, she shouts to him in the blustering wind and snow, "Let's get him inside."

Lifting him carefully, Jonathan carries Sam in the house and places him on the couch. JoAnna places warm skins over him, as Jenny examines his ankle and foot, which is twisted, making Jenny realize that his ankle is most likely broken. With no doctor in the village and no roads out of the village, Jenny immediately thinks of Mary Jameson, who has taken first aid courses and often assists at the health clinic at school. She is the first person usually

called to help with emergencies in the village. She is not a registered nurse but the best medical person in the village. Jenny sends Jonathan to fetch Mary.

When she arrives at their home, Mary examines Sam's foot and agrees that he must see a doctor in Barrows, who can x-ray his ankle and will probably place it in a cast. The only way to get to Barrows, some 100 miles away, is on the plane that comes into the village two days a week, Monday and Thursday. It is now Tuesday, so it will be two days before the plane arrives. It will be a long, tough wait, but then pain is not new to Jenny's family.

JoAnna is skeptical of the plans being made for Sam and confronts Jonathan, "He does not need to fly on that plane. It could crash and he could be killed. What he needs is a board placed on his foot and bound tightly with some skins. This is the way we have done it for years, so I know we can make it right again. There is no use for all this fancy treatment."

Jenny responds angrily, "But there is a better way now. Can't you see the pain Sam is in, and if his ankle is not put in a cast, it may take months to heal and he may limp for the rest of his life."

Accepting new approaches to problems is too complex for JoAnna, who has spent sixty-five years following traditions. The old ways of doctoring have worked for her family, and she has no interest in learning another way. The past traditions have been sufficient to survive amidst all types of tribulations, so why change? She vows to herself that she will continue to communicate to her grandchildren how her family has survived and hopes they will want to maintain their cultural traditions.

While Sam is recuperating, an unusual event happens in the Alaska sky. Every so often during the winter nights, there is an incredible display of swirling, colored lights called the aurora borealis or northern lights. This display of streams of light is a phenomenon of nature that even natives never grow weary of observing.

When Jonathan returned from the village store, he tells the family of the northern lights that are brightly swirling in the sky. The family begins putting on their warm parkas and boots to observe this striking display. Sam does not want to miss the event,

so Jenny wraps him in warm skins, and Jonathan takes Sam outside and places him on the sled so he can enjoy the array of lights. Momentarily, he forgets the pain he has been experiencing since his fall on the ice.

In spite of JoAnna's opposition, Jonathan chooses to accompany Sam on the flight to Barrows for medical treatment. Living in a village without medical aid is a challenge, but maintaining many of their traditional values is a high priority for the family as well. Living in the bush country gives them the freedom of living in the beauty of a land which shows little damage from human habitation, and to Jonathan and Jenny it is worth the inconveniences.

Sam misses a few days of school while his leg is healing, but most of all he misses his friends. His school has a gymnasium, a health clinic, computers, and a satellite dish that provides television. Jenny, along with other parents, convinced the school to include classes related to the culture of the Inupiat people. Today there are even language classes that teach the children to speak Inupiat, as well as textbooks and workbooks written in their language. Sam's school even teaches crafts such as weaving baskets, story telling of the Inupait traditions and native dancing. After school Sam walks to a village store, where he plays video games, as do the children in the "lower 48."

Sometimes Sam even sees his mother as she passes his school on her way to the post office not only to get her mail but also to gossip with neighbors. Having tea and social time with other women is one of the favorite activities for Inupiat women. Trails lead to other villages, but there are no roads, so most of their friends are in the local village. Most of Jenny's time, however, is spent preserving food, making craft items to sell, and caring for her two children. In a village of 250 people, everyone seems to know one another, and most are related. Having so many relatives around provides a great support system for Jenny and Jonathan, especially when there are problems such as Sam's broken ankle.

By the time Sam's foot is almost healed, it is time for the family to be exposed to more traditional Inupiat activities, such as leaving for the seashore for the summer. They will travel more than a hundred miles to arrive at a place in the wilderness near a sea-

shore, where they will make camp. It is here that the men will fish and the women will hunt for berries and other food, as they do each summer. The days begin to get longer and the weather milder, although it is still cold, and Jenny has brought some of the lightweight skins for warmth.

It is an exciting experience for the family to cross the mountains in an old truck borrowed from Jonathan's uncle, who seldom drives anymore since he is elderly. The bumpy roads end at the seashore, where the family hoists their tents. Jonathan removes his small boat and fishing gear from the truck, along with supplies needed for several months to a site near the sea. Without the skills to catch fish and preserve food in the summers, many "bush" families could not survive through the long, hard winters. The fishing camp becomes a village when others arrive to set up their tents, and there is fellowship among the friends of many years.

The scent of salt water fills the air, the waves bump the shore, and migrating birds fill the sky. As Jenny views the ocean and its surroundings, she turns to Jonathan and in an almost reverent voice says, "This connects us to the earth. All winter I have waited for this experience—for the long days and the warmth of the sun."

Early the first morning, Jenny, JoAnna, and Adda leave the tent to pick cranberries, blueberries, and salmon berries or whatever kind they can find. There is an abundance of berries, and after picking, Jenny places them about twelve inches deep in the permafrost ground to preserve them for the winter. Of course, she will keep out sufficient berries so there will be berries on the table each day. Also Jenny will share the berries with friends, especially those back at their winter home, for sharing of their food with others is an important characteristic of the Inupiat people.

While the women are picking berries, Jonathan and Sam are mending the nets and gathering gear for a day of fishing. Even though the water is extremely cold and dangerous, it is necessary to fish if the Inupiat are to continue their traditional way of life. Before going berry-picking, Jenny prepares a thermos of coffee to give the men a little warmth as they wait patiently for seals to surface between floating pieces of ice. Sometimes it is days before they catch a seal, but there is great celebration when it does occur. For the first time when fishing, Jonathan has a CB

radio, which he purchased when he took Sam to have his leg set in Barrows. In fact, there is also a CB radio for Jenny, so Jonathan can now stay in touch with her during the long hours of fishing and hunting.

When Jonathan catches a seal or other large fish, Jenny and JoAnna will clean the fish with Jenny's grandmother's knife called an "ulu" (oo-LOO). Her knife, made from caribou bone, is a real treasure from Jenny's past. The hides will be removed first for drying, then the blubber cut away for making oil, and finally the meat will be cut up and packed in barrels of seal oil for use next winter. Smaller fish will be dried on a rack in the warm sun. Jenny worries about the cold and other dangers for Sam as he and Jonathan hunt for seal, even though it is summer. She can recall when a cousin of hers fell into the sea when trying to retrieve a seal, and before he could be rescued he was dead from hypothermia.

Families from nearby camping villages will gather in the evenings to share stories of their heritage and share in fellowship with old as well as new acquaintances. Often they will perform in song and dance, as did their ancestors. They will relate to the children the many advantages of living a life of an Inupiat and will encourage their children to live in harmony with the earth. These interactions among families and friends are a bonding experience that helps maintain the closeness of the Inupiat, in spite of the intrusion of modern conveniences like electricity, cell phones, computers, and television. It is these transitions from their heritage to the contemporary world that parents dread for their children, yet they are realistic regarding the future of the children who are lured to the modern-day world. It is difficult, almost impossible, to adhere strictly to both philosophies at the same time. Therefore it appears appropriate that young people pick the best of each world and hold fast to principles taught by their families. (Adapted from *This Place is Cold*).[15]

Can Native Alaskan Women Look Forward with Hope?

What brings women and their families to this barren bush country of Alaska, where there are often no roads or railroads

between villages, and at every turn there are barricades and obstacles? Is it the lure of wilderness and the majestic mountains and glaciers, or is it the desire of people to continue the traditions of their heritage? Is it the challenge of establishing a home on a new frontier? Is it a desire to live in the proximity of parents and grandparents and experience a built-in support system, or is it a search for freedom and solitude? Whatever the reasons, the people in this region, and especially the women, are tough, determined, and generally happy with their calling to the wild.

The Eskimos and Indians of Alaska are clearly bound to their ancestors, yet caught between their culture and the technology of the modern life. With a unique mixture of the past and present, they follow the traditions of hunting and fishing yet own a portable television set. Even though there are no roads from some villages, there may be an airplane to provide residents transportation, or they may scoot over roads and trails on a snowmobile. The arrival of electricity has allowed people to buy refrigerators, eliminating the need to dig holes in the frozen ground to store fish, meats, and other foods, and it also brought computers and the Internet. Participating in the modern technological world has automatically eliminated a number of the native cultural traditions.

In addition to adjusting to modern technology, Alaskan women in general enjoy more political, economic, and social rights than in the past. However, parity with men still eludes women, and, according to *The Status of Women in Alaska: Highlights*, they "lack many of the legal guarantees that would allow them to achieve equality."[16] The report also states that women need "stronger enforcement of equal opportunity laws, better political representation, adequate and affordable child care, and other policies that would help improve their status."

Although Alaskan women are tough, some do not survive the abuse of husbands and significant others. One source of help for these women is the Pregnancy Risk Assessment Monitoring System, which publicizes the extent that pregnant women are physically abused and suggests avenues for intervention, particularly for low-income women. Many of these expectant mothers are receiving prenatal care and food stamps and have the availability

of a hotline number. Hospitals have agreed to be alerted to battered women and are being trained on how to respond effectively to domestic violence. The Alaska Family Violence Prevention Project, in partnership with the Alaska Network on Domestic Violence and Sexual Assault, is part of a national health initiative. It is encouraging to know that there are now dozens of organizations seeking to help victims such as Victims for Justice, Standing Together Against Rape, Abused Women, Aid in Crisis, Arctic Women in Crisis, and Aid to Women in Abuse and Rape Emergencies.

Also the establishment of the Interim Women's Commission by the Governor's Office in 1988 was a movement toward helping women. This is a commission of nine members who receive no compensation for their work, and their task "is to improve the status of women in Alaska by conducting research and implementing recommendations on the opportunities, needs and problems and contributions of women in Alaska." This includes education, homemaking, civil and legal rights, labor, and employment. Its policies are ambitious and include such items as compiling information concerning discrimination against women, studying and analyzing facts relating to Alaskan laws, and regulations and guidelines with respect to equal protection for women under the state constitution. Also it is charged to recommend legislative action for equal treatment and opportunities for women. (Administrative Order of the Governor of Alaska, 1988)[17]

In summary, the "health and well-being of American Indian and Alaska Native women falls short of that reported for other women in the United States."[18] The journal also reports that there are poor socioeconomic conditions, many cultural barriers, lack of education, and an inadequate health system that contribute to the poor health status of this population. These agencies will provide women some of the protection they need against injustices. Though progress is on the horizon, it comes too late for many. For others, at best it brings hope that tomorrow will be a day of justice and equality for Alaskan women. Though conditions are far from desirable, there is a large contingency of help that hopefully will attack the problem of inequity for Alaskan women and bring relief, especially for the Indian and Eskimo women.

Conclusion: A Global Responsibility for Justice

JUSTICE FOR WOMEN HAS NOT KEPT PACE with the many advancements of the world. Even in developing countries, televisions, cell phones, improvements in infrastructure, modern technologies and numerous advancements in education and health services are evident, but the area that has the slowest growth appears to be civil rights for women. Old traditions die hard, especially when the benefits are so lucrative for males in having a wife-servant in the home. It is much easier to maintain the status quo than it is to make changes and to develop new paradigms regarding the worth of women.

The greatest hope for the disenfranchised women of the world is Christianity. When Christianity, with its loving concept, is introduced to women, there surfaces a fresh hope through receiving God's healing grace. The spiritual nature of the good news of Jesus enhances the totality of a person's life—replacing injustices, suffering, abuses, and prejudices with love, even-handedness, justice, hope, and mercy. Luke 4:18-19 illustrates God's compassion when on a Sabbath day Jesus visited a synagogue in Nazareth and was handed a scroll with a passage from the prophet Isaiah which revealed God's concern for the disenfranchised:

"The spirit of the Lord is upon me because he has chosen me to bring good news to the poor. He has sent me to proclaim liberty to the captives and recovery of sight to the blind, to set free the

oppressed and announce that the time has come when the Lord will save his people" (Good News Bible).

It is through Christian faith that marginalized women will discover the unconditional love of God, that God reveals himself through love not hate, through mercy not abuse, through freedom and by not being bound by custom and tradition. Jesus' behavior toward women was always overflowing with dignity, benevolence, gentleness, and consideration. Hopefully, men will come to understand Jesus as their model and so emulate him in their treatment of women.

Christians have an obligation to love these sisters in distant countries through sharing the good news of God's love and grace that will bring hope to their tired and weary lives. Christianity will probably only come to these disenfranchised women when Christian women have the yearnings and longings to be God's messengers.

Most developing countries are oblivious to Christianity as women live lives of implicit servitude. Since women in these countries spend much of their life working in the fields, they have limited opportunities to attend school, which plays right into the role of subservience to males. The less education a woman possesses, the easier it is to keep her under "control." There also appears to be a high correlation between low levels of education for men and their maltreatment of women.

This tradition of control and domination has been perpetuated from one generation to the other. Schools, churches, and society in general have failed to teach men to be accountable for their actions toward women; they have not been taught to recognize women as valuable people. To assist in overcoming this quandary, early education regarding an appropriate appreciation and respectability for women must begin in the home, especially with the male children, and also in the schools.

Though women often have little reason to internalize a positive self-esteem, they need to develop a healthy view of themselves and become assured that they are worthy people, deserving of parity in the home and other areas of society. Women must be taught courage and self-preservation in confronting abusive

relationships. However, a woman may encounter almost insurmountable problems if she defends herself in a confrontation with her spouse or removes herself from the home, such as having no place to turn for respite care, no police protection, no education or vocational skill, and thus no means of supporting herself or her children. Sadly, her best alternative may be to remain at the mercy of an abusive spouse. She may even become one of the statistics, since the leading cause of death for women is violence initiated by a spouse. Madeline Albright states in her biography, *Madam Secretary,* that, "Violence against women is no one's prerogative; it is not an inevitable consequence of biology—it is a crime that we all have a responsibility to condemn, prevent, punish, and stop."[1]

Thus, in many instances, women's lives have been stolen, leaving a void in the world because of the lack of contribution from its women. The world will be a more prosperous place when women are given safety, health care, and lives in an environment of acceptance. When women are treated with dignity, they are given a sense of belonging and acceptance instead of being embittered, intimidated, and frustrated.

Women must be empowered to supervise their own lives and to make decisions independent of others. This will provide women the opportunity to become involved in such projects as developing skills in the workplace, becoming proficient in capital investment and managing micro-credit business. Women will be empowered only when they are free to make personal decisions regarding their own lives, such as whether or not they can work outside the home and whether or not they should have additional children when they cannot feed the ones they now have. Having many children generally enhances the male's self-worth.

I am reminded of an incident in Puerto Rico several years ago regarding how women working together can produce success. While serving as an educational consultant to missionary teachers in an Academy in Puerto Rico, I was asked by two women if I would like to walk in the lusciousness of a tropical rain forest. I was delighted. Though I appreciated the beauty of the forest, the continually drenching rain was not especially to my liking. During the several hours of hiking we three women crossed small

shallow streams by stepping on rocks and high spots in the streams as we progressed deeper into the forest. Hours later when we began our return from the rainforest, the little streams that had been shallow and gently flowing had now become swift muddy rivers from the heavy downfall of rain, similar to flash floods. To return to the entrance of the forest it was necessary to cross these streams. We forded the first couple of streams that were about twenty feet wide and a foot or so deep without much anxiety. Then we came to a river that now appeared to be about fifty feet wide and was flowing very rapidly. It was so high that the water was touching leaves on the trees. I said rather emphatically to my companions, "I am not a good swimmer, and I don't think I should try to cross this river. It looks deep." I had no idea as to the depth of the water and at this point I was terrified. I suggested that we wait until the water subsided even if it meant spending the night on the water-logged shore.

However, my companions had a plan. They would place me in between the two of them and each woman would clasp her hands around my arms near my elbows and I would do likewise to their arms and they would escort me across the swollen water. The older woman, a missionary about sixty-five years of age, and the younger Puerto Rican lady convinced me that with the bonding of our hands and arms together we would have extra bonding and the three of us together would have sufficient strength to successfully cross the rapidly flowing water.

Against my better judgment, I agreed to this plan and we began crossing the swollen stream. With each step I buried my feet in the rocky soil of the stream trying to hold steadfast in order that I would not be swept down the river. With water splashing first on our knees, then up to our hips, and finally up to my shoulders, needless to say I was panicky. Then, without warning the missionary slipped and her grip to my arm and hands was broken. I watched in horror as the swift waters drug her downstream. The other lady, a younger Puerto Rican woman, quickly released her grip on my other arm and went to rescue the missionary. I was left stranded in midstream, paralyzed with fear. I dug my feet deeper into the bottom of the river and struggled to

maintain my stance in the stream as the water splashed against my body. As usual, when I have gotten in tight circumstances before, I prayed, "God, just let me get out of this one and I promise that I will not get myself into a dangerous situation like this again."

The Puerto Rican woman managed to swim downstream and eventually caught up with the missionary. They struggled against the forces of the swift water by catching bushes and limbs to pull their way back along the edges of the stream where I stood taut with shock with only my head thrusting out of the water.

With all the effort they could muster, they courageously reentered the water to rescue me. By clasping our hands and arms together again, even tighter this time, we struggled to the shore. My clothes had been wet for six hours but, wet or dry, I was thankful to place my feet on firm, though muddy, earth. Alone I could not have survived, but because of the courage of two women and our bonding together I survived. It is the courage of joining together with others that provides us with the ability to connect and be empowered to accomplish our highest potential. If we join hands together for the cause of women we can provide much needed solace.

The dilemma of women is symbolized to a degree by a painting I secured while in South Africa. I lived with a Wesleyan missionary family whose daughter is an artist. She had painted a female Grecian statue that fascinated me so much that I purchased it to bring home. The painting is a thought-provoking charcoal rendition, primarily the trunk of a woman's body. The statue is without a head and one arm is severed at the shoulder and the other arm above the elbow. There is only a stub of the left leg and the right leg is severed at the knee. As I observe this extraordinary and unique statue of a woman, I ponder about the symbolism of this mutilated woman; she cannot speak or even think for herself, she is unable to move about freely, she has no hands so she cannot defend herself. This is the status of millions of women; only the trunk of a body exists with limited justice.

Even though many countries include civil rights in their constitution, women experience few civil rights and are most

likely to be excluded from participating in the political process. Laws alone will not remove the barriers women face. It will take a lot of caring, diligence, leadership, and sacrifice by many women of the world to affect change for those women caught in impoverished and discouraging circumstances. When women are treated with dignity, they will have a sense of belonging. When women are free from abuse and subjugation, they will thrive and prosper. When they have good health, they can better minister to their families. When they have an education, they will flourish. When they are treated with merit, they will have a more stable home. When a family is bound with love and respect and accepted with decorum, their communities will be recipients of more productive citizens and the world will be a better place.

We must not sit in silence while many women of the world remain in bondage. C. S. Lewis said, "To pray for our loved ones is a sweet duty." Perhaps as women we need to pray for the women in obscurity as a sweet duty. Are we the vessels that can enact change for these women who need to be unshackled from their fetters? Perhaps our global responsibility is to minister to these women who thirst for love, who need to feel a "togetherness" with other women, and receive the touch that heals.

Study Guide

Chapter 1. Russia and Its Silent Women

1. In your opinion, what is the biggest challenge regarding employment that Russian women face?
2. In what ways do women in Russia have a "high price to pay for freedom"?
3. How is the Methodist Church in Russia different from other prominent religions and denominations?
4. What are some of the alternatives to the current way of life that Russian women are choosing/ seeking?
5. What changes are necessary to improve the status and lives of women in Russia?
6. Describe the health status of Russian women, during and after the Communist era.

Chapter 2. Macedonian Women Struggle

1. What are some challenges that Macedonian women face in their daily lives?
2. What characteristic(s) make Macedonia attractive to sex traffickers as a destination and transit point?
3. Discuss the benefits of education for women. In what ways are educational opportunities for Macedonian women limited?

4. Contrast urban vs. rural life for women in Macedonia.
5. Discuss discrimination by Macedonians toward Muslim women.
6. List several ways in which the Eastern Orthodox faith differs from Islam.

Chapter 3. Kosovo—Scene of Carnage

1. What are some of the changes in the roles women in Kosovo are expected to fill since the war? How do they differ from the accepted roles of women before the war?
2. How did the war affect Muslim women in Kosovo?
3. What are the two factors that most hinder the progress of Kosovar women?
4. In what ways were women targets for Serbian soldiers?
5. How does a Kosovar husband react when his wife is raped?
6. Discuss how local and national organizations assist women in Kosovo.

Chapter 4. Australia's Aborigines

1. What are some of the factors that have kept the Aborigines from being assimilated into the larger Australian culture?
2. What health problems face Aboriginal women?
3. What are some of the major needs of Aboriginal women?
4. How has the Aborigine's "Dreamtime" religion contributed to their plight?
5. Contrast the living conditions of the Aborigines with those of other people of Australia.
6. Discuss contributions that have been made by female Aboriginal artists and athletes.

Chapter 5. Guatemalan Women—Slaves to Tradition

1. What is one reason that 80% of refugees worldwide are women?
2. Describe some of the challenges that refugee women in Guatemala face.

3. What types of discrimination against women are common in Guatemala?

4. Why is a wife a necessity for a Guatemalan man?

5. What jobs are commonly held by indigenous women in Guatemala? What problems are associated with each of these jobs?

6. How could American manufacturers, who outsource their products to Guatemala, improve the working conditions for women in the factories of Guatemala.

Chapter 6. Educador—A Country of Contrasts

1. What are some of the factors that contribute to the abuse and mistreatment of women in Ecuador?

2. What are some health concerns for women living in rural areas?

3. What benefits do women gain from education?

4. How did civil war in Ecuador affect women?

5. Contrast rural Ladino women with middle and upper class women.

6. Discuss health issues as related to pregnancy.

Chapter 7. Alaska's Women—Rough and Tough

1. What are some difficulties in the daily lives of native Alaskan women?

2. Name some unusual occupations held by women in Alaska.

3. What are some factors that contribute to the poor health status of Alaskan women?

4. What are some of the causes for health problems for native Alaskan women?

5. Why do you think 26% of the native Alaskan women are abused? Is domestic violence more of a social issue than a medical problem?

6. Give two reasons why native women have more health problems than other Alaskan women.

Notes

INTRODUCTION

1. "Our Globe and How to Reach It," (Pamphlet). Barrett & Johnson, 1990.

2. Kidd, Sue Monk, *The Dance of the Dissident Daughter*. Harper Collins-San Francisco, 1996, p. 6l.

CHAPTER 1

1. *Russia: Then and Now*. Lerner Publications Company, Minneapolis, 1992.

2. "The Russian Journal," *Moscow Weekly*. February 02, 2003.

3. Fader, Kim Brown, *Russia, Modern Nations of the World*. Lucent Books, Inc., San Diego, CA. 1998, p. 77.

4. Rice, Terence M. G., *Russia, Countries of the World*. An imprint of Times Edition, Singapore, 1999.

5. Jurgens, Urda, *Raisa, The 1ˢᵗ First Lady of the Soviet Union*. Summit Books, NY, 1990.

6. "The Russia Journal," *Moscow Weekly*. May 2000.

7. Young, Katherine, "Women, Loyal Wives, Virtuous Mothers." http://unlhrfsls.unl.edu/hrfs865/RUSSIA/WOMEN.HTM, pp. 1-7.

8. Ibid.

9. Ibid.

10. Ibid.

11. Ibid

12. Ibid.

13. Jurgens, Urda, *Raisa, The 1ˢᵗ First Lady of the Soviet Union.* Summit Books, NY, 1990.

14. Ibid.

15. Pella, Judith, *Heir of the Motherland.* Bethany House Publishers, Minneapolis, MN, 1993.

16. Brewster, Hugh, *Anastasia's Album.* Madison Press Books, Ontario, 1996, p. 6.

17. Worthington, Linda, "The Church with Women Priests Is Growing in Russia." *United Methodist Connection Daily,* Sunday, June 18, 2002.

18. Lakhova, E. F., *Women's Movement of Russia.* Moscow. http://www.ol.ru/win/women/wmr, Jan.19, 2003.

19. Ibid.

20. "The Russian Journal," *Moscow Weekly,* February 02, 2003.

CHAPTER 2

1. Danforth, Loring M., *The Macedonian Conflict.* The Princeton University Press, Princeton, NJ, 1995, pp. 5-10.

2. Ibid.

3. Poulton, Hugh, "Who are the Macedonians?" Indiana University Press, Bloomington, 2000, pp. 193-194.

4. Danforth, Loring M., *The Macedonian Conflict.* The Princeton University Press, Princeton, NJ, 1995, pp. 5-10.

5. Poulton, Hugh, "Who are the Macedonians?" Indiana University Press, Bloomington. 2000, pp. 193-194.

6. "Women in the Republic of Macedonia," UWOM.doc, www.sozm.org.mk, 9-2003.

7. "Information from Women in Macedonia," neww@new.org, March, 2001.

8. Ibid.

9. Ibid.

10. Poulton, Hugh, "Who are the Macedonians?" Indiana University Press, Bloomington, 2000, pp. 193-194.

11. "Women Can Do It: Women Empowerment in a Patriarchal Country," Union of Women of the Republic of Macedonia, www.sozm.org.mk, 9-03.

12. "Traffickers Lure Women to Macedonia," BBC World Service, August 2000.

13. "Macedonia-Environmental Aspects," *Pesticide & Toxic Chemical News,* March 2003, p. 36.

14. Ibid.

15. "Women in the Republic of Macedonia," UWOM.doc, www.sozm.org.mk, 9-2003.

CHAPTER 3

1. George, Alexandra, "Kosovo Women Come of Political Age." United Nations Development Fund for Women, June 2001.

2. "The Ravaging of Kosova," *New York Times*. June 08, 1999.

3. Roughton, Jr., Bert, "Kosovo Refugees Tell of Serb Brutality." Cox News Service, http://www.s-t.com/daily/ 3-1999.

4. "The Ravaging of Kosova," *New York Times*, June 08, 1999.

5. "Residents of Kosovo Tell of Killings There," Associated Press, June 17, 1999.

6. "The Ravaging of Kosova," *New York Times*. June 08, 1999.

7. "Serb Gang-Rapes in Kosovo Exposed." Women Rights Section of the 2000 World Report, New York, March 21, 2000.

8. Ibid.

9. Knickmeyer, Ellen, "Refugees Tell of Serbs Raping Women." Associated Press, April 26, 1999.

10. "Serb Gang-Rapes in Kosovo Exposed." Women Rights Section of the 2000 World Report, New York, March 21, 2000.

11. George, Alexandra, "Kosovo Women Come of Political Age," United Nations Development Fund for Women, June 2001.

12. "Active Support in Overcoming Fear for Women," www.balkansnet.org.

CHAPTER 4

1. Davidson, Art, "Endangered People." Sierra Club Books, San Francisco, 1993.

2. Ibid.

3. Ibid.

4. Harvert, Arden, "Journey into Dreamtime," *National Geographic*, Vol. 179, No. 1, January 1991, p. 8.

5. Newman, Cathy, "Cape York Peninsula," *National Geographic*, Vol. 189, No. 7, June 1996, pp. 14-20.

6. Andrews, Penelope, "Violence Against Aboriginal Women in Australia," *Albany Law Review*, Spring 1998, p. 6.

7. Iorns, Catherine J., "Report on Aboriginal Women and Bias in the Western Australian Justice System," *Murdock University Electronic Journal of Law,* Vol. 2, No. 1, April 1995.

8. Huxley, Elspeth, *Their Shining Eldorado–A Journey Through Australia.* New York, William Morrow & Company, 1967, p.16.

9. Andrews, Penelope, "Violence Against Aboriginal Women in Australia," *Albany Law Review,* Spring, 1998, p. 6.

10. Donnan, Shawn, "Domestic Abuse of Aboriginal Women Exposed," *Christian Science Monitor,* July 5, 2001, p. 1.

11. Iorns, Catherine J., "Report on Aboriginal Women and Bias in the Western Australian Justice System," *Murdock University Electronic Journal of Law,* Vol. 2, No.1, April 1995

12. Newman, Cathy, "Cape York Peninsula," *National Geographic,* Vol. 189, No. 7, June 1996, pp. 14-20.

13. Nangala, Joanne, Australian Aboriginal Art Investment. (member.ozwmail.com), November 2002.

CHAPTER 5

1. Simon, Jean-Marie, "Guatemala: Eternal Spring, Eternal Tyranny." W. W. Norton Company, New York, 1987.

2. MacNabb, Valeria, "Women's Role in Guatemala's Political Opening." Central American Analysis Group, Guatamala City, Guatemala, October 1998, pp. 1-5.

3. Simon, Jean-Marie, "Guatemala: Eternal Spring, Eternal Tyranny." W. W. Norton & Company, New York, 1987.

4. "Observations of the Committee on Economic, Social and Cultural Rights." Guatemala. Office of the United Nations High Commissioner for Human Rights, Geneva, Switzerland, May 2001, p. 3.

5. Morrison, Marion, *Places and People, Mexico and Central America.* Franklin Watts, NY, 1995, p. 15

6. Moore, Don, "The Sociolinguistics of Guatemalan Indigenenous Languages and the Effect on Radio Broadcasting." Ohio University, 1989. www.swl.net/patepluma/central p. 2.

7. Guatemala: Office of the United Nations High Commissioner for Human Rights. Geneva, Switzerland, May 2001, pp. 3-5.

8. "Committee on the Elimination of Discrimination Against Women." Human Rights Library, 1994, pp. 1-7. http://1.umn.edu/humanrts/cedaw/cedaw-Guatemala.htm

9. Moore, Don, "The Sociolinguistics of Guatemalan Indigenenous Languages and the Effect on Radio Broadcasting." Ohio University, 1989. www.swl.net/patepluma/central p. 2.

10. Morrison, Marion, *Places and People, Mexico and Central America.* Franklin Watts, NY, 1995, p. 15

11. MacNabb, Valeria, "Women's Role in Guatemala's Political Opening." Central American Analysis Group, Guatemala City, Guatemala, October 1998, pp. 1-5.

12. Delahaba, Lewis,"Guatemala Maya and Modern," *National Geographic,* Vol. 146, No. 5, p. 661.

13. MacNabb, Valeria, "Women's Role in Guatemala's Political Opening." Central American Analysis Group, Guatemala City, Guatemala, October 1998, pp. 1-5.

14. Delahaba, Lewis, "Guatemala, Maya and Modern," *National Geographic,* Vol. 146, No. 5, p. 661.

15. "Domestic Workers: Legal Discrimination and Daily Exploitations." Gender-specific Labor Rights Violations in the Domestic Work and Maquila Sectors, Human Rights Worldwide, 2002. www.hrw.org/reports

16. "Committee on the Elimination of Discrimination Against Women." Human Rights Library, 1994, pp. 1-7. http://1.umn.edu/humanrts/cedaw/cedaw-Guatemala.htm

17. "Guatemala: Women and Girls Face Job Discrimination." *Human Rights News,* Human Specific Labor Rights Violations in the Domestic Work and Maquilla Sectors, Human Rights Worldwide, 2002. www.hrw.org/reports.

18. Ibid.

19. Central Intelligence Agency, *The World Fact Book,* Guatemala, August 2003, p. 12.

20. "Observations of the Committee on Economic, Social and Cultural Rights." Guatemala. Office of the United Nations High Commissioner for Human Rights, Geneva, Switzerland, May 2001, pp. 3-5.

21. "Committee on the Elimination of Discrimination Against Women." Human Rights Library, 1994, pp. 1-7. http://1.umn.edu/humanrts/cedaw/cedaw-Guatemala.htm

22. Ibid.

23. Ibid.

24. MacNabb, Valeria, "Women's Role in Guatemala's Political Opening." Central American Analysis Group, Guatemala City, Guatemala, October 1998, pp. 1-5.

25. Moore, Don, "The Sociolinguistics of Guatemalan Indigenenous Languages and the Effect on Radio Broadcasting." Guatemala, Ohio University, 1989. www.swl.net/patepluma/central p. 2.

26. Delahaba, Lewis, "Guatemala, Maya and Modern," *National Geographic,* Vol. 146, No. 5, p. 661.

27. "Basic Rights: Protection from Violence." Oxfam Community Aid Abroad, Oxfam Horizons, January 1997, p.1.

28. Ibid.

CHAPTER 6

1. *Good News Bible, The Bible in Today's English Version.* American Bible Society, New York, 1976.

2. Lelpthien, Emilie U., *Enchantment of the World:* Ecuador. Children's Press, Chicago. 1986.

3. "The Confederation of Indigenous Nationalities of Ecuador," Nacionalidades Indias. (Newsletter) Quito, Ecuador 2004. pp. 1-4. http://conaie.nativeweb.org/brochurce.hetml.

4. Ibid.

5. Ibid.

6. Ibid.

7. "Respect for Human Rights," Country Reports on Human Rights Practices by the Bureau of Democracy, Human Right, and Labor." March 4, 2002. http://www state.gov/g/drl

8. Lelpthien, Emilie U., *Enchantment of the World: Ecuador.* Children's Press, Chicago, 1986.

9. Family Planning and Nutrition in Ecuador, Third World Women's Health. 2003. hhtp://www.arches.uga.educ/

10. "Respect for Human Rights,"Country Reports on Human Rights Practices by the Bureau of Democracy, Human Right, and Labor. March 4, 2002. Http://www state.gov/g/drl

11. Family Planning and Nutrition in Ecuador, Third World Women's Health. 2003. hhtp://www.arches.uga.educ/

12. Lelpthien, Emilie U., *Enchantment of the World: Ecuador.* Children's Press, Chicago. 1986.

13. Ibid.

14. Ordonez, Sandra, "Studying the Women in Ecuador." Benson Institute, 2001, Vol. 22, p. 5. http://bbenson.byu.edu members/tiffanylet

15. "Family Planning and Nutrition in Ecuador, Third World Women's Health." Hhtp://www.arches.uga.educ/2003

16. Ibid.

17. Lelpthien, Emilie U., *Enchantment of the World: Educador.* Children's Press, Chicago, 1986.

18. Tui de Roy, *Galapagos Islands; Lost in Time.* New York, Viking Press, 1980, pp. 1-10.

19. "Respect for Human Rights," Country Reports on Human Rights Practices by the Bureau of Democracy, Human Right, and Labor. March 4, 2002. http://www state.gov/g/drl

20. "The Confederation of Indigenous Nationalities of Ecuador," Nacionalidades Indias. (Newsletter) Quito, Ecuador, 2004. pp. 1-4. http:// conaie.nativeweb.org/brochurce.hetml

CHAPTER 7

1. Jenness, Aylette and Alice Rivers, *In Two Worlds: A Yup'ik Eskimo Family.* Houghton Mifflin Co., Boston, 1989, p 25.

2. Beckett, Elizabeth and Sarah Teel, "Tingit Women," *Women in Alaska's History.* 1997. http://library.thinkquest.org/11313/Early_History/ Native_Alaskans/tlingit

3. Ibid.

4. Hoyt-Goldsmith, Diane, *Artic Hunter,* Holiday House, New York, 1992.

5. Joe, Jenny R., "Health of American Indians and Alaska Native Women." *Journal of the American Medical Women's Association,* Vol. 51, 2000. www.jamwa.org.

6. "Cigarette Smoking Among American Indians and Alaskan Natives," *Behavioral Risk Factor Surveillance. Weekly Newsletter,* 1992. www.cdc.gov/ epo/mmwr/preview

7. "Pregnancy Planning and Wantedness Among Mothers of Alaskan Newborn," *Dateline,* July 1995, p.1.

8. Ibid.

9. "AIDS and HIV Infections in Alaska," *State of Alaska Epidemiology Bulletin.* Vol. 2, Number 2, Anchorage, Alaska, Oct. 1998.

10. *Family Health Dateline,* Newsletter. Vol. 3, No 4, 1997.

11. STOP Service, (Service-Training-Officers-Prosecutors). Alaska Governor's Press Release, 1995.

12. *Family Health Dateline,* Newsletter. Vol. 5, No 2, 1997.

13. STOP Service. (Service-Training-Officers-Prosecutors) Alaska Governor's Press Release, 1995

14. Ibid.

15. Cobb, Vickie, *This Place is Cold,* Walker & Company, N Y, 1991.

16. "The Status of Women in Alaska: Highlights." Fact Sheet. Institute for Women Policy Research. 2000. www.iwpr.org

17. Administrative Orders, Office of the Governor of Alaska, Juneau, Alaska, June 1988.

18. Joe, Jenny R. "Health of American Indians and Alaska Native Women." *Journal of the American Medical Women's Association,* Vol. 51, 2000. www.jamwa.org.

CONCLUSION

1. Albright, Madeline, *Madam Secretary.* Thomas Dunne Books, 1997

Index

Christian School, 186
Christianity, 39, 136, 189, 281–282
Christians, 39, 50, 73, 188, 217, 282
 See also Mayan Christians
church, xxi, xxii, 41
Church of Christ the Savior, 41, 42
Chuvashs, 7
cigarettes, 106, 143, 253
citizenship, 131
civil rights, 32, 81, 132, 133, 162–163,
 186, 194, 198, 216, 232, 233, 281,
 285
clergy, xxi, 40
clothing, 10, 54–55, 65–66, 74, 105,
 141, 166–167, 167, 170, 174, 204,
 214, 244, 245, 249, 261, 268
 See also dress
codes of conduct, 179
Commonwealth of Independent
 States, 5
Communism, 3–4, 28, 29, 31, 38–39
Communist
 party, 3, 5, 41
 régime, 1, 4–5, 9–10, 11, 18, 21, 27,
 29, 31, 37, 39, 40, 47
Communists, 3, 5, 27, 32
La Compania de Jesus, 195
computers, 13–14, 267, 276, 278, 279
conflict, 7, 58, 60–61, 81, 82, 92, 97,
 123, 130, 160, 162, 198
contraceptives, 94, 169
 See also birth control
control of women, xxi
coral, 127–130, 129
corn, 52, 53, 154, 155, 159, 169, 205,
 207, 210, 226
"corroborees", 135
Costa, 200
coup d'etat, 5
crabs, 229
crafts, 75, 173–174, 188, 190, 192, 204,
 206, 209, 215, 266, 267, 276
 needle, 62
Craig, Rachel, 270
crime, 2, 24, 47, 118, 180, 212
 rampant, 8
Crimean War, 236
Crosby, Mattie, 237

culture, 58, 60, 66, 72, 78, 83, 85, 114,
 117, 120, 123, 130, 131, 132, 141,
 143, 147, 149, 150, 155, 162, 163,
 167, 168, 170, 183, 184, 191, 194,
 198, 199, 203, 209, 212, 232, 233,
 236, 267, 269, 270, 276, 279
 See also Russian culture
czars, 3, 35
 reign of, 3

D
dachas, 16, 17
Darwin Bay, 221
Darwin, Charles, 221, 229
Dawson Creek, 238
Dead Horse Gulch, 263
defeated, 1
deity, 188
destitution, 9, 140, 154, 193, 207
Diamond Lil, 237
didgeridoos, 123, 135, 148
diet, 22, 143, 169, 207, 210, 248
 See also food
dignity, xxiii, 25, 85, 117, 192, 216,
 232, 270, 282, 283, 286
dingo, 130, 143–144
Directory of Women's NGO, 84
discipline of wife, xix
discrimination, 59, 77, 81, 84, 136, 156,
 161–162, 178–180, 194, 212, 280
disenfranchised women, 281, 282
divorce, 18, 25, 38, 39, 71, 211
doctors, 21–22, 39, 76, 213, 274
dogs, 146, 231, 234, 262, 268, 269, 273
 See also dingo
Dolly's House, 238
domestic
 employees, 156, 173, 175–178
 work, 175–178, 180
domestic violence, 25, 32, 77, 118,
 137, 183, 212, 255–256, 280
domination, xxi, 77, 282
Down's Syndrome, 112
Dreamtime, 130, 131, 134–136, 146,
 147, 148, 150, 151
 ancestors, 133
 culture, 133, 134, 150
 worship, 132

About the Author

Winnie Williams is a retired associate professor of special education from Southern Wesleyan University, Central, South Carolina. She received her undergraduate degree from Mississippi College, Master's degrees from New Orleans Theological Seminary and Clemson University.

She is a member of the First Baptist Church of Clemson, South Carolina, a frequent writer on missions and women's issues and speaks to churches, retreats, women's groups, and civic clubs.

Her travels have taken her to more than forty countries where she has served as an educational consultant, university teacher, missionary, speaker and humanitarian volunteer. Most of her writings, including her first book, *Women I Can't Forget,* have been a result of her work in many of these countries.

Winnie and her husband Woodie, emeritus professor at Clemson University, live in Clemson, South Carolina. They are the parents of three adult children and six grandchildren.

She may be reached at wwwill@innova.net.

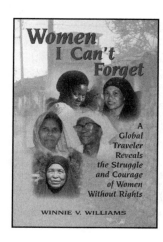

Women I Can't Forget

A Global Traveler Reveals the Struggle and Courage of Women Without Rights

Winnie V. Williams

ISBN: 1-57733-097-8, 6.25 x 9.25, hard cover, $24.95; ISBN: 1-57733-081-1, 6x9, soft cover, 224 pages + 16-pg. color insert

"Winnie Williams ventured where those of us who consider ourselves sensible thought she shouldn't go.... This book creates mental images vivid enough to ensure that you, too, can't forget these women."
—**Sandra A. Reeves, Ed.D.**

Winnie Williams, psychologist, college educator, and world traveling missionary, shares the personal stories of women in third-world countries to elevate awareness of their plight.

From Albania to China, Peru, India, Haiti and South Africa, Ms. Williams describes the everyday lives of women and how they are affected by cultural dogma, and economic and social conditions. Amidst almost overwhelming oppression, Ms. Williams also uncovered their feelings of hope along with a timeless desire to be loved and accepted.

- Women in China cope with the limits of the one-child family, threats to unwanted female children, and the long-standing customs of servitude and domesticity.
- At puberty, South African girls are sent to "tikhomba" school where they learn to be subservient and man-pleasing. Women are beaten by their husbands, sometimes raped, and forced to share their husbands with other women.
- Women in Thailand endure subservient status and physical abuse, and many are afflicted with AIDS.
- Indian women do not sit at the table if men or guests are present. Wives considered "unsatisfactory" are murdered in "kitchen fires" (with no consequences) so their husbands can seek new wives and receive additional dowries.

Blue Dolphin Publishing • Orders: 800-643-0765
www.bluedolphinpublishing.com